Bare Bodies – Thresholding Life

Mariella Greil (Ed.)

DE GRUYTER

Bare Bodies –
Thresholding Life

Mariella Greil (Ed.)

DE GRUYTER

TABLE OF CONTENTS

MARIELLA GREIL

Amaryllisation:

The Uncovering of the Life Cycle

Amaryllisation – Uncovering the Eco-Sensory Fabric Weaving of the Life Cycle

> The most admirable flower would
> not be represented, following the verbiage of
> the old poets, as the faded expression of
> an angelic ideal, but, on the contrary,
> as a filthy and glaring sacrilege[1]

Divining metamorphosis beyond the unnecessarily
polarising tension of ideals or sacrilege is the core of
amaryllisation, for the intimate beauty of blooming
vigour and subversive decay are equally captivating
when exploring the laying bare of thresholds.
Botanist and member of the Citizen Potawatomi Nation,
Robin Wall Kimmerer embraces the notion that plants
are our oldest teachers.[2] Amaryllisation has been
devoted to a wisdom quest for cultivating dwelling
places (from the Greek 'oikos') – an ecology – sensitive
to the thresholds of metamorphosis. At the intersection
of bioethics and posthuman philosophy, an intimate
entanglement with the Amaryllis belladonna, commonly
called 'naked lady',[3] has begun through attending
closely to transformational vitality processes, meticulously
exciting micro-phenomenological changes.
Transformation processes activate the differential
perceptibility threshold, which describes a difference

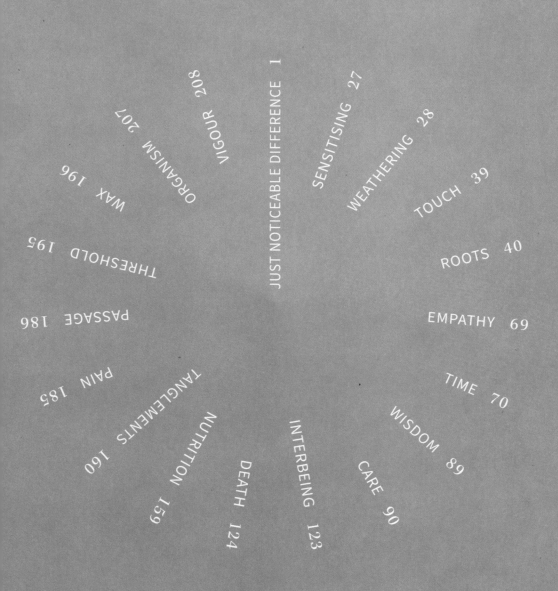

THRESHOLDING LIFE

in stimulus that is just noticeable to the senses.
Biologist and philosopher Andreas Weber argues:
'True, trees and plants do not possess nerve cells.
But they do produce hormones with which they
transmit sensory stimuli through a fine network of
veins to their own organs – in this way they feel, see,
hear and communicate.'[14]

In my Amaryllisation project (2020-23), I have been
probing and provoking floral fancies by blending
photographic, writerly, and performative practices.[5]
Unexpectedly, I found myself scrutinise and
challenge, once again, the classic discussion on
beauty and abundance. Inspiring jouissance[6]
emerged both in revealing the weathering erotic
of ageing, and in the birthing into existence across
the various stages of the life cycle.

As a premise, I consciously focused on stages of
passage, aware that I wanted to anchor ideas
and values firmly in the crudeness of bare bodies.
A practice of dwelling emerged, flowering wildly[7] –
including the blooms of decay – and formed the
horizon of amaryllisation, now nesting between
and dancing across the pages of this book. The
Brasilian landscape architect, artist, and ecologist
Roberto Burle Marx, who was among the first Brasilians
to speak out against the deforestation of the rain
forest, created 'Living Art' and worked on landscape
architecture for public spaces to provide 'dignity

for the masses', as he put it. His botanical explorations revealed each plant's character and its effect on the whole garden. Roguishly he asked: 'Do you realise that when you give someone flowers, you are actually putting a bouquet of genitals in their hands?'[8] It is exactly the coupling of facticity and poetry that amaryllisation is aspiring to. In the cyclic permutation of life, the dwelling at the placeless passage, the supposedly stable identity temporarily collapses, fades, dissolves. It is a hanging in there, staying with the threshold and relishing the opening towards potential transitions and futures. The photographic day to day process following the life cycle of the amaryllis, witnessing the living and dying of the naked lady, revealed the dynamics of the life cycle mostly in gradual transitions, occasionally in sudden shifts. Photographs were always taken at dusk, in the tenderness of the early morning light, the threshold where night becomes day, darkness dissolves and turns into daylight.

This anthology delves into life cycles in their eternal recurrence[9] and abundant diversity[10] activating the movement of thoughts around thresholding or as Ursula K. Le Guin states 'true voyage is return'.[11] Returning to bodies and their bareness follows circularity and is composed for honouring liminality. As has shown, the difference limen of human and more-than-human metamorphosis emerges at times

in unexpected ruthlessness, evoking growing pains,
resistance, and overwhelmedness as well as strange,
ineffable beauty. Through the composition of texts in
relation to each other, the anthology unfolds as a
soul-searching choreography, traced through
emergences and disappearances of bare bodies.
Sounding out metaphorical potential, particularly
for contemporary performance and dance dramaturgy,[12]
activates the prospect to create presence, to grow
in-depth transformative collective experience through
experiments that linger right on the threshold, radiant
by the precariousness of imagination. In this
shared liminal space of not yet or no longer knowing,
it is the form itself that calls for surrender to a
practice of radical expanded[13] feeling the way
forward into futures. These hopeful acts of trusting
that there will be futures attends to more-than-human
forms of sociality and artistic co-creation. The bare
body of the amaryllis in its artificial corsage made
from wax, this tender material that isolates the deep,
wild nucleus of life, paradoxically activates through
shoots and leaves the invigorating power plant
that drives photosynthesis. The violence of the soft
coating exposes the bare force and will for living,
sprouting dramatic beauty even more so. Despite
the impossibility of relying on environmental
nourishment, of planting roots in essential nutrients,
that support and contain the dark living energy,

the hidden depth of life force emerges from the micro-primordial ocean and harbours vital juices that compose the sap and force of life.

Working on the book sparked conversations and exchanges, reflections and meditations on bare bodies – in their plural manifestations – emotional, protesting, lenient, exposed, earthbound, painful, frozen, public, aging and trespassing thresholds. Shimmying along the transitions and edges of art and life practice, the cycle of life starts with rooting nucleation. The first meditation by Athan Crawley 'On Emotions' as a fact of existence, of breathing and becoming flesh, addresses repressed emotions, racialisation, the ongoing process of life and revelation in togetherness. In 'Care for the Earth, Love of the World: Thinking with Hannah Arendt on Somatic Movement/Dance' Gurur Ertem roots her reflections in the political thought of Hannah Arendt and unfolds aesthetic experience and embodiment as forms of engaging in ecological ethics. The second stage, sprouting growth, is 'Laying Bare the Unbearable – Confessions, Participative Apparatuses, and the Lenient Material of the Soul', a conversation with Barbis Ruder on soul-searching, the existential dimension of breath, turning points in art practice, and the role of the body in transformation. Mia Habib and Laurel V.

McLaughlin discuss the choreography of protest and the urgency of bare bodies in 'ALL—A Physical Poem of Protest: A Real-Time Negotiation among Strangers'. This stage closes with laying bare the processes of performing 'Nakedship' — narrated and commented in a trialogue by dancers Alice Heyward, Rebecca Hilton, and Salka Ardal Rosengren. Dancers usually — as is the tacit convention — rarely voice their experiences of performing. In the trialogue, relations and sensations of doing the labour of performing 'nakedship' get into focus. The cycle turns and blossoming maturescence faces 'Pain as Polis', a critical reflection by Pavlos Kountouriotis on the potential to '(re)train revolt, and stay with pain as quintessential to existence, as Spock, First Commanding Officer of the starship Enterprise, exposes. What sets the cycle in motion, moving the wheel of life? K.T. Zakravsky (as author) deals with ZAK RAY's atypical work biography in 'Passed Out: An Autobiographical Emergency', channelling the gender-fluid performative presences that emerged accidental, minced, meshed, and passed. In the section decomposing 'transition', Heba Zaphiriou-Zarifi confronts necropolitics as narratives of bare bodies in 'Frozen Bodies, Frozen Lives'. In personal stories on encountering 'Six Dead Bodies', Rebecca Hilton unearths the transmateriality of affects and losses as felt

bare bodies. With the final phase of the life cycle thresholding immanence the embodied spiritual dimension of 'Inhabited Bodies' and the potential of movement to be seismic is opened up by Fiona Bannon's textual tapestry. She ponders on bodies as sensibilities of thought and reveals watching performance as actualising practice.

Ingrid Dengg and Simona Koch attend to the felt sense while dwelling at the threshold between life and death. 'Dreamwork Entanglements: Staying with the Threshold' is the transcript of a waking-dream process. Applying the present continuous, also called the present imperfect, to the noun threshold combines the present tense with a continuous aspect. Thresholding therefore describes something that is taking place as being or act at the present, while sustaining the moment. Burgeoning processes of transformation and seething sentiments found a truthful catalyst in the assembling of the anthology 'Bare Bodies-Thresholding Life'.

'Beauty is the splendour of the true,' said Joseph Beuys.[14] In this sense, may the cycle of life continue to weave it's sensory fabric with brilliance in tune with ecology!

here bodies. With the final phase of the life cycle Masculating comes the embodied spiritual dimension to 'Inhabited Bodies' and the potential of movement to be serious is opened up by these forms.' Instead Kapadia, the painter, embodies no possibilities of thought and reveals nothing performance an exclusionary practice.

David Dong and Simone Wood attend to the full scale textile dwelling at the threshold between life and death. 'Downort Entanglement: Staying with the Trouble' is the thorough of a nature-cream-process, applying the general continuum, also called the general imperfect, to the way threshold combine the general force with a continuum appeal. Masfaking therefore describe something that is beyond place as being as part of the general textile materine the moment. Transgressing processes of transformation and settling nothing forms a truthful catalyst in the assembling of the anthology 'Bar Bodies-Masfaking life.'

'Beauty is the apotheosis of the true,' said people Bang.' In this area, man, the cycle of life continues to move its perpetual fabric with brilliance is here with ecology.

[1] Georges Bataille, 'The Language of Flowers', Visions of Excess: Selected Writings, 1927–1939, trans. Allan Stoekl, Carl R. Lovitt and Donald M. Leslie Jr. (Minneapolis: University of Minnesota Press, 1985).

[2] Robin Wall Kimmerer, 'In the Footsteps of Nanabozho: Becoming Indigenous to Place', Braiding Sweetgrass: Indigenous Wisdom, Scientific Knowledge and the Teachings of Plants (London: Penguin Books, 2020), 263.

[3] Kathie Carter, 'Amaryllis Belladonna (Brunsvigia Rosea) and Hippeastrum Hybrids', Center for Landscape and Urban Horticulture, Cooperative Extension/Botany Plant Sciences Dept., University California Riverside, 2007.

[4] National Geographic, Journal 8/2015, 88–111. See nationalgeographic.de/umwelt/die-sinne-der-pflanzen, translation from German by Mariella Greil.

[5] The project generated 1,296 photos, across five phases, selecting 108 photos per month over a year, followed by the practice of dwelling with these selected photos, dancing and writing in response to them. Selected reflections are woven into the materiality of text and photo presented in this book, while I am currently working on a performance emerging from Amaryllisation.

[6] 'Jouissance, in Hélène Cixous's sense, is a fusion of the erotic, the mystical and the political' (Sandra M. Gilbert, 'Introduction', The Newly Born Woman, authors Hélène Cixous and Catherine Clement, trans. Betsy Wing [Minneapolis: University of Minnesota Press, 1975 (1986)]) and fractures the structures of signification through which the subjects know themselves (Richard Middleton, Studying Popular Music [Philadelphia: Open University Press, 1990 (2002)]).

[7] Dani Brown's performance The Pressing is staged in a black-box theatre lavishly decorated with flowers and butterflies. She performs a 'cunt' monologue sharing a wild deflowering of post-anthropocentric landscape in the format of queer stand-up comedy. By contrast, Amaryllisation cherishes the factual drama of inevitable plant-human entanglement bound together through evanescence and revival.

[8] Noel Kingsbury, Die Geschichte der Blumen - Und wie sie unsere Lebensweise verändert haben (Berlin: Laurence King Verlag, 2022), 6.

[9] Friedrich Nietzsche, The Gay Science, trans. Walter Kaufmann (New York: Vintage Books, 1974 [1882]), aphorism 341.

[10] Petra Kuppers argues for a shift from abjection to affirmation of exploiting human diversity's 'juicy narrative and sensory potential' (Petra Kuppers, Can Creative Writing Really Be Taught? Resisting Lore in Creative Writing Pedagogy, eds. Stephanie Vanderslice and Rebecca Manery [New York: Bloomsbury, 2017], 152).

[11] Ursula K. Le Guin and Donna Jeanne Haraway, Carrier Bag Theory of Fiction (London: IGNOTA Books, 2020), 1.

[12] Jeroen Peeters, And Then It Got Legs (Brussels: Varamo, 2022).

[13] Choreography as expanded practice here relates to the expansion of timeframes, space structures, sensory modalities, ontological epistemologies, transdisciplinary contexts, etc. For sure this is an incomplete list and is rather an invitation for thinking to be continued quantum liked.

[14] muenster.org/beuys/erweiterter-kunstbegriff.htm.

SENSITISING
ˈsnsətɪzɪŋ

Sensitising specifies the process of heightened awareness, responsiveness, or susceptibility to certain stimuli or factors. It suggests methodically enhancing the sensitivity of an individual, an organism, or a system to distinctive influences or desired outcome. Sensitising can cultivate a general openness, but in this context, the focus is on somatic integrity beyond the mere factual (anatomical) boundaries of the body, attending to the political ontology of the flesh where world and *sōma* entangle. Sensitising ecosystems or organisms to post-digital, environmental change supports research into ecological responses to shifts in conditions, whether in the development of immunity, in chemical experiments when mixing substances, in symbiogenesis, or networked artificial intelligences. Sensitising agents increase the reactivity, accelerate reactions, or make them more responsive to living conditions and potential thresholding. Overall, sensitising involves intensifying receptiveness and adaptability, often leading to more informed decisions, imaginative solutions, creativity, and collective action.

WEATHERING
ˈwɛðərɪŋ

Weathering points to the gradual process by which natural forces, such as wind, water, temperature, fluctuations, and (bio-)chemical reactions, break down and alter the properties of materials and bodies on Earth's surface. Physical weathering denotes the breakdown of an organic entity into smaller fragments without altering their composition. Common mechanisms include expansion and contraction, and the activities of plants and animals. Chemical weathering entails the alteration of composition due to chemical reactions with substances, such as the gnawing of rust. Processes like hydrolysis, oxidation, and dissolution can transform materials, leading to the formation of new compounds. However, weathering is not only a fundamental geological process that plays a crucial role in shaping landscapes and transforming Earth's features over extended periods. This process also affects bodies and organisms and influences the degradation and transformation of historical, cultural-aesthetic structures and artefacts. Weathering shapes culture as well as valleys, riverbeds and coastlines. Its effects are evident in the diverse and evolving landscapes that define Earth's geography and political history as much as the future bodies that will live on this planet.

ROOTING
NUCLEATION

ROOTING
NUCLEATION

Rooting Nucleation

> If I swallowed a seed and some soil, could
> I grow grapes in my mouth?[1]

What can a bare body in all its exposure do?
Which visceral, transformative powers lie dormant?
How to bare embodied thresholds as qued for life?
And what sustenance – or in the old-fashioned
term, 'sustentacles', 'that which upholds or supports' –
will be necessary for future living?
The posthuman tentaculum – literally 'feeler', from
Latin 'tentare', 'to feel or try' – will, without doubt,
with jouissance, surpass anthropocentric epistemologies.
Root zones inhabited with transfiguring enactivist[2]
mycelia are formed by millions of finest root hairs
that provide us with a hold, sustain livelihood so
urgently needed. Across geological strata, miniscule
creatures populate these shared grounds. Proliferation
happens in the surrounding fecundity of soil. Its
ingestive and receptive qualities subvert norms of
mesoscopic, measured pace, speed and volume of growth;
instead, a feast of excess is taking place. As Bataille
writes, 'the impossible and fantastic vision of roots
swarming under the surface of the soil, nauseating
and naked like vermin'.[3]
So, what does rooting entail?

The relentless cycles of thresholds form what we call life. These verges keep instigating curiosity for yet (un)known life forms and togetherness. Can the planting of an embodied and situated nucleus of an experimental idea really be holding potential for unfolding otherwise possibilities¹ of life-cycling — or is it all given?

In the light of a ubiquitous search for the soul of soil which has gone missing, environments that have been exploited and creatures that have gone extinct, emotions form the ground for practicing otherwise knowledges², collective modes of action, and, beyond that, uncompromising care for the earth. The planting of wild life deep into the fibres of existence uncovers the virtues and generative plasticity of bare bodies living at the cusp, at home, at the threshold, generates spiritual connection³, and yields care for blue horizons.

¹ Dillard Annie, Pilgrim at Tinker Creek (Rymble NWS: HarperCollins e-book, 1974 [2007]), 117.
² Di Paolo, Rhode and De Jaegher emphasise that '[n]atural cognitive systems…participate in the generation of meaning…engaging in transformational…interactions'. See Ezequiel Di Paolo, Marieke Rhode and Hanne De Jaegher, 'Horizons for the Enactive Mind: Values, Social Interaction and Play', Enaction: Toward a New Paradigm for Cognitive Science, eds. John Stewart, Oliver Gapenne and Ezequiel Di Paolo (Cambridge: MIT Press, 2014), 33.
³ George Bataille, 'The Language of Flowers', Visions of Excess: Selected Writings, 1927-1939, trans. Allan Stoekl, Carl R. Lovitt and Donald M. Leslie, Jr. (Minneapolis: University of Minnesota Press, 1985) 10-14.
⁴ Ashon Crawley's 'otherwise possibility' presumes 'that whatever we have is not all that is possible'. (interfictions.com/otherwise-fergusonashon-crawley).

ASHON CRAWLEY

On Emotions

Emotion is. It is a fact of our existence and breath and becoming.

I have been wondering about emotion and breath and becoming because I want to practice making things for myself, for others, with myself, with others. And the kinds of things I make are all about emotion, all about feeling and sense and mood as a collective process and practice that can catch hold, that can be handled and felt as a social modality.

If we feel things, it is within the social world of such feelings' emergence.

Yet we live in an epistemological moment, a post-1492 moment, a post-1444 moment, that presumes emotions are the sign and symbol used to discuss the expression of some, but not all, dispositions and postures. And this because there is, on emotion, a categorical distinction that is grounded in racialisation *as* the practice of gender segregation, sexual orientation as biological and uncrossable. We're all living the afterlives, not only of slavery, as Saidiya Hartman offers. We are also living the afterlife of predestination doctrine, elaborated most fully for our modern world by the theologian John Calvin.

My art practice is an attempt to resist and reject predestination as an ideology and way of conceiving worlds. Nothing is inevitable. We have the capacity to make things with one another, to make worlds otherwise, not as a normative spacetime to inhabit, but as the ongoing process of fashioning lives together, living along in the way Gwendolyn Brooks describes it.

Putting the flesh on the line, dancing in one spot repetitiously in a circumambulatory posture and plea: it is to say 'yes'. I am trying to sense beauty in the lifeworlds that have produced me, even when those lifeworlds have renounced relation to my breath and becoming. And by beauty, I mean the letting-be of sense experience – their uncontainable and uncultivated nature, the senses in their wild interrelation. A kind of joy through depth of perception. Though brain science offers that there are different parts of the biological mass that process different perceptive behaviours, I want to think about the brain as a system, as a whole that integrates through distinction.

What if the emotion of delight is produced by the sight of blue?

In lovely blue the steeple blossoms
With its metal roof.
Around which Drift swallow cries,
around which Lies most loving blue...

But what if the sight of blue is more than its sight, what if the brain processes the emotion as a sense perception too? What if *most loving blue* is itself a sense-perceptual response, not contained by sight but spilling over into taste, touch, hearing, smell? This to ponder what if emotion *is* and all we ever do is discuss the way emotion happens, the form emotion takes? And what if the form emotion takes has been, through the post-1444/1492 epistemology, racialised and gendered and classed such that only *some of us* are supposed to operate through emotion, some of us have been *relegated to* emotion and not allowed to leave or relinquish relation to or renounce the capacity for producing emotion and being emotional? This is another inflection on what I believe is the problem of our day, the problem of the colour line that preceded W.E.B. Du Bois' necessary elaboration, the problem that remains with us today.

It is a problem of renunciation.

Because what do we mean when we say, for example, *women are emotional,* and offered too, *men are rational*? What do we mean when we say Black folks are emotional and lack the capacity for controlled thought, stability, understanding, reason? What is meant by the idea that queer folks are simply acting through the flesh and not concerned with higher spiritual ideals? In order to somehow escape these purportedly degraded stations, these positions and forms of social life that have been marginalised by a normative and violent world, emotion is one of the things one's gotta give up. And so, we pretend that what we achieve is an emotionless state, a way of control and rationality, not given to the whims of hearts aflutter or anger out of control.

But how does one renounce emotion? How does one give it up? Like whiteness, never in the final end achieved, which makes emotion a problem for thought, one only gives up emotion as an unachievable idea or aspiration. Because emotion is. It is the state of one's mind in context, one's mood. And one is always in a mood, even when only some moods are considered to be moods. And one is always in

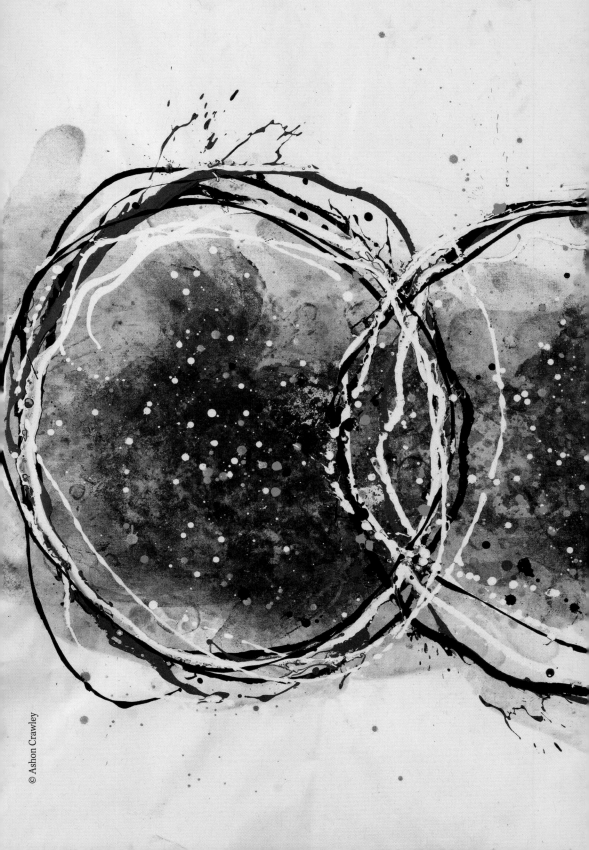

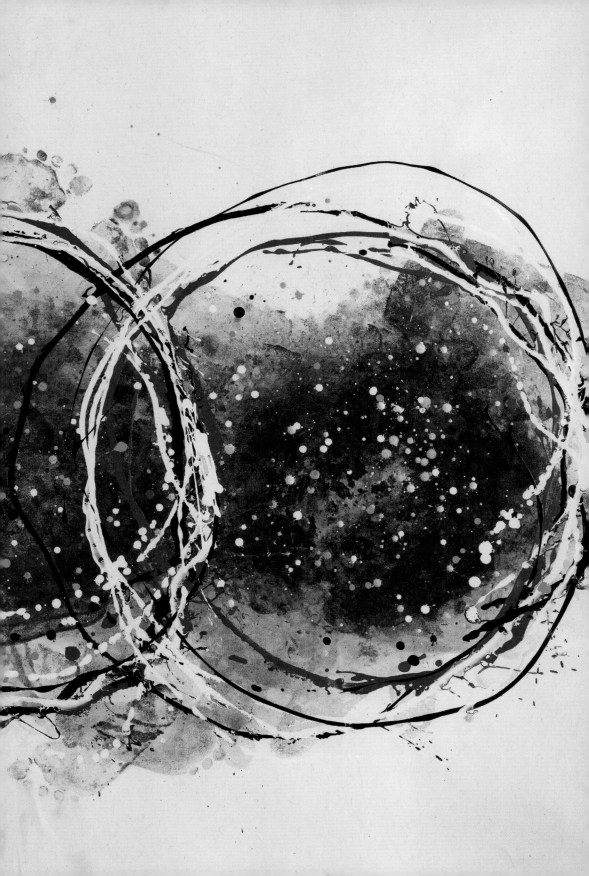

blackness, even when only some are considered to be Black. The normative world is produced by renouncing relation to that which precedes it. The normative world is a giving up, a yielding, a letting go of possibility, of relation, of care. This giving up, this yielding, this letting go is an emotional minefield.

So, I make things. I make things that take breath and pause and rest. I make things that are about emotion – 'How does it feel?' D'Angelo sings – but prescient too. Because I am trying to figure out how it felt to be, as a young person, in the Black Pentecostal churches that taught me so much about listening, sensing vibration, being attentive to sense experience in its range and uncultivated nature. We felt beauty there because we were allowed to let our brain mass get confused and mix up sense perceptions. The sound of the Hammond organ and hand claps sensed and felt and known as spiritual connection to one another, to a world otherwise that we tried to bring down to earth with us in a material way.

And I've been trying to let go of what it means to know in this particular and peculiar epistemology that is racialised. I've been trying to know through emotion, through feeling and mood. I've been trying to know against the limit of the injustice of the individual subject, to know in the direction of the social, knowledge produced there and then only reflected upon in singular momentary ruptures of what we might imprecisely call 'individual thought'.

Because so much of what we think we are, and think possible, is predicated on the idea that we have knowledge already before an encounter, that we have knowledge before, or previous to, any situation. We're all little Kantians. But what this presumes is that knowledge, under the guise of the thing called 'theory', has to be verified before encounter with the material world. But as bell hooks said, theory is the thing that comes after the practice and the living of life, theory gives a method to make something of what has been made and sensed and felt and known. Theory is just another kind of art practice, a making of things, a putting together of things, a taking apart of things, with hopes of moving others, prompting others. To sense delight and something lovely, like blue.

TOUCH
tʌtʃ

Touch is a fundamental sense that enables organisms to interact with their environment through physical contact. It is referred to as tactile perception, involving the detection of pressure, vibration, temperature, weight, and texture, conveying a wealth of information about bodies, objects, and surfaces. Specialised nerve endings, known as tactile receptors, are scattered throughout the skin and mucous membranes. They respond to different stimuli, such as pressure, temperature, and pain. Pressure touch detects mechanical deformation of the skin, while thermoreceptors sense temperature changes. Nociceptors signal pain in response to potentially damaging stimuli. Generally, tactile pathways processing in the somatosensory cortex enables the brain to perceive and interpret tactile sensations. We also know that touch plays a vital role in social bonding, emotions, support, and comfort, and of course in communication between species. Skin-to-skin contact and tactile stimulation promote attachment and sensory exploration. In essence, touch is a complex sense that allows (bare) bodies to navigate their surroundings, establish connections with others, and perceive the world in ways beyond vision and hearing.

ROOTS
ruːts

Roots are vital components of plants, serving various essential functions in growth, nutrition, and support. They are typically found underground, originating from the plant's stem or embryo. Roots interact with soil microorganisms, forming symbiotic relationships that enhance nutrient availability and contribute to ecosystem health. Roots have an ecological role to play for anchorage and support, nutrient and water absorption. They anchor plants in soil, preventing uprooting by wind or water, and absorb water and minerals from the soil through fine root hairs. Some roots store energy reserves in the form of starches, sugars, or other nutrients. These reserves sustain plants during periods of dormancy or adverse conditions. Roots aid in metabolic processes and growth, also through decay. Roots (materially and metaphorically) influence plant and human community dynamics nutrient cycling. They are vital for growth, survival, ecological balance, and complex interactions with their environment.

GURUR ERTEM

Care for the Earth, Love of the World

Thinking with Hannah Arendt on Somatic Movement/Dance

In the past decade, there has been a revival of interest in the political thought of Hannah Arendt in the wake of the conflict between factual truth and politics, new waves of refugees, multi-regional uprisings, and contemporary versions of authoritarianism. However, her astute insights that have significant implications for an ecological ethics have not received equal attention. As early as the launching of the Sputnik satellite into Earth's orbit in 1957, Arendt had foreseen the predicaments of the desire to flee the earthly condition, namely nature, corporeality, and the material basis of life.

Arendt foregrounds humans as fundamentally terrestrial creatures and invites us to think about the political implications of being earthbound – and the resistance to it – in the context of consumerism, capitalism, modern science, and technology. In particular, the prologue and the final chapter, 'Vita Activa', in *The Human Condition*, and her later essays such as 'Man's Conquest of Space' and 'Archimedean Point', are compelling precursors of, and interlocutors to, current Anthropocene debates. It's only recently that some environmental thinkers and Arendt scholars have begun to pay attention to this aspect of her work.[1]

In this essay, I examine the distinctions Arendt draws between the 'world' and the 'earth'. I propose that 'care for the earth' (the material, given nature, our planet)

as well as 'love for the world' (artworks, objects, artifacts, etc.) are intertwined in Arendt's understanding of culture and crucial for maintaining human dignity as well as the stature of political action. Given the curious absence of the body in much ecologically oriented art today, I envision reclaiming aesthetic experience and embodiment as ways of coming to terms with ecological concerns and for 're-enchanting nature' by discussing somatic movement practices. I focus in particular on the Tamalpa Life/Art Process developed by Anna Halprin and Daria Halprin.

PLANETARY EXILE

Arendt's thinking was based not on ideas but events, which is one of the main reasons she considered herself not a 'philosopher' but a 'political theorist'.[2] The experience of totalitarian regimes, the atomic bomb, the Cold War, the space expeditions, and the threat of a nuclear catastrophe that could eliminate all life on the planet were the very events that made her rethink the role of modern science in the processes of what she calls 'world alienation' and 'earth alienation'. While most readers focus on the parts that develop a theory of action and consider the book Arendt's main contribution to twentieth-century political thought, *The Human Condition* is more than that: It is a genealogy of 'modern world alienation, its twofold flight from the Earth into the universe and from the world into the self'.[3]

World alienation and earth alienation are distinct yet connected experiences for Arendt. She traces this alienation to three key events in the West in the sixteenth and seventeenth centuries: first, the discovery of America and mapping of the entire surface of Earth; second, the Reformation, which expropriated land and uprooted millions of peasants from their homes; third, the invention of the telescope, which encouraged a departure into space from Earth and introduced a universal instead of terrestrial relation to the cosmos, and finally, the triumph of Cartesian doubt and geometry, which 'freed' humans from geocentric conceptions of space.[4]

'World alienation' implies, for Arendt, 'a loss of shared experiences, intersubjective reality, and commonality'.[5] It's the loss of a place, belonging, and the absence of a sphere where meaningful activity can be pursued with others, facilitated by the bonds of a shared culture, language, or tradition. It entails uprootedness and loneliness, the perfect ground for totalitarianism and variants of authoritarianism to flourish. The 'world' consists of durable, material, and immaterial human

constructions, including artefacts, cultivated land, institutions, artworks, and poetry. 'Worldliness' provides a space between people that brings about the possibility of a public realm where people can gather, disclose who they are, and act in concert. For Arendt, living in the world is to live in a world of things between those who have it in common. The famous example she gives is the table. It separates and unites those who sit around it and provides a space-in-between where political action and meaningful conversations can occur.

For Arendt, human beings have two aspects to themselves: Besides building a world, we are of the earth, part of nature as an animal species subject to biological needs. She posits 'earth alienation' as a feature of modern science. It's the process marked by the domination, conquest, and transformation of the earth through colonial explorations, expropriations, technological inventions, and the flight from Earth into space, resulting in a collapse of spatial distances and estrangement from the planet. The launching of Sputnik – the first artificial satellite, on October 4, 1957, as part of the Soviet space programme during the Cold War – is the event under which Hannah Arendt sets forth her argument in *The Human Condition* as the prime example of 'earth alienation'. This event, was 'second in importance to no other, not even to the splitting of the atom'.[6] She observed that the primary response to the event was neither joy nor pride at the tremendous power of human achievement, but relief about 'the first step toward escape from men's imprisonment to the earth'.[7] From time immemorial, Arendt writes, Western philosophy and Christianity looked upon the earth as a 'vale of tears' and considered their body as a prison of the mind and the soul; yet nobody until then had conceived of the earth itself as a prison, manifesting 'an even more fateful repudiation of an Earth who was the Mother of all living creatures under the sky'.[8]

What we are witnessing today is that the desire to flee the earthly condition is in full swing. And, it's not only geopolitical powers but also corporations promoting the 'conquest of space' and the plundering of nature.[9] While numerous artists were refusing to travel via airplanes due to ecological concerns and the majority of the world's populations were under quarantine, NewSpace companies, SpaceX and Blue Origin, founded by billionaires Elon Musk and Jeff Bezos, organised highly mediatised space expeditions.

For Arendt, a novel feature of new science and technologies in the modern world is that humans do not only act upon nature but *into* it.[10] With new science, we

introduce irreversible processes with unforeseeable outcomes, such as nuclear fusion. In that regard, nature and history become 'man-made' processes. With her thesis that human beings have begun to act *into* nature, Arendt anticipated the now well-known hypothesis of the Anthropocene: that human and geological times intersect. She saw that the advent of atomic weapons and artificial processes could destabilise the conditions that make the earth and the world permanent. In other words, the world's materiality and objectivity are transformed and can no longer be taken for granted.

Central to Arendt's account was how the 'Archimedean point' of view developed by modern science displaced geocentric conceptions of the Earth into a universal context.[11] The transition from a geocentric to a universal point of view from outer space, as though one could hinge on Earth with a lever and look at it from a distant point, foretold a broader form of alienation and destabilised embodied experience. This view introduced a discrepancy between sense experience and scientific truth: Although we could now know that the sun revolves around the sun and the sun does not 'set', it does not change the lived experience of a sunset. Arendt's insights also resonate with the so-called 'Gaia principle' regarding our planet's uniqueness and habitability.[12] Arendt was aware of the distinctiveness of the planet's capacity to support life and was concerned with the technological attempts to cut human ties to nature and even escape the planet itself, our wish to exchange life as it has been given, 'a free gift from nowhere (secularly speaking)', to something we have made ourselves. She had already written in 1958 – long before Gaia ideas began to circulate – that 'the earth is the quintessence of the human condition, and earthly nature, for all we know, may be unique in providing human beings with a habitat in which they can move and breathe without effort and without artifice'.[13]

The modern frenzy to transcend our terrestrial, earthly condition is a question of the first political order for Arendt because the survival of humanity, both as a species and a political community, is at stake. For this reason, it's a problem that 'can hardly be left to the decision of professional scientists or professional politicians'.[14] Yet, she does not offer recipes for action and instead advises that first 'we stop and think what we are doing'.[15] Against a withdrawal from the world into cynicism and nihilism, Arendt insists on maintaining 'love of the world' (she had intended to title *The Human Condition* as *Amor Mundi*) as well as respect for the earthly condition. Although she does not offer clear examples of what it might

look like, there are hints in her essays 'Culture and Politics' and 'Crisis in Culture'. Some political ecologists and environmental philosophers have recently taken up these hints. They argue that while we cannot completely adopt a non-interference perspective of nature, we can deploy an attitude of loving care that entails awe, gratitude, and respect, instead of domination and rejection.[16]

ATTITUDES OF CARE

In 'The Crisis of Culture' Arendt traces the etymology of the word 'culture' – the prime activity that builds a lasting world that we can share in common – to the Romans' use:

> The word 'culture' derives from *colere* – to cultivate, dwell, to take care, to tend and preserve – and it relates primarily to the intercourse of man with nature in the sense of cultivating and tending nature until it becomes fit for human habitation. It indicates an attitude of loving care and stands in sharp contrast to all efforts to subjugate nature to the domination of man.[17]

Here, one can discern that Arendt does not pose a nature/culture divide (as many of her critics have claimed) but places them on a continuum.

Political ecologist Kerry Whiteside contends that Arendt's work provides a basis for an environmental ethic in which nature is to be valued and cared for in the same way we care for works of art and other cultural creations and approach it with a non-domineering, non-utilitarian attitude.[18] It entails engaging with nature, not as something to be exhausted, but to be treated as an existential partner. Whiteside illuminates why respect for the world and the qualitative dimensions of life, appreciation of the earth, and political activity are closely connected. Making the world is possible by the 'givenness' of the earth. Yet, it does not imply passivity. Gratitude for the earth can be accompanied by a commitment to change the world and build it anew. Similarly, environmental philosopher Anne Chapman argues that gratitude for the earth involves attending to nature that welcomes what we find there instead of an attempt to make nature into something that conforms to our ideas about how things should be.[19] Such an attitude would entail granting nature its objectivity in the sense of object as *Gegenstand* (an object/subject that 'stands against', in a way, as an 'agent'), instead of as *Bestand* (object as supply, as something to be used up).[20] Political scientist Ari-Elmeri Hyvönen suggests that

we can expand Arendt's notion of gratitude and political responsibility to include the biosphere as a whole and not only the 'world', extending our solidarity to non-human entities. In other words, he argues that *amor tellus* ('love of the earth') is deeply linked to *amor mundi* ('love of the world') and cannot be conceived independent of each other.[21] Such an attitude, Hyvönen writes, can be found in the material culture of respect among native peoples in how they maintain and care for different species to co-exist.[22]

MASTERY OF NON-MASTERY?

What other 'down to earth'[23] attitudes are possible and/or could be recuperated? I would argue that tapping into aesthetic experience and 'landing on the body', that is, taking the body in/as nature seriously, is essential for any critical thinking regarding our ecological 'crises'. Theodor W. Adorno and Max Horkheimer wrote, in the *Dialectic of Enlightenment*, that the history of the world is the history of the domination of nature, including the subjugation of women, animals, and even oneself and one's own body.[24] Against this dominance, anthropologist Michael Taussig proposes the 'mastery of non-mastery' as a non-domineering attitude to nature and ethical stance toward the world. The existential threat posed by the planetary crisis has made us realise the things that we had overlooked, and 'we have begun to sense our animal selves, plant selves, and insect selves'.[25] With the planetary meltdown, Taussig writes, it has become apparent that the body does not exist outside of its relation to the cosmos.

Taussig also believes that our capacity for mimesis has been remarkably increasing in the age of political and ecological collapse, and we could turn this to an advantage. He sees the amplification of the mimetic faculty as an opportunity to make one sensitive to 'becoming mimetically sensuous beings'[26] with the ocean, sun, insects, and plants, among other entities. In order to articulate this, we need new modes of connecting and a new poetic language. He argues that it entails tapping into the 'bodily unconscious' in which 'the body came to mean my body, your body, and the body of the world'.[27]

For Taussig, the proliferation of 'green books, freshly minted journals, essays, research grants, talk shows, films, fellowships, political campaigns, and endless conferences on the Anthropocene, animism, life, vibrant matter, and the "ontological

turn"...even if couched in crabby secular language'[28] are all proof of a re-enchant-ment with nature. Different genres of art that address environmental concerns have, indeed, become part of the artistic mainstream in the last decade. Biennials, festivals, exhibits, and global network projects on ecological themes are abundant. And yet so many of these attempts – even when they claim to be in the fields of dance – do not seem to be paying much attention to the body if we consider the body itself as nature. Even in the contemporary dance field, the somatic dimension is often absent. Somatic practices moved to the margins of the dance field as New Agey, esoteric concerns that are not considered intellectual enough. Or, there are almost literal representations of ecological themes in the field that take the natural environment either as a backdrop, raw material, object of inquiry, or resource for art. Also, much talk about ecological themes does not go beyond preaching to the converted. So, in a way, it's not only nature that's been disenchanted, but also the arts. As Byung-Chul Han observes, this disenchantment in the arts is not only because the aesthetic is colonised by the economic logic of cultural capitalism, but also art is increasingly being displaced by discourse.[29] In the place of compelling, captivating, seducing forms, we find discursive content where 'meaningfulness disappears as it's being reduced to a single meaning'.[30] Magic and enchantment are disappearing from culture and art is becoming 'anaesthetised'.[31]

Similar to Han, philosopher Timothy Morton criticises much ecologically oriented art that has become more informative and discursive rather than aesthetic. For example, numerous artists have compiled massive lists of life forms and species that are going extinct with this risk of becoming yet another 'huge data dump'.[32] Aesthetic experience is not about rational argument or persuasion, Morton writes, but about 'being in solidarity with what is given'.[33] It's about the feeling of an object's power over one; being haunted, charmed, enticed, and enchanted. Morton speaks of this aesthetic experience as one potential mode of an ethics of ecological awareness. Also, Morton playfully suggests that we cannot *not* have ecological awareness because we are ecological beings, whether we like it or not: 'We are already symbiotic beings, entangled with other symbiotic beings, breathing air, our bacterial microbiome is humming away, evolution is silently unfolding in the background, a bird is singing, and clouds pass over your head.'[34] Emotions, sensuous experiences, and awareness of our embodiment are the basis for Morton's deep engagement with ecology. That is, he too calls for a more embodied, 'lived ecology' modelled after aesthetic experience.

'RETURNING HOME':
SOMATIC MOVEMENT/DANCE

Somatic dance/movement practices entail care for the earth by being attuned to it, artfully, in a world-building and culture-creating way. Philosopher and movement researcher Thomas Hanna popularised the terms 'somatics' and 'somatic education' in the 1970s.[35] He brought attention to the Greek term '*soma*', meaning the living organism in its wholeness. *Soma* signifies the 'living body' as distinct from the 'body', emphasising that soma is alive and a process, always in dynamic exchange with other entities, bodies, life experiences, and the environment. The difference between the body and *soma* is similar to the distinctions phenomenologists, from Edmund Husserl to Maurice Merleau-Ponty, drew between *Körper* (body/object) and *Leib* (the lived body).

Somatic practices arose simultaneously at multiple locations across the globe from the turn of the nineteenth century into the twentieth. Although it's been systematised mainly in Europe and the US, its resources and inspirations are ancient and intercultural.[36] Many examples of such somatic practices include the Feldenkrais Method, Body-Mind Centering, Butoh, Amerta Movement, and Katusgen Undo. I'm most familiar with the Tamalpa Life/Art Process developed by Anna Halprin and Daria Halprin, due to my immersion in the practice for the past three years. Life/Art Process is an intermodal approach to arts that includes movement/dance, voice/sound, dialogue, performance, and reflection, to improvise, gain insight, and forge connections with the outer and inner world, and acquire the tools to live creatively and in constant awareness of one's embodied state as well as those of others and the environment.[37] Life/Art Process, like other somatic approaches, is based on the premise that movement is a constant in our lives since the first instance of the formation of our cells. It encompasses multiple interrelated tools such as movement ritual, body-part explorations, psychokinetic imagery, RSVP cycles, creative writing, the five-part process, witnessing, and active listening. Summarising these aspects, and how they evolved out of Anna Halprin's lifework, is beyond the scope of this essay. I will briefly focus on two parts of the Life/Art Process that are particularly salient examples of caring for the earth and building a world: work in the natural environment and ritual.

Just as natural environment and the idea of place was a core aspect of Halprin's practice, it's an essential dimension of Tamalpa Life/Art Process teachings. Also,

just as Halprin refused to limit what could be considered 'dance' or who could be a 'dancer', she expanded where dance could take place or what it could pay attention to.[38] She treated the environment not as a backdrop, theme, or raw material but as a dancing partner with a deep sense of kinship with nature. She also resisted symbolically interpreting nature and natural phenomena and preferred to let it *be*.

Halprin's respect for, and connection to, the natural environment was enriched during her long-term relationship with the Pomo Indians and the culture of indigenous people. While she was against appropriating indigenous beliefs and practices for art, she was drawn to their understanding of the earth as a living entity. As she writes:

> The Pomos lived their experience of nature, not just in thought, but in their daily interactions and worship. Their dance expresses their belief in the sanctity of nature, and their dance consecrates the world. I have been attracted to their ways not because I wanted to imitate their life or their rituals, but rather to understand better something I believe is true for all of us, as human beings in relation to earth.[39]

She believed that our relationship to nature had been severed and nature was reduced to an 'inanimate object' that we attempt to dominate and control. Part of the intention of her work and Tamalpa Life/Art Process is to 're-establish a sense of relatedness to the natural world'.[40]

For Halprin, the work in the environment generates a feeling of 'coming home' because our bodies are not separate from nature; we are nature. This is not a metaphor but a fact: We are part of the earth we inhabit and our bones, breath, and blood are the minerals, air, and water around us and dance and movement are important ways to experience this interconnectedness.[41]

Tamalpa Life/Art Process facilitates re-engaging with nature through specific movement practices, becoming sensitive to our inner and outer landscapes, and responding creatively to them. For these reasons, some dance scholars locate the Life/Art Process within the burgeoning field of 'ecosomatics'.[42] Influenced by ecopsychology, ecosomatics refers to somatics applied to addressing environmental issues and a call to attune with the earth and become aware of oneself participating in/as the natural environment.[43]

In his book *Sacred Ecology*, applied ecologist Fikret Berkes explores how rituals can act as a way to pay respect to nature or as a reminder of ethical obligation towards it.[44] Indigenous peoples have long used rituals as a portal to the natural world. Yet, rituals do not only provide communion with nature, they also build a world and forge communities. Byung-Chul Han writes that rituals are 'symbolic techniques of making oneself at home in the world',[45] making time and space habitable. They stabilise life and make it objective, independent of human beings. In a way, they are like the 'things' Arendt talks about that build a common world, providing durability and endurance, unlike things used up and consumed. They are symbolic practices of bringing together a community. More importantly, rituals are processes of embodiment and bodily performance. They create bodily knowledge and memory.

For Halprin, one important intention in her work is to make rituals that are art. As she writes: 'It is my...highest ideal in the creation and use of the Life/Art Process to make rituals that are art and to make art that is ritualistic in nature.'[46] Her well-known works *Circle the Earth* and *Earth Dance*, among others, are community rituals that take place in the natural environment with participants across the globe.

For Halprin, the vital characteristic of ritual is that it carries the specific intention to create change She works consciously with notions of ritual time and space, differentiating them from daily life and theatrical performance. The workshops she taught and the training sessions of the Tamalpa Life/Art Process entail a liminal period of ritual. Preparation of the spaces – either in the studio or natural environment – is also ritualistic. Spaces become place as they are sacralised. For example, the blessings of spiritual leaders, both indigenous and Western, together with honouring the four directions, have been an ongoing feature of *The Planetary Dance* since 1981. The encounter with the natural environment is also ritualised. For example, in one movement exercise, participants search for a rock that is the size of the skull. Elements of nature become imbued with personal symbolic meaning, functioning as a 'container for the feelings, fantasies, insights, dreams, and associations generated during the workshop'.[47] And, participants' relationship with, say, a rock continues to evolve beyond the studio.

CAVEATS FOR FURTHER THOUGHT

This essay began as a part of my ongoing inquiry into the role of art and aesthetic experience in the political philosophy of Arendt, as well as my involvement in somatic movement/dance. Arendt never wrote about the body or ecology per se. Yet, during my recent re-readings of her critical works with the Virtual Reading Group led by Roger Berkowitz at the Hannah Arendt Center for Politics and Humanities at Bard College, I became mindful of how certain aspects of her thinking regarding 'earth alienation' and 'world alienation' resonate with current debates on the Anthropocene. Because Arendt takes her bearings from the phenomenological tradition, one can argue that her thoughts are also relevant for thinking about somatic practices. Also, I propose that instead of 'thematising' environmental and ecological concerns in some current dance practices, a return to the lived body and a somatic movement could be considered a way to land on the earth.

I am aware that it could be a challenge to reckon with the need for re-enchantment, meaning, and communing with nature when everything is and can be commoditised and 'New Age silliness' abounds on all sides of the political spectrum. There are many practices of well-being that are at the service of the happiness industry, serving to psychologically optimise by adapting us to existing forms of social domination. It's essential, therefore, that somatic practices and rituals do not become yet another service to the neoliberal imperative of individual happiness, distracting us from existing forms of social and economic domination by instigating disengagement with the world and a withdrawal into the self.

1. See the latest edition of *HannahArendt.net Journal for Political Thinking* 11, no. 1, 'Natur und Politik', 2021. In particular, see: Antonio Campillo, 'In Praise of the Terrestrial Condition'; Toni Čerkez, 'World is At Stake: Arendt, "Anthropocene", and "Mankind's Earthly Immortality"'; Ari-Elmeri Hyvönen, 'Amor Tellus? For a Material Culture of Care'; Veronica Vasterling, 'Arendt's Post-dualist Approach to Nature: The Plurality of Animals', hannaharendt.net/index.php/han/issue/view/19. Also see the current research project 'Hannah Arendt on Earth', coordinated by Dipesh Chakrabarty, Samantha Frost and Nancy Tuan, arendtonearth.com.

2. Hannah Arendt, '"What Remains? Language Remains", a Conversation with Günter Gaus', *Essays in Understanding* (New York: Schocken Books, [1964] 1994), 2.

3. Hannah Arendt, 'Prologue', *The Human Condition* (Chicago: University of Chicago Press [1958] 2018), 6.

4. David Macauley, 'World Alienation and the Search for a Home in Arendt's Philosophy', *The Bloomsbury Companion to Arendt*, eds. Peter Gratton and Yasemin Sarı (New York: Bloomsbury Publishing, 2020), 650–655.

5. Ibid., 651.

6. Hannah Arendt, 'Prologue', *The Human Condition* (Chicago: University of Chicago Press, 2018), 1.

7. Ibid.

8. Ibid., 2.

9. Antonio Campillo, 'In Praise of the Terrestrial Condition', *HannahArendt.net Journal for Political Thinking*, 2022, hannaharendt.net/index.php/han/article/view/453.

10. Hannah Arendt, 'The Concept of History: Ancient

and Modern', *Between Past and Future*, ed. Jerome Kohn (New York: Penguin Books, [1958] 2006), 41–90.

11. Hannah Arendt, 'The Archimedean Point', *Thinking Without a Banister*, ed. Jerome Kohn (New York: Schocken Books, [1969] 2018), 406–418. Also see: Hannah Arendt, 'The Conquest of Space and the Stature of Man', *Between Past and Future*, ed. Jerome Kohn (New York: Penguin Books, [1958] 2006), 260–274.

12. British scientist James E. Lovelock resurrected the ancient Greek mythological figure of Gaia in the 1960s ensuing from his work for NASA concerned with detecting life on Mars to illustrate that the Earth is a unique, self-regulating system composed of a diversity of indivisible elements that evolve through mutual modification. American microbiologist Lynn Margulis later improved the Gaia hypothesis in the 1970s by proposing that all organisms and their inorganic surroundings on Earth are closely integrated to form a single and self-regulating complex dynamic, maintaining the unique conditions for life on the planet.

13. Arendt, 'Prologue', 2–3.

14. Ibid., 5.

15. Ibid.

16. See, for instance, Dipesh Chakrabarty, *Climate of History in a Planetary Age* (Chicago University of Chicago Press, 2021).

17. Hannah Arendt, 'The Crisis in Culture: Its Social and Political Significance', *Between Past and Future*, ed. Jerome Kohn (New York: Penguin Books, [1960] 2006), 208.

18. Kerry H. Whiteside, 'Worldliness and Respect for Nature: An Ecological Appreciation of Hannah Arendt's Conception of Culture', *Environmental Values* 7, no. 1 (1998): 25–40.

19. Anne Chapman, 'The Ways That Nature Matters: The World and the Earth in the Thought of Hannah Arendt', *Environmental Values* 16, no. 4 (2007): 433–445.

20. Martin Heidegger, *The Question Concerning Technology and Other Essays* (New York/London: Garland Publishing, 1977).

21. Ari-Elmeri Hyvönen, 'Amor Tellus? For a Material Culture of Care', *HannahArendt.net Journal for Political Thinking* 11, no. 1 (2022), hannaharendt.net/index.php/han/article/view/460.

22. Paul Wapner, 'The Changing Nature of Nature: Environmental Politics in the Anthropocene', *Global Environmental Politics* (Berlin: De Gruyter, 2014). Here, Wapner elaborates that for many indigenous cultures, nature or wilderness does not stand for the absence of humans but rather building and maintaining a particular set of relationships between human beings and non-humans. For example, the task of preserving wildlife requires maintenance of salmon beds, harvesting certain plants, among other activities of care.

23. Bruno Latour, *Down to Earth: Politics in the New Climatic Regime* (Cambridge: Polity Press, 2019).

24. Theodor W. Adorno and Max Horkheimer, 'Notes and Drafts', *Dialectic of Enlightenment* (New York/London: Verso, [1944] 2016).

25. Michael Taussig, *Mastery of Non-Mastery* (Chicago: University of Chicago Press, 2020), 61.

26. Ibid.

27. Ibid., 11.

28. Ibid., 53–54.

29. Byung-Chul Han, *The Disappearance of Rituals* (Cambridge: Polity Press, 2020), 25–26. (Also see the related discussions in: Claire Bishop, 'Unhappy Days in the Art World? De-skilling Theater, Re-skilling Performance', *The Brooklyn Rail*, 2011; Robert Pfaller, *Interpassivity: Aesthetics of Delegated Enjoyment* [Edinburgh: University Press, 2017]).

30. Ibid., 25.

31. Byung-Chul Han, *The Palliative Society* (Cambridge: Polity Press, 2021), 4.

32. Timothy Morton, *All Art is Ecological* (UK: Penguin Books, 2021), 57.

33. Ibid., 57–58.

34. Ibid., 105.

35. Thomas Hanna, *Somatics: Reawakening the Mind's Control of Movement, Flexibility, and Health* (Cambridge: Da Capo Life Long, 1988).

36. See Martha Eddy, 'A Brief History of Somatic Practices and Dance', *Journal of Dance & Somatic Practices* 1, no. 1 (2009): 5–27.

37. See Tamalpa Institute, tamalpa.org.

38. Libby Worth and Helen Poynor, *Anna Halprin* (London: Routledge, 2018), 33.

39. Anna Halprin and Rachel Kaplan, *Moving Toward Life: Five Decades of Transformational Dance* (Hanover: Wesleyan University Press, 1995), 214.

40. Ibid., 225.

41. Ibid., 214.

42. See Susan Bauer, *The Embodied Teen: A Curriculum for Teaching Body-Mind Awareness, Kinesthetic Intelligence, and Social and Emotional Skills* (Berkeley: North Atlantic Books, 2018). Also see: Martha Eddy, *Mindful Movement: The Evolution of Somatic Arts and Movement Education* (Bristol: Intellect, 2017), 258.

43. See: Susan Bauer, 'Body and Earth as One: Strengthening Our Connection to the Natural Source with EcoSomatics', *Conscious Dancer* (Spring 2008): 8–9.

44. Fikret Berkes, *Sacred Ecology* (London: Routledge, 2018).

45. Han, *Disappearance of Rituals*, 2–3, 10.

46. Halprin and Kaplan, *Moving Toward Life*, 28.

47. Worth and Poynor, *Anna Halprin*, 148.

SPROUTING GROWTH

SPROUTING
GROWTH

Sprouting Growth

> The way plants persevere in the
> bitterest of circumstances is utterly
> heartening. I can barely keep from
> unconsciously ascribing a will to these
> plants, a do-or-die courage, and
> I have to remind myself that coded cells
> and mute water pressure have no idea
> how grandly they are flying in the teeth
> of it all.[1]

Growth - is this not the satanic root of all evil
that brought consumerism and its cousins, poverty
and climate change? Well, growth is essential
for keeping the cycle of life going; however, it is
necessarily bound to relinquishment and decay.
There is a law of reciprocity and an economy
of gift that is the underplanting of all that
strives in dynamic being, at home in ephemerality
and always on its way to unfold into what
is to come.
The pressing urgency of growth is core to cultivating
a vivid sense of embodied, posthuman awareness,
embracing the potentials of speculations as much
as the felt sense of fact and reality. The fact of
bare bodies gets realised as embodied tanglements

of visceral attention to perception, spirit and its sensuous manifestation. Through bare bodies, tacit knowledges of unspoken or unspeakable experiences such as trauma or taboo make their plural appearances in brutal ruthlessness, at times concealed in a gentle insistent tone. These sprouting capacities of bare bodies emerge at thresholds, on unstable grounds, the shifting quicksand of consciousness. Sprouting and burgeoning practices are obviously part of botany, but I feel there is a kinship to the somatic field.[1]

Can I dive deep into microbial growth in the gut, its metabolic dances? Or attune to how movement nourishes fascial flow, the continuous liquid transfiguration of bodies' inner architectures? How do depth relations, through ongoing trigger point cotillion pressures, and tracing along the meridians of the body, nourish elasticity of fleshy tissues and deep structures? Fueled by provocation as much as insistence, revolt as much as the lenience, elasticity, and variability of embodied relational structures, growth sprouts soulful bare bodies. In contemporary performance, bare bodies are an offering to get under the skin of the performing body and grow awareness of flesh as transformative material. Performance calls for recipience to live on. Poetic protest and strange naked (friend)ship emerge as encounters with collective bodies and lay bare the sprouting growth of entangled world-making.

[1] Dillard Annie, Pilgrim at Tinker Creek (Pymble NSW: Harper Collins e-book, 1974 [2007]), 164.

MARIELLA GREIL &
BARBIS RUDER

Laying Bare the Unbearable

Confessions, Participative Apparatuses, and the Lenient Material of the Soul

Mariella Greil and Barbis Ruder are performers and colleagues at Angewandte Performance Laboratory in Vienna. They have known each other since 2017 and are in regular conversations about contemporary performance, love, and life.

> *The Angewandte Performance Lab (APL) is a transversal artistic research and education platform that focuses on the relationship between the body, perception, and the arts and society in a post-digital context. Its purpose is to serve as an incubator to promote performance as an artistic medium and as a field of research.*
> – Angewandte Performance Laboratory

This spoken conversation between Mariella and Barbis was conducted in autumn 2021 and edited in summer 2023. The text explores concepts of the confessional, exposure, body politics, the neutral, becoming a mannequin of a situation, overcoming the ego, relation to the space, agency, and transformation.

Mariella: Barbis, your work manifests in a range of media and forms; however, in the context of this conversation, I would like to focus on the relevance of *bare bodies* and their emergence in your artistic work. Can you share how you approach and how you relate to the concept of *bare bodies* and is *'bare'* a term you work with? Or in other words, are you interested in *baring* as a fundamental attitude influencing your artistic decisions and actions?

> **Barbis:** If we assume that a bare body doesn't stop at the body but also goes to the psychological dimension, to the aspect of opening up towards the so-called 'confessional', then I worked with confession as an act of opening something up that is actually too much to handle and is in fact too much information (TMI). This aspect I find most interesting, not just on a physical, but on a psychological level.

Mariella: You point to laying bare as a confessional moment that reveals something usually not shown or might tap into the unconscious.

EXPOSING THE BARE BODY

> **Barbis:** The taboo, the shameful, something that you don't want to be honest about to yourself even. And putting it all out there. I think that's a really bare moment to create, and I feel that's also what I'm interested in uncovering in performance...

Mariella: There is a facticity of *being a human body* that is quite loud in your work, as both your sculptures and performances invoke a bare body, like those confessional, revealing moments that you mentioned. You paradoxically bypass the nude or naked body in a nonchalant way by wearing skin-coloured underwear, which even underlines the *in-itself-ness* of the body. This body is held by the boundary that the skin forms around who we are and then is dressed up in a second layer of skin-coloured costume, which absurdly highlights its nakedness. The bare – in the sense of showing a rough, vulnerable body – maybe reveals an existential dimension beneath the sole trivial physicality of the body. A body that goes beyond itself.

In the description of *DOWN DOG IN LIMBO*, you address free-floating angst – one may say 'the existential angst' – that you explore related to the meaning, purpose, and value of human existence through performing with, or better within, your sculptures. How do you tap into affects and what does such a complex concept as *soul* really mean to you? On your website, you invite us into your *digital soul*, obviously with a wink. Can you share your thoughts around the alliances between *bare body and soul, hard and lenient materials*, and also *sculpture, performance, and space*?

> **Barbis:** The first thing that came to my mind is about exposure in a very existential, pure, rough, and raw way. Somehow putting on that layer that exposes even more, even though you wear something, is interesting and

makes people uncomfortable. I don't feel this anymore, but I was feeling uncomfortable with myself and it was about overcoming the uncomfortable feeling of having an exposed female body. I grew up trying to hide my breasts and had really bad posture. I was cringing to not be so exposed, but anatomically it was impossible. So, it might have even been a way of opening up by overexposing it, highlighting it, obviously in order to overcome it as an act of self-empowerment. Everybody sees the body. We are not invisible. As women in the public space, even in Europe, in a privileged situation, we are visible and sometimes exposed to danger. We are exposed to how people view us. So, this was a statement combined with how women are shown in public space in advertising: overexposed, all these naked bodies in magazines looking at us. So, I was thinking, 'Okay, I own this space. Now I take this language and I overdo it even more in order to push that boundary and reclaim it also.' And at the same time, exactly not doing that. But one expects that one would judge another woman capitalising on her naked body; here I am capitalising on my naked body that is not naked. That's kind of the twist I'm making with it. And through that, it's again taking over control of a situation in a certain way.

Mariella: So, you dictate the rules *how* you expose your body.

Barbis: Absolutely. Yes, and even more. I don't like to look at myself in that way, but I find it necessary as a political statement. And it's not me. Barbis is the person, but the person performing the persona or the image of *Barbis*. Yeah, it's a difference.

BECOMING A MANNEQUIN OF THE SITUATION

Mariella: Yes, I'm really interested in that transition. How do you become the person who is no longer Barbis, the private person? Do you have specific rituals that ease you into the process of becoming a public body? Or is this something that happens on a conceptual level?

Barbis: I think it is a conceptual shift in the way that I always make a game for performance. So, there's a certain status that I tried to claim via the performance. For those older performances, the idea was to create a neutral body, which is never possible to have. This neutral and authentic body. I perform for the moment, and I'm sure adrenaline helps, but also rehearsing it so much that the movement just becomes an action. You're kind of an image, and effigy. I don't know if that's the right word. Or, what is the mannequin of your own work? I actually become a mannequin of a situation I create. And I do it. Every bit, like every movement of the hand, is part of the programme I write for the mannequin.

Mariella: So, there is the phase when you create or conceive of the performance and the stage of the interpretation and performance of the work. Sometimes you collaborate with other performers, other times it is your

own body performing the work. Let's focus for a moment on your work, *DOWN DOG IN LIMBO*, where body and sculpture are actually mutually complementing each other: the sculpture couldn't exist without the body and the body wouldn't be able to perform without this sculpture. It strikes me as a symbiotic transformation and extension, a kind of transformative co-dependency.

> **Barbis:** This was quite a funny process. I was first imagining the work to be the body completing an architecture. I thought of a classical arc trying to put myself like a triangle, with elongated legs and arms for making a down-dog triangle. This would be another kind of an arc, where people can walk through underneath. So, that's the image that I started with. And then I wasn't able to do it because there were so many other things and I forgot about it. Half a year later, Peter [Kozek][1] actually reminded me that I had had this idea and then I thought, 'Oh, you're right.' Then I was looking at the images again and I really started with the image of a body in a triangle with longer stilts. I did some research, how to make it possible and the process brought me to Otto Bock,[2] the healthcare company, and to really get professional ortheses.

Mariella: Was it the first time you worked with ortheses?

> **Barbis:** Yes.

Mariella: So, this is where this thread of your work started because now the use of an orthesis feels like quite a significant part of your artistic practice.

> **Barbis:** I was always interested in things that complement the body or are close to it. I was interested in medical aesthetics and it was a great opportunity that this company agreed to make the orthesis for me. This is so important for me, coming there as an artist from a completely different world, open to making a project that doesn't make sense in their corporate ways. Nevertheless, this creative collaboration brings both sides further and closer. I love getting in touch and collaborating like this. Artistically, I had the opportunity to create a work where I find myself becoming more like the object. I am the subject creating an object and the object is myself.

Mariella: What do you mean by the object?

> **Barbis:** Art objects, like, when I perform it, I'm the object of the artwork, but also the author. So, I'm the subject creating an object that one looks at...

Mariella: It's a correspondence, a vice-versa relation, the object needs to be activated, the body really needs to be there. How would it be if it was just the orthesis, the work as a sculpture?

> **Barbis:** It's different. It works as well, but it's different.

Mariella: It feels like something is missing. There is an orthesis as placeholder there for a body, implying the performance of the body.

> **Barbis:** Yes. And you always feel it directly.

Mariella: I immediately intuit the body as the link.

HOW TO OVERCOME YOUR EGO

Barbis: One thing I learned through practicing and doing performances is to really overcome one's own ego, which makes it possible to get into the so-called 'neutral space'. And this is not easy when you perform the work for the first time. I mean, it helps to rehearse, I think. But then still, when you perform, the first couple of times you're so nervous, you don't know when people like it or not. There are all these kinds of aspects. And my feeling is through showing works over and over again you get rid of your own ego in your work, which helps you perform the action that you require from the work to perform. And it's something different when you're both the author and performer of a work. It's not easy. And I've just learned that over the years you have to work with your own nervousness and the pressure of how is my work perceived, could be killed by the audience by not liking it or whatever.

Mariella: Right, for many years I was nervous whether an audience would even show up to experience my performances. That's even worse. All the nervousness and there's always a fear that they won't show up, these un-known others, the wit(h)nesses, that complete the performance work.

Barbis: Yeah. But then I also think it happens. It's part of it to show up. And if there are three people in the audience, or if the audience is talking and ignoring you, you still have to give 100%. But that's exactly overcom-ing your own ego. And I like that, to think about that a bit. I was talking to the students, saying that now you have to experience ego death and then you can do anything. You're free, actually, in a way.

Mariella: However free we can be.

Barbis: However free we can be, absolutely.

Mariella: I wonder whether this is really the ultimate goal. Or is the aes-thetic that we establish what we actually have to give as artists? But let's go back a bit to the alliances between the bare body and the soul, since we are talking about the ego. Can you say a bit more about this complex entanglement? Also, what do you mean by your *digital soul*?

Barbis: It's exactly this kind of self-exposure that you do as an artist. We are very ego driven. So, what we do is, of course, egoistic in a certain way, but at the same time it opens up a space for interpretation. People can read your work in a completely different way, then you have to overcome your own ego again because people don't understand the work like you intended it to be understood. One cannot expect that. At the same time, this exposure is also a soul striptease in a certain way. So, the soul strip-tease or the confessional, there is something very personal in every work, especially when you work with your own body. The history that's written in your own body, the history that we bring with us, it's part of the work.

For example, *DOWN DOG IN LIMBO* is a different work if performed by somebody else because somebody else comes with a different body, with another history, with another neutral, so-called 'neutral state' that they try to make this action.

Mariella: How often did you see *DOWN DOG IN LIMBO* performed by somebody else?

Barbis: In the rehearsals, two colleagues also went into the sculpture and it was completely different because they had different physiques. But it was great to see somebody else in it, how it looks or feels from the outside.

Mariella: Why did you decide, in the end, that *you* should be the body performing the *DOWN DOG IN LIMBO*?

Barbis: It was very important at that point. The ortheses are accurately fitted to my hands and feet and they're exactly to my proportions. I was in the Otto Bock workshop, having the moulding materials on my own hands and feet and rubbing their plaster copies. It was really funny to work with your own body parts. This is something to go further with.

Mariella: It was tailored to your body and the sculptural form is really moulded around your body.

Barbis: It is, this is version one. So, maybe there will be another version tailored for other bodies or open for other bodies to experience, but probably with a different technique. So, it will be the same image, but then maybe it's a different kind of technique that one works with to get into the sculpture.

WORKING WITH THE BODY IN RELATION TO THE SPACE

Mariella: I am curious about your use of hard and lenient materials because with *Mouthpieces* elasticity comes in as a topic. Also, I hear now that maybe there could be another version of *DOWN DOG IN LIMBO*, maybe one where the materials are a bit more lenient...

Barbis: Easier... Yes. It depends on the possibilities that arise. I would love to work at Ars Electronica Center. They have 3D printers or you can 3D-scan bodies. Or I was thinking of a way you can get in there yourself, like a bracer you can open up and close. I had a lot of thoughts.

Mariella: Solving the mechanical challenges?

Barbis: Yes, the mechanical. It could be the same *form* that produces a completely different action, but you end up in the same form. And I like to think of different ways. There could be a version where you could lie and then actually, through muscular strength, push yourself in and out, or somebody is pushing the construction. And this is always the more interesting part for me, then, okay, it's myself in the work. But also, I don't want to push that kind of pressure or danger, to do what I'm doing, on somebody else. Though at times it's possible, when I've been through it and know how to give directions.

© Jana Enz

Mariella: Here I would like to take up the word *'form'*. I see *form* as one of the pillars of your work, this rubbing against and working through its rough form and coupling it back with performance and space, like in your latest work, the big *A*.

Barbis: The *A*. Yeah, it is.

Mariella: I feel it is a complete intertwinement of sculpture and performance, one creating the other.

© Helmut Prochart

Barbis: Yeah. It's again, starting from the body in relation to the space, the architectural space. The triangle is an amazing form to work with. It's these endless possibilities. I like the balance and imbalance you can create, just through this form. I have made the trio as well. We create the spaces around us so that space is performative in a different way. So, wherever you enter, you relate. What an architect thought of has a certain meaning, like if you enter a church it has to show the greatness of God. You're in this space that is huge, but you feel small. So then, what is the body in relation to the space? There's this big sculpture, but it also works with the body. I don't know if you've seen them, like ones where bodies on the edge are measuring the space. And also, I mean, it's Le Corbusier who was thinking of architecture differently in relation to the human body. But why was this new? It is weird, right? It was mostly representative before that, there were a lot of representative moments. And, like the body in relation to that space, the voice is also big in a space like that. If you snapped your fingers – the loudness of that click – it was like a huge insight.

Mariella: The acoustics and reverberations of the space...

Barbis: Yes, acoustics. That's why I also needed to build this sculpture, which again relates to the space, showing the space with this arrow somehow. But it is a wobbly rod. It's not straight, it's more of a waggish kind of movement. And to invite people into the experience of the sculpture was, for me, the next step. Yes, experiencing oneself in relation to a thing. A sculpture made for the body.

Mariella: Yes, the relation to the sculpture, the space, but also, in relation to each other, the different bodies, right?

Barbis: There are a minimum of three people: to get into contact – and only be able to together – get some sort of a movement, and really feel it's a swing with a counter swing. So, it's always making a bigger movement and then you kind of stand still.

Mariella: There is a lot of weight.

THE ROLE OF THE BODY IN THE TRANSFORMATION OF ART

Barbis: Weight and balance. Yeah, it's very heavy. And you think that you have to push hard to get it moving. But as a matter of fact, you don't have

to push at all, you have to go softly. And with the soft kind of impulse in the right moment, it can go really big. It's really nice to see and feel that. I like to have these physical aspects alongside the kind of engineering part. I love that.

Mariella: Who did you collaborate with for the engineering part?

Barbis: I worked with Philipp Reinsberg. He's both a carpenter and an architect. So, he really knows these things well. We've looked at the attic of the church because it is also a triangle construction. Triangles are the most stable form as a matter of fact, and at the same time they can be imbalanced really quickly.

Mariella: In psychology, *triangulation* is crucial for opening up the binary symbiosis of early bonding…

Barbis: Funny, but true because otherwise it's so symbiotically sealed and closed to the outside. So maybe the triangle is the way to connect. For the *A*, it was especially important to have this imbalance that can be balanced or harmonised, but at the same time it's not really controllable.

Mariella: It could be a pyramid. Stable, right? But you build a work that is in constant motion.

Barbis: If people are in there. If not, then it's stable, of course. But it's made for use. I felt very imbalanced…on a psychological level. I created the work after the first year of the pandemic. This was a way of getting back into a balance, but always being a bit in movement and volatile. This is a new kind of feeling. There's a strength here, while you have the possibility to still move. I really like that, for me personally, but I also think we are talking about tipping points and the world getting out of balance. So, it's a little balancing action and getting a physical feel for it, what it could be like.

Mariella: You mean, what kind of future balance might emerge?

Barbis: Yeah. And it's not so out of balance. It breaks, but it's kind of rooted yet stays alert. I call it an 'instrument'. I'm still not sure if 'instrument' is the right word because it's also, actually, an architectonic body. It's like a house or Noah's Ark.

Mariella: Yes, that's been my association as well.

Barbis: Yeah, for some people, but you have this feeling as if you're on a boat. It's really this wave.

Mariella: Do you feel that your work has the potential to transform? And what is the role of the body in that transformation?

Barbis: I think it happens with this sculpture. I asked how to develop these experiments that I do with myself and open them up for others. It's interesting, like with *DOWN DOG IN LIMBO* for example, this free-floating angst. It's about getting over your fear and enduring a moment that's not comfortable. You fit into this sculpture, but you know you cannot stay there forever. How do you trust people to take you out properly? How can you trust your body to be in the situation? With *Mouthpieces*[3] it's similar. Through this extension, you suddenly have a different possibility to bend

backwards, which you wouldn't be able to do otherwise. So, you have to press against the upper teeth. Through with this counterpressure you're enabled to be more a cyborg. You enable yourself, with counterpressure, to suddenly do a movement you're not able to do in another way.

THRESHOLD EXPERIENCES OF TRANSFORMATIVE ART

Mariella: Yes, it's actually expanding one's potential and opening a new physical experience. The horizon has shifted. How, then, to come back and allow that experience to transform you?

Barbis: Yeah. And also, for others to dare to do something like that. I think the *A* is the first step. It's the direction that's interesting to me because it's a nice way to be in contact, but also, it's not too dangerous. One has to be careful still. It's like a playground for adults, but it's not playing to go crazy. It's somehow a different experience that has a more subtle feel. You're part of something. And when you're on it, you can feel like you're in mom's belly too. It's really funny. You have to come and feel it.

Mariella: There is this empowering moment you're thriving for.

Barbis: Definitely.

Mariella: But there's also a contemplative moment, right? It's a form of artistic contemplation that the audience practices, there in the church at Krems, that you're offering.

Barbis: It's an offering nobody is forced to do.

Mariella: Yes, these transformative moments. I would call them *threshold experiences* that you create with your artistic work. Can you share how people were reacting to these offerings? Maybe you had some feedback.

Barbis: I think that people are really touched and moved. They feel empowered. That's what's important to me. There were always moments of overcoming my own fear and insecurity, also self-hate. I even like to overcome the 'self'. I think we all feel that sometimes. There's a certain kind of healing moment. And now, with the *A*, it's a soothing experience, but also opens up a new space. It's playful and soothing and fun and whatever happens can happen.

Mariella: In *DOWN DOG IN LIMBO*, I was struck by the intensity of your breath and how it seemed to reach deep into this existential dimension of the bare body, stretched between the orthesis. Can you talk about the role of breath or generally the body in relation to these sculptures that strangely only feel complete if your body gets fixed into the prepared position?

Barbis: The breath, especially in that work, has a holding and concentration function. It's the Ujjayi breath from yoga. I really try to come to that moment of concentration. It has this Darth Vader feel which I also like. (laughs) Especially in the space where I first performed it, Heiligenkreuzerhof; it had the acoustics that made it even bigger. Yeah, it's the point of

concentration, which probably may feel even awkward for the viewers, but it's somehow something to hold on to.

HOW IMPORTANT IS THE SENSORIAL EXPERIENCE OF THE AUDIENCE IN RELATION TO YOUR ARTWORK?

Mariella: Are you at all concerned about representation, and if so, in what way? How much are you interested in the experience of the audience in relation to the experience of the artwork?

Barbis: I think, actually, the body and the object or the thing or the sculpture, I see them as equal, really 50/50. That means, in that equation, that the sensation is the maximum. And the moment of touch, or where something happens, friction, or all these kinds of sensations that can come. So, it's really about *being in contact*, to quote you.[4] I'm still figuring it out because actually I'm circulating around it with all the works. I think exactly this moment, where something happens *in between*, is what interests me and I think that's also what interests the others. Because we work with the body or always feel interlinked to a person doing something with the body, we're all empathic. This empathy is so important. So, I think this empathetic moment of seeing and feeling with the person performing, or the potential of 'Oh, I could also experience that myself with the new sculpture. Do you dare to do it?' is what interests me, really. And of course, it's representation. It's aesthetic and that's fun and I love it too. I want it to be absolutely appealing and fascinating.

Mariella: Yes, there is a call to engage with the artwork – as you create the conditions for being courageous – as an experiment. It's an invitation for an empathic experience.

Why did you choose the position of the downward-facing dog among the myriad of yoga poses? Are there any connotations intended that you wanted to capitalise from or associations such as 'underdog' or 'down' meaning collapsed or lower position?

Barbis: The first idea was based on form and the architectural notion. But of course, yoga is today's trend sport and it's become really competitive. Down dog looks like such a hard pose, but it's a relaxing pose. It's exactly the in-between moment and there is so much to experience. Limbo is this in-between stage: if you're not doomed for heaven or hell, you're in limbo, which is even worse because there's no place to go. And that was like a feeling of insecurity: you can't go up, you can't go down, you can't go anywhere, you're stuck. It's worse than anything.

Mariella: You are dependent on others to help you in and out of the orthesis.

Barbis: Yes, it's all about trust.

Mariella: Conceptually, this is really an interesting turning point.

THE TURNING POINT IN THE DEVELOPMENT

Barbis: It was quite an experiment. We made the sculpture. It was measured, figuring out the exact angles and stuff we were trying out. I was there with my friends: 'Okay, how do I get in there now?' I was panicking the first few times because you imagine something, work on it for a couple of months, and then stand there and it's like, 'shit, how?' That was a moment, but then I was so relieved. There's always this magic moment when you know if the work works. The next question was how to stage it. The same applies for the *A*. The first time we knew it worked was in the church. Three of us were swinging in it and it was such a moment of bliss, you know, and that's, for me as an artist, the most fun. That's why I do it. And, of course, aesthetics and so on are important as well.

Mariella: Your research revolves around the body and as you're creating these sculptures that complement, or are complemented by, bodies. I'm interested to hear your thoughts on the body's materiality and human, as well as more-than-human, agencies. How do you negotiate that vibrant zone where the affordance of a bare body provokes the shiftiness of affects – the sphere where withdrawal emerges as movement – as a form of removal from the artistic work?

TAKING AGENCY OVER SOMETHING YOU DIDN'T HAVE CONTROL OVER

Barbis: A lot of the works come from psychological dilemma or an uncomfortable situation and I try to transform it through the work. It's about taking agency over something I didn't have control over or didn't know how to touch. So, there's this therapeutic movement. I need my personal experience from which I draw ideas. Or the body is in the centre, and then overcoming that. So, it's away from your own ego. Then you can actually mould it the way you want it. We didn't touch upon humour, but I think humour – humoristic turning points or laughing about how silly you can be – is sometimes important. And when I refer to the *digital soul* it is a humorous kind of wink.

Mariella: To close the cycle, can you articulate your approach to an understanding of the bare body? Is baring a method influencing your artistic/compositional process?

Barbis: It feels like, now, baring is the starting point of everything. (laughs) It's about being honest to yourself, to be bare to yourself, to be open enough to see it and face your own kind of inadequate stupidity, fun, whatever, everything, and to go from there into creating a work. That comes out as a pure, maybe rough, and sometimes aesthetic work. So

'baring', in that sense, is important and different than just a bare body. What's the bare body and soul?

Mariella: You make yourself available for the work.

Barbis: But at the same time it's also kind of making the decision of what is available and what is not. So, there is agency. I'm exposing my body to the work I create. There is a dialogue you have with yourself, how far you want to go. I used to be more brutal with myself, exposing myself to situations that were uncomfortable. That's one of my talents, to endure really uncomfortable situations. But I also realised I don't always have to go that far, negotiating it is part of the development of the work.

Mariella: Yes, baring of the self.

Barbis: How much are you able to bare in order to create something? I think a lot comes from repeatedly overcoming unbearable situations. Yeah, the earlier works are more unbearable for the audience as well because they come from a place of a lot of discomfort, which I'm used to somehow. If I'm overcoming my own unbearableness it's more fun. Now, it's more joyful. I mean, there's also a joy in being in unbearable situations. If you know, you get out of it, otherwise, not. *(laughs)*

Mariella: There seems to be growing weight and seriousness at the same time. I mean, the *A* is really a grand gesture.

Barbis: I always said I want to make works on eye level, but now this church asked for something else. I wanted to make one statement. And I said, yes, I have a space that I can take and claim as a woman artist. Blah, blah, 'women artists', I hate the term. Now it feels like it was always there. It was a great opportunity, not only the body part, which is fun. I love the engineering part. I love making things work. In combination with the body, technological engineering is also part of me. So, finally there's space for it because I overcome my unbearableness. *(laughs)*

Mariella: Thanks for sharing the Unb(e)arable Lightness of Being,[5] Barbis!

1. Peter Kozek, Senior Artist at Angewandte Performance Lab and longterm artistic companion of Barbis Ruder's artistic work.

2. Otto Bock Healthcare is a company that is specialised in prosthetics, orthothics, wheelchairs, and engineering.

3. See documentation of *Mouthpieces* in Madeleine Frey, *Barbis Ruder. Werk – Zyklus – Körper / Work – Cycle – Body* (Vienna: De Gruyter, 2023), 199.

4. Mariella Greil, *Being in Contact: Encountering a Bare Body* (Berlin: De Gruyter, 2021).

5. See page three of the 1984 novel by Milan Kundera entitled *The Unbearable Lightness of Being*: 'The heavier the burden, the closer our lives come to the earth, the more real and truthful they become. Conversely, the absolute absence of burden causes man to be lighter than air, to soar into heights, take leave of the earth and his earthly being, and become only half real, his movements as free as they are insignificant.'

EMPATHY
ˈɛmpəθi

Empathy is the capacity to understand and share the feelings, thoughts, and perspectives of others (including others such as more-than-human agencies and lifeforms). It necessitates a deep emotional connection, recognising and attending to the nature-culture continuum, experiencing their states or emotions in all their entanglements across species. Yes, world-human-plant-object-animal-planet-being manifests in a myriad of ways as (non-)living phenomena. Empathy goes beyond sympathy, as it requires active listening, non-judgement, and genuine concern for another's prosperity and sustainable future. It promotes stronger interconnected relationship, and effective communication. Empathy cherishes a sense of unity and compassion within cohabitation. In posthuman practices, empathy stretches across a wide range of agencies and highlights the complex interplay between and beyond kinship. It underscores the importance of fostering understanding, empathy, and inclusivity to widely promote social, political, and environmental justice including the rights of nature.

TIME
taɪm

Time is a fundamental concept that measures the progression of events and experiences (too) often in a linear sequence. It is an abstract dimension that governs the order and duration of phenomena and usually perceived as past, present, and future, shaping memory, anticipation, and decision-making. In physics, time is a dimension intertwined with space, forming the fabric of spacetime in Einstein's theory of relativity. Time raises philosophical questions about its nature, whether it is continuous or discrete, and its role in human existence. It is linked to entropy, reflecting the irreversible trend toward disorder and decay, influencing aging and weathering processes in the natural world. Time impacts cultural practices, rituals, and social norms, influencing how societies organise daily life, celebrations, traditions, and their (mis)understanding of biological rhythms and processes, exploring time's subjective nature or dreaming of time travels. The concept of time offers profound perspectives on memory, nostalgia, and the passage of time. Time's cyclical nature challenges human understanding, invites exploration across disciplines and prompts in-depth contemplation about existence, change, and the universe's evolution.

MIA HABIB &
LAUREL V. MCLAUGHLIN

ALL – A Physical Poem of Protest

A Real-Time Negotiation among Strangers

In this asynchronous essay, the cultural workers – choreographer and dancer Mia Habib and art historian, writer, and curator Laurel V. McLaughlin – collaborate through embodied memory and writing to offer a textual choreography among excerpts from the scores, strains of research, and discursive reflection from *ALL – A Physical Poem of Protest* (2018) and its predecessors *A Song To...* (2015) and *HEAD(S)* (2012).[1] We slip in and out of first, second, and third person, conveying our compounded orientations through time and space, performance, and understanding. Our 'we' refers both to, 'we' two cultural workers at times, the 'we' of co-creators in the various works, and the potential 'we' of masses. Together, the duet demonstrates the interconnectedness of protesting bodies across conceptual models, spaces, and times. Our polyphonic dialogue with the embodied score, warm-up exercises and ongoing research, alongside our voices in the text comprise a bare material for the reader to articulate the pacing between different modes of sharing.

1. We acknowledge that the dancers and designers involved in *A Song To...* and *ALL – A Physical Poem of Protest* have co-developed the practices and language used in working with volunteers and communities in the piece: Cecilie Lindeman Steen, Ingunn Rimestad, Jon Filip Fahlstrøm, Loan Thanh Ha, Hanna Mjåvatn, Ida Gudbrandsen, Kira Senkpiel, Keyon Gaskin, Sandy Williams, Tarek Halaby, Fie Dam Mygind, Linn Christine Ragnarsson, Asaf Ahronson, Przybyslaw Paz, Povilas Bastys, Jules Beckman, Shantelle Jackson, Nina Wollny, Oskar Landström, Hedda Rivrud, Harald Beharie, Karen Høybakk Mikalsen, Monica Gillette, Marion Carriau, Jassem Hindi, and Ingeborg Olerud.

ALL – A Physical Poem of Protest in Portland in 2019, hosted by the Portland Institute for Contemporary Art (PICA) at Pioneer Square, the central city plaza, which is home to civic celebrations and gatherings as well as nationally broadcast protests spotlighting conflicts between leftist Antifa activists and right-wing white supremacist groups such as the Proud Boys.
© Brittany Windsor

Borders exist. The boundaries are sometimes soft, almost invisible and in the skin, in the body, in the movement, among people. On the stage, in the spine. The negotiation between the vertebrae; between the will and the body's own boundaries; between people and harder boundaries. The grand boundaries that draw geographies, that are drawn and drawn again by negotiation, war and conflict. And those which cannot be negotiated.

Despite the increasing privatisation and regulation of public space, a phenomenon spreading across many countries, public spaces still potentially serve as sites for collective protesting, grieving, and performing solidarity and care. *ALL – A Physical Poem of Protest* is an embodied public negotiation in times of large sociopolitical movements. This work deals with the question of how to draw the macro-political into the body and root it within various local contexts. *ALL – A Physical Poem of Protest* investigates this protesting body – the human mass and its force – through the meditative actions of walking and running in circles.

This is a project with, and for, numerous communities of differing geographical locations and demographics, moving together in solidarity, in collaboration with local artists. The 'physical poem' consists of a mass of local people of various ages, backgrounds, and appearances. The participants share their micro-urgencies (communal and individual) and differences through the power of gathering in rehearsal and performance.

ALL may manifest as a forty-five-minute to three-hour performance on stage, an hour-long manifes-

BEFORE STARTING – a warm-up:

Hello everyone, |

Let's come together in a circle |

Not an oval, not a square – a circle |

Holding hands |

And we go |

One, and two |

And one back |

Bordeaux with activist groups of the city; a manifestation for the freedom of artistic expression by the Dance Artists' Union in front of the parliament in Oslo; the protest 'Love-in. Queer Action for Chechnya' at the Soviet War Memorial in Treptower Park in Berlin; an indoor durational piece at Burgtheater in Vienna and La MaMa Experimental Theatre Club in New York; a short performance at Dance Élargie/Théâtre de la Ville de Paris; and a public manifestation at Pioneer Square in Portland, Oregon, to mention some.

SCORE: ELBOW CIRCLE

I will be talking while we do these steps on the circle

Standing in a circle, facing inwards
Every second person turns outwards, one at a time
Turn outwards towards your left shoulder
Soft gaze, looking at the person turning
Arms up together with the group, take our time
Hands a prolongation of the arm, feet a hip-width apart
Start to lean onto each other
Start to move the circle together
Fall out of the circle together
A moment of soft and silent walks in curves around in the space, passing through each other,
looking at each other while passing before gathering in the corner with the group[2]

And one back

Yes – exactly – great – crashing a bit – perfect

One, and two

And one back

We are here together

We will spend the next days here together.

2. The meaning of 'gathering' has changed since 2018 when *ALL* debuted. In September 2021, *ALL* was performed in an old coffee factory in Oslo (Kaffelageret) and the strangeness, felt inside the group, of being many naked bodies gathering in such proximity amidst the COVID-19 pandemic was powerful, weird, painful, and beautiful.

Excerpt from volunteer Shiloh Hodges' reflections after performing ALL in New York:

Mia reminds us that we are walking and standing for something. A process constantly ongoing, but heightened in this work. I consider the generations of queer ancestors and siblings that have not been able to walk in public as themselves. I consider the danger of walking in public as a person of colour. Different bodies experience the vulnerability of public space in different ways. For some, it is a place where power is exercised. For some, it is uneasy. For others, it is quite dangerous. To perform naked on stage in New York is still to propose your being in a public space; riskier for some than others. As we walk through the space, I am reminded that we are not walking alone. We are walking with the past and the future that each of us carries individually and that all of us carry together. I am bowled over by my privilege. No matter how tired my legs are, I'll keep walking.

MIA HABIB & LAUREL V. MCLAUGHLIN | ALL – A Physical Poem of Protest

73

Together we will be | *running,* | *walking* | *and* | *standing* | *In circles* | *Most of us do not know* | *each other* |

SCORE: THREE SINGLE WALKS

One person is left alone in the space walking three rounds
Person number two walking two rounds
Person number three walking one round

The group supports and looks at the single people walking
The people walking: walk with your intention:
for whom or for what are you walking
Take your time in walking, carrying the space with you, and
those you walk for: bring them into the space

Volunteer in ALL:
As we are all being called to stand
and walk for and with the Black
community, I have been thinking of
ways to continue the conversation and
bring people together to walk, to run, to
feel community, to heal. And ALL keeps
coming into my mind.

SCORE: RADAR I

Everyone in with last person walking alone

Take time for walking
One person initiates the running which installs the different speeds
Allowing radar to exist for a while with the different speeds

Make sure we keep the different lanes of speed
Move faster than the ones on your left shoulder, move slower than

as strangers |

Maybe some of you will become |

friends during these days |

But most of us will leave as strangers as well |

We are sharing this moment together |

as strangers |

Soft and silent walking and running

This picture, from *ALL – A Physical Poem of Protest* at Köln Theaterszene Europa-Studiobühne in 2018, was taken by one of the volunteers in the piece, a man in his mid-1980s. He joined the score for the first time in 2016 in Copenhagen when it was part of the piece *A Song To...* (2015). Since then, he has taken the train from Copenhagen to join as a volunteer in Trondheim, Cologne, Vienna, and Paris. In Cologne, he brought his old camera.
© Kaare p Johanesen, 2015

ALL – A Physical Poem of Protest (2019) in Portland, hosted by the Portland Institute for Contemporary Art (PICA)
© Brittany Windsor, 2019

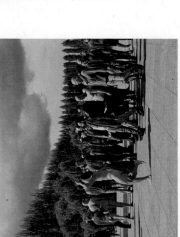

The artists Jeremy Wade and Jo Koppe borrowed the score as a part of a protest, the walk of sol-idarity 'Love-in. Queer Action for Chechnya' at the Soviet War Memorial in Treptower Park in Berlin in April 2017. This protest was in solidarity with lgbtqia+ people in Chechnya.

ALL – A Physical Poem of Protest
© Mia Habib Productions, 2017

MIA HABIB & LAUREL V. MCLAUGHLIN | ALL – A Physical Poem of Protest

75

Volunteer in ALL:

It feels both significant and meaningful to be part of the performance. It confirms her new body ideal. It has also been wonderful to get out of the cancer bubble, which has only been about her and the disease. She is grateful that she is able to participate, even if she gets tired.

THE CHOREOGRAPHY OF PROTEST

As the epigraph from Tali Hakuta's 'Choreography of Protest' relays, movement with political conviction operates through social ties and spatial configurations. In 2011, from Tel Aviv – during Habib's pursuit of her Masters in Conflict Resolution and Mediation amidst the upheaval of the Arab Spring – to the Occupy Movement in the United States and protests in southern Europe, uprisings calling for social justice erupted across the world. And with the 22nd of July massacre in Norway, mass gatherings took on collective grief. There was palpable belief in the streets that by being and acting together, change could occur. The energy of this mass became a zone of possibility that a few bodies alone could not access.

Habib brought the question how, or *if*, it was possible to transform any of this energy onto the stage and into her 'mass solo' *HEAD(S)* by exploring spatial ideologies, the mechanisms of social dynamics through images and gestures that we recognise from the media and from expressions of resistance, grief, group movements, repression, and popular culture. As a repercussion of the mass gatherings, a programme description emerged:

Political marches begin with footsteps, with repeated and multiplied rhythms of sound and social bonding. As the most primal form of human locomotion on land, walking is a spatial method by which people make their opinions on the dominant political order into a public event. Dominant political orders are also manifested in our built environment. Buildings and monuments – designed by architects, planners and policymakers in an endless process of production – define and change our landscape and establish a spatial array. This socio-spatial array forces us to adjust to particular social contexts, behavioural codes and political regulations. But at the same time this spatial array also provides us with a space in which to negotiate, oppose and resist – a stage.[3]

3. Tali Hatuka, 'The Choreography of Protest', *HEAD(S)*, eds. Mia Habib and Jassem Hindi (Oslo: Transnational Arts Production/Trap & Mia Habib Productions, 2012), 48. *ALL* is an ongoing insistence on exploding the space with the only action consisting of standing, walking and running bodies inspired by Hatuka's term 'choreography of protest'.

A moment |

Running |

standing |

and |

walking together |

And then we will leave –

as strangers |

What we do here cannot be done with one

performer's body is imperceptibly gone and the audience has taken over the performance. The audience may run the performance for hours, it may change the space, it may collapse, it may never end.

Habib's interest in the choreography of protest and the power of the mass manifested in her subsequent piece *A Song To...*, a work with sixteen professional dancers and thirty to fifty non-professional volunteers, a total of circa sixty people on stage. In the work, she zooms in on the actions of standing, walking, and running as well as concepts around monumentality. The last part of *A Song To...* is a 'radar' score, later developed into the work *ALL – A Physical Poem of Protest.* The placing of audiences in *ALL* deeply matters, whether they look frontally at the work, around the work, or participating inside of it. And its site directs the work, whether in a gallery, as part of a protest, or in other public spaces. The work is unknown before it happens. It touches an urgency that occurs in public manifestations, which one facilitates rather than rehearses.

The score of the performance, consisting of the 'circle' standing, 'radar' spiral, and instructions, is set. But this formal structure and the basic physical actions therein turn into poetic space [opening itself] to many other spaces. [There] is [a] real-time negotiation with those that participate. It is a negotiation of difference because people gather who are unknown to one another. Even though we follow the same directions of walking, running, standing, we walk differently, we have different perspectives of speed, and we take information differently. In accepting these differences, we allow ourselves to build energy and engage in something bigger than ourselves.[4]

4. This collaboratively-written description comes from an adapted conversation between Laurel V. McLaughlin and Mia Habib, 'Running, Walking, Standing: A Conversation with Mia Habib', Portland Institute for Contemporary Art, 2019, pica.org/blog/running,walking,standing; AConversationwithMiaHabib.

HEAD(S)
© Spalaturie, 2012

HEAD(S)
© Mia Habib Productions, 2012

Yeah – a folk dance you feel | you have done before – not exactly this one | But something like it. | These simple steps – repeating | They can go on and on and on and on | They could have been any dance anywhere at any moment | From the start – whatever that may be – | anyways – very far back |

SCORE: CIRCLE STANDING I

Everyone leaves radar into standing in
a circle facing inwards,
standing in silence for a long while
Filling the circle with your intention and listening
to what is there,
the energy generated
Stand in a position which feels good to you
in that moment of listening
No need for equal space between each performer
You can stay close to someone if you want

PROTEST AS CHOREOGRAPHY

... walking politics of protest is a very basic tool for citizens to temporarily
break free of individualist constraints and to resist and suggest collective
counter-position. This temporality, however, has consequences. As Elias Canetti
puts it: Only together can men free themselves from their burden of distance;
and this, precisely, is what happens in a crowd. During the discharge distinc-
tions are thrown off and all feel equal. In that density, where there is scarcely
any space between, and body presses against body, each man is as near the
other as he is to himself [...] But the moment of discharge, so desired and so
happy, contains its own danger. It is based on an illusion;
the people who suddenly feel equal have not really become
equal; nor will they feel equal forever. They return to their
separate houses, they lie down on their own beds, they
keep their own possessions and their names.[5]

5. Tali Hatuka, 'The Choreography of
Protest', *HEAD(S)*, eds. Mia Habib and
Jassem Hindi (Oslo: Transnational
Arts Production/Trap & Mia Habib
Productions, 2012), 49–50.

Choreographic Principles

The score consists of a durational insistence of one living system (the radar) through a real-time
mediation of strangers (the participants). The score shifts between actions of the individual and
the actions of the mass. In some editions of the piece (depending on duration) the audience grad-
ually becomes participants as well. The score is accompanied by voice. The participants form a
drone choir, going from loud polyphonic drone scream.
The principles of walking, running, standing, and the use of circles can be found in various

The human, in a circle |

Around the fire |

Moving around, celebrating, marking something |

Generations before you |

Far far far back |

Great grandfathers |

Vertical movement/stasis/standing Marching/linear movement

1 *The Tank Man, 1989:* An unknown Chinese protester who stood alone in front of a column of tanks on Tiananmen Square called for an end to violence and bloodshed against pro-democracy demonstrators.

2 *The Standing Man, 2013:* The artist Erdem Gündüz stood quietly on Istanbul's Taksim Square as a protest against President Erdoğan's conservative government. His standing, which came out of a collective practice of standing performed by artists, provoked a silent struggle across Turkey for the right to protest.

3 *The March on Washington for Jobs and Freedom, 1963:* Sought to address the conditions under which most Black Americans were living at the time. It was before this gathering that the day's most prominent speaker, civil rights leader Martin Luther King Jr. delivered his 'I Have a Dream' speech.

4 *The Asylum Seeker March, 2007:* Carried out in Norway by forty-five Afghan asylum seekers, refugees, and their allies. The march followed the old pilgrimage route from the historical church Nidarosdomen in Trondheim, Norway, all the way to the parliament in Oslo, marking the one-year anniversary of a twenty-six-day hunger strike the year before protesting Norway's policies on returning refugees to Afghanistan.

© Amin Senatorzade, 2007

© AP/Jeff Widener, 1989

© AP, 2013

MIA HABIB & LAUREL V. MCLAUGHLIN | ALL – A Physical Poem of Protest

Storming/running

5 Arab Spring, 15 May Events, 2011: 1,000 pro-Palestinian protesters stormed the border into Israel from Syria. One protester made it all the way to Yafo and had a coffee at a shop before he was arrested.

© AP/Yaron Kaminsky, 2011

Circular movement/centripetal force

6 Mothers of the Plaza de Mayo, 1977: During the military dictatorship in Argentina, it was illegal to stand in a group of more than three people in a public place because it was considered a potential protest. This did not stop the mothers who had their children taken from them in the night. They began to walk around the Plaza de Mayo in a circle, white scarves on their heads. These meetings of a few women turned into a ritual still practiced in the square today.

7 'Liberated Gwangju', May 26, 1980: Protesters gather at the roundabout in front of Provincial Hall in Gwangju which marked the first step of the overthrow of the military dictatorship in South Korea. 'The roundabout organised the protest in concentric circles, a geometric order that exposed the crowd to itself, helping a political collective in becoming.'[6]

8 Tahrir Square, Cairo, February 2011, during the Arab Spring: 'These images became the symbol of the revolution that led to the overthrow of President Hosni Mubarak...described by urban historian Nezar AlSayyad as "Cairo's roundabout revolution".'[7]

© REUTERS/Amr Abdallah Dalsh, 2011

6. Eyal Weizman, *The Roundabout Revolutions*, eds. Nikolaus Hirsch and Markus Miessen (Berlin: Sternberg Press/Critical Space Practice, 2015), 1.

7. Ibid., 7.

Tapping into these movements |

Tapping into the past – very far back |

And into the future |

This could be anywhere |

Anyone |

At any time |

SCORE: RADAR II W/ VIRUS⁸

One person starts walking in the circle. Slowly people join
Take time for walking
One person initiates the running as in Radar I
Slowly starting to use the virus. One person initiates it

Virus means that we can touch someone's shoulder or upper back
when seeing or feeling such a touch
Accompany someone as long as you wish
Leave the virus when you wish
Continue to use your gaze to meet the other, look at the other
Virus ends when we see someone standing in the outer circle

8. Habib started using the word 'virus' in *A Song To...* in 2015, saying 'don't look for it, it will find you', with the intention that the touch slowly starts spreading in the group. Performing it again in September 2021 in Oslo added another layer, perhaps a sinister one, but also slightly humorous in light of the pandemic. The radar in *A Song To...*, which later turned into becoming *ALL*, was created with dancer Jon Filip Fahlstrøm.

ALL – A Physical Poem of Protest
became a part of this feminist
protest in front of the National
Opera in Bordeaux in the frame of
the 'Déprogrammation' festival at La
Manufacture Atlantique, 2018.
© Déprogrammation, 2018

THE MONUMENTALITY
OF THE MASS BODY

There is something frightening and dangerous about a single body moving in front of a mass of people. Something is exposed.

And yet, by Descartes [sic] word: larvatus prodeo [...] she comes forward, masked. Something starts inside her body [...] And then, like a distorted ritornello, something resurges which could belong to anyone. Which could have been sang [sic] or danced by someone else. In the horizon of this dancing body, signs appear, fragments of masses which haunt her, and come to us, slowly, from behind the mask. We are being hosted by a single body.

And yet, a mass solo is also about a body that lets itself be invaded. Mia lets the crowd come to her, almost into her. Politically, socially, intimately. A high risk for a single body: to be given to an unknown crowd. To invert the laws of hospitality and of public theatre: her house becomes everyone's house – a radical operation.

But also a perfect cache: hide it where everyone can see it. To reveal her body as just one of many. Suddenly the idiot multiplies and she fades into a shimmer of masks, faces, costumes. The crowd becomes the masking body. An opacity of sound, opinions, rushed decisions. A crowd: body that generates a space of its own, recreating everything, disrupting the timeline that was initiated by one.[9]

Masses – moving to the specific space-times of multiplicity – are what Habib's collaborator Jassem Hindi describes in *HEAD(S)* as retaining power; and yet, they reckon with one another's vulnerabilities, fragments, hauntings. There is an energy exchange between the singular and the mass that conjures the concept of the monumental. In its large scale, the human is both enfolded into the collective and simultaneously individual.

The historical and simultaneously harmful ideologies concerning monumentality established

9. Jassem Hindi, 'Larvatus Prodeo', *HEAD(S)*, eds. Mia Habib and Jassem Hindi (Oslo: Transnational Arts Production/Trap & Mia Habib Productions, 2012), 1–2.

This is us, only us.

Together

This will never happen again

This is only us, only now, only here

It can never happen again

Not tomorrow, not the day after

only now;

only here,

this is only us

Together

We are a living archive

This could be anywhere

Anyone

At any time

Closing eyes

ies cannot be defeated. These ideologies are now coming back into focus. *A Song To…* was a way to touch these bodily images and destabilise them. In Oslo, the Vigeland Sculpture Park provided a sculptural study of body ideology precedents. The park opened in Norway during German Nazi occupation and portrays the monumental moments in life, like birth, death and aging. In *A Song To…*, Habib worked with the question: What would this park look like if it were made now? In a way, even though they are rendered in stone, they are white bodies portraying a historical version of Nordic identity. So, what would it look like if it mirrored current society, wondering what is vulnerable for bodies now? And what does the multiplicity of bodies mean here?[10]

Of course, there is a problematic side to addressing the idea of 'the body' in the abstract and the concept of the mass as monumentality. On the one hand, we asked, can the shape of the 'radar' in *ALL* be read as something fascist in that it insists on a certain articulation of the mass even though it provides a guide within which participants can bare themselves? As *ALL* lends itself to different participants, sites, and contexts for each iteration, the reading of the piece also continuously changes. In this process we also queried: How do we ask strangers to come together in a powerful way and then leave? And finally, we talked about the title: Who is 'all'? What does that mean? It doesn't add up in a way. A certain failure – even danger – exists in all of these elements, which *ALL* openly exposes and even invites to the conversation.

10. McLaughlin with Habib, 'Running, Walking, Standing: A Conversation with Mia Habib'.

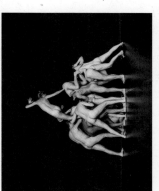

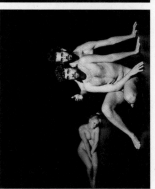

A Song To…
© Yaniv Cohen, 2015

Resting our hands in those of our neighbour's |

Feeling the circle and everyone's hands through our sweat and touch. |

Trusting our neighbour to hold our hand |

The most formal way to get intimate – sharing hand sweat of our neighbour, |

With the other strangers in this room |

Together |

SCORE: CIRCLE STANDING II

Everyone leaves radar into standing in a circle facing inwards,
standing in silence for a long while
One person initiates that

Filling the circle with your intention and listening to what is there,
the energy generated
Stand in a position which feels good to you in that moment of listening
No need for equal space between each performer
You can stay close to someone if you want

Volunteer who chose to participate in
New York, Portland, and Vienna:
This opportunity to get to know different
artists and different bodies and different
languages while moving in a very short
period within one week is so exciting to me. I
love the challenge.

A REAL-TIME NEGOTIATION BETWEEN STRANGERS

Understanding space as both a material and social construct, we would like to draw particularly on the act of walking, one among the many dimensions in the choreography of dissent and demonstrations – a strategy by people to manifest their ideology in public. Distinguishing this act from the perambulation movement on land, we name this movement a choreography of walking politics. The walking politics of protest is an opinionated and planned ideological action with significant spatial attributes – opinionated because walking politics is an action that expresses a conviction of wrong or injustice. Since protesters are seen as unable to correct the situation directly by their own daily efforts, this action is intended to draw attention to grievances, to provoke the taking of ameliorative steps by some target group. As such, protesters depend upon a combination of sympathy and fear to move the target group to action on their behalf.[11]

11. Hatuka, 'Choreography of Protest', 48–49.

disappear into the ground |

Standing |

Slowly letting go of the hands of the neighbour |

Opening the eyes |

Seeing the others |

Let's start walking |

is how to host differences by creating a caring space of togetherness where the volunteers can enter a mode of soft listening to each other, the space and themselves. The methods for creating this space have been developed over time during our research and work with the volunteers in *A Song To…* and later *ALL*. There is always a core team of dancers who work together with the choreographer to facilitate the process. As clearly as possible, we give instructions. In the vulnerable moments of being naked together, the choreographer is always naked too – doing, watching, talking or guiding. If someone does not want to do something, we never push or ask again. People do what they want to do. There are not many rules for those who participate. Everyone is welcome. And then we have to live by that. We focus on the experience of being together, of creating something you cannot do alone, of being generous, of treasuring the ongoing work of accepting different ways of understanding without judgement. In this physical poem of protest, the walking and running of a mass uses a set of rules to build the logic of how the group operates and with different footsteps, rhythms of sounds, and social bonding.

The day together always starts with a warm-up in a circle, holding hands while simultaneously talking and moving.[12] We talk about the circle, togetherness, strangers, ancestors, protest, and hand sweat. While stepping on each other's feet, we are reminded that there is failure, that humans are just humans, that we can laugh about it, that lightness and heaviness can exist in the same space at the same time.

12. This warm-up and its language is inspired by performer and dance teacher Ingunn Rimestad and performer and choreographer Keith Hennessy, which developed in practices through the dance lineages of countless others. The warm-up is also informed by Habib's countless encounters with communal social dances in various spaces, people who are no longer here and their ways of sharing togetherness.

A Song To… at Stadt-
theater Freiburg, 2016
© M. Korbel, 2016

Saying hello with our eyes |

It is a meeting |

Seeing for real |

We see for real |

We see the other |

Continuously passing others, passing through |

openings. |

SCORE: RADAR III W/ DRONE CHOIR

One person starts walking in the circle. Slowly people join
Take time for walking
One person initiates the running as in all Radars
After a good while in the radar the drone choir starts:
Going into humming and all the way up in max volume with drone choir

Starts with humming on the verge of listening with closed mouth.
Allow the humming to grow in intensity
Open mouth gradually as volume increases: getting towards max volume with MA with a large open mouth. (The open mouth also creates an image.)

When breathing in on max volume: keep your mouth open to keep the image.
After max the group finds the low humming together.
As soon as we are all in the humming; let it die out.
Imagine your head, mouth and throat as a cave of infinity releasing sound in a relaxed way.

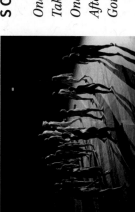

Performing at the International
Student Festival in Trondheim in an
old circus manège.

ALL – A Physical Poem of Protest
© Mia Habib Productions, 2018

BARENESS IN AND THROUGH BODIES

Since volunteers shed their clothes, the piece involves nakedness. But the piece is actually not about naked-ness, but bareness. The mass becomes abstract when you zoom out with this unifying mass of lines and move-

ness. It is both the exposed flesh and the extra-bodily, including taste, smell, sight, and sound. You taste the sweat of others running alongside, smell the odours of flesh, and voice the 'MA sound' yourself and in chorus with others.

The body, both individual and collective, is then like a projection screen where, through this repetition and ongoing insistence on the score, there are many associations. The audience can transcend into different states and depending on the place, when there are naked bodies, they might conjure schools of fish, abstract lines, images of naked bodies – some of which aren't pleasant historical images. But it's a flow of association. In France when we did it, we had Kurdish female activists. And nudity there would've been an exclusionary choice. So, in some cases it makes more sense to be clothed, to be more inviting to more people. In Portland, the naked body is quite common, but the risk of attack is still there, so we had volunteer de-escalation personnel situated around the performers. For a transgender person the nakedness was life-giving, and for a breast cancer survivor joining us it was necessary. The action can still be baring, insisting and holding the potentiality of an inescapable encounter. It holds the power of a demonstration.[13]

13. McLaughlin with Habib, 'Running, Walking, Standing: A Conversation with Mia Habib'.

Volunteer who participated several times on different continents:
The piece helped me transition into a more vulnerable place and more accepting place with myself. I felt like I had more of a responsibility to take care of myself and do the things that I really want to do.

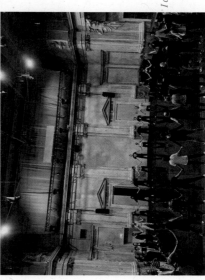

Walking through the openings created by the others, by us, together

I can change at any time

I can change my direction and any time,

I keep seeing

Warming up before performing in Burgtheater, Vienna, 2020, during the programme *EUROPE MACHINE*, curated by director Oliver Frljić and the philosopher and activist Srećko Horvat.

ALL – A Physical Poem of Protest
© Mia Habib Productions, 2020

THE BARE BODY AS THE URGENT BODY

An important part of this process is care and solidarity. We offer a guiding invitation and question to the volunteers to consider during the work: *For whom or what do you stand and walk? What is your urgency?*

This is a way of rooting the collective and group work back into individual urgency. One way of doing this is to invite each person anonymously to write down for whom or for what they stand and walk. Then these notes are shared (if agreed upon) and read by the collective just before enacting the score. While walking and running there is a resonance of multiple intentions fuelling the group and silently touching the audience. In a strange but powerful way, the consciousness of the group, now knowing the multiplicity of intention, makes the solidarity stronger.

Wherever we have performed *ALL*, the volunteers stay in touch afterwards. Some of them travel to join us in other places, to perform again or watch. Some of them started dancing afterwards, some say they came out of a period of depression, others made a performance about this performance.

Notes from the participants of *ALL –*
A Physical Poem of Protest
© Mia Habib Productions, 2018

SCORE: THE END

The Radar continues in silence after the drone choir is over.
After a while begin walking in Radar.
Slowly turn down the speed of the walk till we come to standing for a long while.
Whenever you feel ready, start leaving the space, one by one.

WISDOM
ˈwɪzdəm

Wisdom is a profound blend of knowledge, experience, discernment, and sound judgement, exceeding mere intelligence. It entails the ability to apply insights gained from life's lessons to navigate complex situations with prudence and insight. Wisdom emerges from a deep understanding of life's challenges, successes, and failures, honed through lived experiences in attunement with the cycle of life. Critical discernment, distinguishing nuances, and making ethically sound decisions considers the broader consequences of actions, valuing sustainable solutions over short-term gains. Wise agents seek open-mindedness, remain receptive to other ideas and perspectives and acknowledge their limitations. They maintain equanimity in trying circumstances and strive for cultural-contextual sensitivity along with a sense of communal responsibility. Wise choices are aligned with principles of justice and integrity, emphasising a holistic understanding of existence. While wisdom is an intangible quality, its influence is tangible and transformative, shaping the world through thoughtful decision-making, aligned with harmonious relationships. Wisdom understands the law of reciprocity and contributes to the collective and sustainable journey on this planet.

CARE
keə

Care encompasses a wide spectrum of compassionate actions, considerations, and efforts directed toward the well-being, support, and nurturing of individuals, communities, and the environment. It reflects real concern, empathy, and responsibility. Care emanates from a genuine desire to improve the quality of life and create a sense of belonging. An in-depth understanding of trust, respect, and reciprocity forms the foundation for caring extended to the entangled biosphere, advocating for sustainable practices to ensure a thriving planet. Caring communities collaborate to address local challenges, promote inclusivity, and cultivate love, support, and a sense of security. Countering recklessness and negligence in responds to today's diverse crises (hunger and poverty, war, climate disaster, unjust distribution of resources, economic, financial and healthcare crises) means to persistently nurture equity, justice, the common good, and ethical treatment for all agencies. Care ensures the dignity and respect for marginalised groups. Ultimately, care embodies the essence of compassion and empathy, drives future change through strengthening solidarity and activates sustainable flourishing of human and more-than-human connections.

ALICE HEYWARD,
REBECCA HILTON &
SALKA ARDAL ROSENGREN

Nakedship

Trialogue

Alice Heyward, Rebecca Hilton, and Salka Ardal Rosengren are dancers who make choreography and teach. Becky and Alice are both from so-called 'Australia'[1] and Salka is from Sweden. Alice and Becky have known each other since 2010 and met Salka in 2016. The three artists/dancers/women have performed together in various manifestations of *TEMPORARY TITLE, 2015* (*TT*), choreographed by Xavier Le Roy in collaboration with Scarlet Yu. *TT* premiered in November 2015 at Carriageworks in Sydney, Australia as the 31st Kaldor Public Art Project. The work has been presented in Venice, Paris, Pantin, Berlin, Essen, and Taipei.

> Temporary Title, 2015 *is an exhibition where visitors enter and leave at will. That situation is made with performers forming and deforming groups or assemblies while composing a landscape in perpetual transformation. The performers' actions and presences oscillate between recognisable and unrecognisable appearances whose characteristics could be sculptural, animal, vegetal, mechanical [...] and, sometimes, they approach the public to engage in conversations.*
>
> – Xavier Le Roy and Scarlet Yu

This written conversation between Alice and Becky was conducted at the end of 2021. Salka added her comments later, in March 2022. The text explores concepts of embodiment, sensation, gaze, perspective, and agency they experienced in the making and performing of *Temporary Title, 2015.*

Alice in Berlin: I like our title, 'NAKEDSHIP'.

> **Becky in Melbourne:** Yeah, I like '-ship' as a suffix. Somehow it addresses many things we're interested in unfolding in our conversation – the state or condition or quality of being something; the position, status, or duties of something; the art or skill of exhibiting, or embodying something, or participating in a specified activity.

Alice in Berlin: Hmm, so, 'nakedship': the state or condition or quality of being naked in public, the position, status or duties of nakedness in public, the art or skill of exhibiting or embodying something naked. That's a lot to think about. These definitions change a lot. They all become so different in different circumstances.

> **Becky in Melbourne:** Maybe we can start by describing some of the physical sensations our nakedship produced. What springs to mind when you think about the sensations produced by performing *TT*? For me, it's the epic middle-aged-lady hot flashes constantly triggered by lying in the midst of a pile of naked colleagues. No one ever mentioned my hot flashes and I didn't explicitly talk about them. I think I thought my sweatiness was tacitly inviting menopause into both the work and the world; anyway, it became one of the multiplicity of sensations we experienced separately and together.

Alice in Berlin: I don't think I recall that you specifically had epic sweats, but I do remember you talking about your menopause, so it was definitely with us. We shared a lot through physical contact in the work, so your sweating was our sweating. I think a little sweat made some things better when we were in touch, we could slide on each other's bodies a little easier. I remember that in Sydney in 2015, the bare skin on my knees and knuckles hadn't toughened up enough not to break and bleed as we crawled around for hours across the thin black carpet, naked except for Band-Aids, which were never sticky enough to rely on to actually help for very long.

> **Becky in Melbourne:** The Sydney carpet was particularly hardcore. It was like a giant Brillo pad. Other carpets in other places were a little kinder. Once I had a wound, I was locked into a relationship with managing it until it was healed. I think in some ways I constructed my whole sensational practice around avoiding that broken skin pain. I did less. I moved less because of it, so I think I laid around a lot. It took me a while to understand the power of the preventative Band-Aid.

Alice in Berlin: Yes, those high-tech, gooey, 'second skin' type ones worked if you used them preventatively. There was that nice guy at

Carriageworks, Neil Simpson, who would bring new packs every few days. Visitors would get intrigued by our wounds and bandages; it was sometimes hard to move the conversation away from there. I remember thinking about how unprotected human bodies are against surfaces, how – compared to animals or machines, or rocks, or even plants – we are so fragile, exposed to the elements. Animals are much more present in, and at one with, their environment, whereas we Western humans live *on* it and make machines to extract things from it.

Becky in Melbourne: It's interesting to think about surfaces and the way our relationships to them, personal and cultural, change over time. When I was a kid, I spent a lot of time lying about on the floor waiting for adults, especially in museums, libraries, art galleries. I can recall the feeling of the cool floors, the quietness, how time would stretch out, slow down in those places. It's funny that at age fifty-four I returned to this childhood floor practice, but now it's with twenty-two other naked people!

Alice in Berlin: Children are way more like animals than adults. And maybe your wounds helped you stay more at one with the ground because you had to notice and manage your relationship to it so carefully, so intensely.

Becky in Melbourne: Yes, come to think of it, this heightened sense of noticing, allowing myself to be totally absorbed in and transported by the intensity of the experience, is why I love performing at all. In any context.

Alice in Berlin: I remember big red circles appearing on the skin over my greater trochanters from continually dropping my weight onto one hip or the other, landing heavily, my breasts jiggling, on that hard floor.

Becky in Melbourne: Being substantially older than most of you, a lot more of me was jiggling than my breasts. The thought of my lumpy, loose flesh in constant relation to the smooth, firmness of you younger ones created a particular nexus of horror and wonder in me. But wonder eclipsed horror, there was freedom in being unable to hide. There was just no disguising who and how we were and I found a brutal beauty in that. But everything seemed softened by the sweet-scented, moist Sydney summertime.

Alice in Berlin: I remember the warm air streaming through the huge open doors, leading out to the disused railway tracks. I miss the density, the headiness of the sub-tropical air. I realise I began to recognise people by smell, you always smelled like Bio-oil, that orange stuff... Sydney was the only place where the show was open to the air outside... It felt good. Being naked in fresh, outdoor air is pretty special.

Becky in Melbourne: And the light, the quality and play of the light on the bare bodies would totally mesmerise me. I would find ways to both do the practice and witness it, to watch it from the inside of it. Time would flee and I'd startle to the realisation that my shift was over. And getting dressed again would make me self-conscious about my nakedness. I felt most naked in the times between, in the transitional times, the times when I was alone undressing and dressing instead of amongst the pack.

Alice in Berlin: Yeah, getting dressed and undressed did feel very weird, handling clothes after being naked for a two- or three-hour shift, or taking my clothes off to begin one. It could feel exciting, going from 'normal' to another kind of normal for us performers of this work. I think I too felt most naked when half naked, more exposed because being fully naked suddenly wasn't my normal 'nature', like it mostly is in this work. I think encountering nakedness in this work has very much to do with it being a group work. We are all very different naked bodies and seeing one of our naked bodies alone is different than seeing our group of naked bodies, forming a constantly changing landscape by doing things naked together.

Becky in Melbourne: Yes, I agree that the experience was one of profound groupness for those of us in the work, but who knows what it was for those who encountered it as visitors, who knows if they perceived us as a landscape or as twenty-two singular exhibitionists or as a group of kooky nudists? My hope is that they stayed long enough to allow it – however they first perceived it – to transform into something else. As the simplest example of this, often I would notice a visitor begin standing, then they'd lean against a wall, slide to sitting, recline on an elbow, and then lie all the way down. The work would perform this on them and I would become a spectator. I don't think I have ever felt this before inside the act of performing: roles reversing, a world within a world. Very occasionally the line between the visitors and us would blur so much that someone would disrobe and join in. That would totally amaze me, as if we had collectively cast a spell on that person. I realise now that I didn't think so much about the nakedness, I preferred to think of other things, like the relations and the sensations.

Alice in Berlin: I remember my eyelids slightly closing with the imagination of a hot sun beating down from above. I remember my stomach pumping gently as I inhaled and exhaled through my nose. I remember my face splitting wide open as I would yawn massively, my tongue stretched far out, my eyes scrunched. I remember my sacrum and tailbone pressing on the floor as I would curve and arch my spine repetitively, trying to synchronise the duration of isolated movements with a rhythm playing in my mind and with the other bodies around me. I remember my arms and legs suspended and waving slightly in the air, my torso softening into the

carpet through the expanse of my back, my heart rate slowing, the perspiration of my body slippery with that of another right next to me, though I often didn't know whose body it was. I had short hair in 2015 and later I found out the pain of having longer hair, when someone would roll on it, pinning me by my ponytail to the carpet.

> **Becky in Melbourne:** Sometimes the sensational and relational experiences were so overwhelming that I had to go and lie in a corner and rest from the relentless production of them. I remember watching you a lot, Alice. Maybe because we knew each other from before and because we were making, by being in this work together, a transition from teacher/student. We became something else to each other. Colleagues. Peers.

© Christian Schuller

Alice in Berlin: Yes, this work undoes things if you let it. Experiences of time and experiences of change seemed to become one and the same thing. The material transforms from animal, machine, plant, human, mineral. Relationships transform too, the collective experiences of asking questions, our common mode of production, with voices and bodies in different ways, blurred the roles we were/are used to in our lives. I was so occupied by becoming other things, among other bodies, that being a naked human body often receded for me...even when I was having a conversation with a visitor in a human way, my experience usually wasn't about being looked at, or the difference between us (visitor, performer), but rather thinking together about transformation: ageing, growing, learning, falling in and out of love etc. There's a photo from the show in Essen depicting me deep in conversation with a woman, Luísa Saraiva, who was a visitor. I'm naked and she's dressed for the snowy winter outside and we're both totally engrossed in our exchange. This was the first time we met, now we're close friends and collaborators.

> **Becky in Melbourne:** Yes, the experience nurtured so many kinds of relationships, new and old. There were people whose relation*ships* stretched way back into the past and would continue on into the future, so the 'position, status, or duties' of some members of the group were much more temporary than others and I wonder what that produced.

Alice in Berlin: There are many long, deep relationships in the group, predating the project, that came together in 2016 and between people in the group in Sydney in 2015. But I don't think it was only those bonds with prior histories that were lasting, despite the different degrees of experience with each other... For me at least, shared experiences in this work formed many ongoing connections, developing into other situations in the future, proving not to be temporary, but continuing and changing. How do you understand being more or less 'temporary' in the work or otherwise? There's a paradox in how something's continuity – a relationship, a practice, a life – reveals so clearly the inherent temporariness within it, but not necessarily *of* it. Like, nothing really ever ends, but everything always changes...

> **Becky in Melbourne:** Ah yes, 'Everything changes, nothing is lost.'[2] I agree that we are always and continually in the process of making temporary communities and that those relationships continue to evolve and live on beyond the temporal boundaries in which they begin. But something still pulls at me about whether our determination to approach both the workplace and the artwork as places of unquestioned equality served the whole group throughout the whole process? Maybe in not spending more time understanding and articulating the diversities within the group, we unconsciously confirmed a 'norm'. Was it difficult for some concerns to be voiced by some people because doing so might reveal a lack of faith in the process? Did we paradoxically exclude the voices of some *because* we were so committed to being equal?

Alice in Berlin: Equality is not sameness, not about flattening or generalising into norms. Maybe equality depends on taking differences into account, affecting how we relate to each other, and creating conditions for all the different people involved in a group to subjectivise. I remember we talked a bit about 'The Ignorant Schoolmaster', Jacques Ranciere's theory-tale about Joseph Jacotot, the teacher who taught in French to Flemish students who didn't understand French. He discovered that an inequality of knowledge isn't necessary in order to teach, nor is explication (teaching and writing which presumes an intellectual inequality between the teacher/writer and the student/reader) necessary in order to learn. He takes difference as a departure point for relation, to produce exchange, to generate growth, learning. After an awareness of difference in this process, how do we also acknowledge that we lack direct, first-hand involvement of others' experiences and what this lack means for how we think and do together?

> **Becky in Melbourne:** I understand that was what we were trying to do, I am just wondering whether we managed to do it or not. For instance, when we began to share the work with the public, it became clear that some of us were being objectified in ways that were disturbing for all of us,

but particularly difficult for the ones it was happening to. I think that, as a group, we weren't really prepared for that, we hadn't spent enough time in the process exploring that particular difference between us, so we had no concrete strategies for dealing with it. I think maybe we desperately wanted the work itself, and our commitment to it, to change the ways of the world, even though we were all quite aware of the ways of the world. So, I wonder, did we make a world within a world that was impossibly utopian and not sustainable once the work, both as an ideal and an art experience, met the 'real' world? And I think that was much harder on some of us than it was on others.

Salka in Sweden: True, we didn't. Makes me think of several dance-creation processes I've been involved in where acceptance of difference is tacitly assumed rather than explicitly discussed. Maybe because talking about difference would reveal a lack of faith in the process, as you write, Becky. Or maybe it was more a crisis of ambiguity? What I mean is that by not exploring the particular differences between us in an explicit way, an air, an atmosphere, a mood, even a site for uncertainty was produced, which opened the piece up for many potential readings, which articulating our differences might have flattened or broken? I do want to believe, and to hope, that the world we made could have held both. So it's interesting to think of what might have come out of us spending more time reflecting on our obvious differences. I think it would have felt good having the differences acknowledged more explicitly, like how having a pussy feels and how having a penis feels and how, depending on body weight and butt size (lol, sorry for the explicitness!) some pussies are much more exposed to the viewer than others. Just to have it said. Acknowledged. Sometimes I had a feeling that the realities of bodies still felt taboo to discuss as a group; like the women who had their periods would speak about it with each other but not with the whole group. Our bodies being more leaky. Discharge on the black carpet etc. For me, at least it would have been great to have had time to discuss those differences so that when a crisis situation happened, like the discovery of the creep with the hidden camera in Paris, we had some shared strategies to employ as a group.

Alice in Berlin: I think you're right that we didn't try to fix on identifying our differences, maybe to avoid establishing roles based on them, trusting that our differences are a part of how we subjectivise; we're free to choose how to while moving through the score in the work. For example, if we want to think about it, we all know I am the youngest in the group and Jan [Ritsema] was the oldest, but we didn't reiterate differences like these in how we worked, in order to create space to think about things beyond these kinds of dominant identity markers. We did not pretend that anyone was 'the same', and we didn't want to attach to what usually separates us in the 'real world'. For the most part, I appreciate this immensely and found it kind of emancipatory. Personally, I don't want to feel my age or gender as strongly as I already have to in the 'real world' so often. It's not about denying, neglecting, or ignoring differences like gender, age, race, or sexuality, which are real and matter and part of our subjectivities and did affect different experiences and relations with visitors for individuals in

our group, some which shook and crossed boundaries and were very difficult to be the direct recipient of. When, from visitors, differences that form inequalities in history and society crept into our experiences in the work, it felt shocking because usually, ideally, the work isn't operating through this kind of violent terrain of potentially degrading power dynamics.

I don't imagine this world we make in the work as the 'real world'. It affords a different way to exist, temporarily, different to how we live or behave in society. The objectifying encounters with visitors felt like 'real world' sensations (of inequality) piercing through the world we constructed, experiences of, as I remember, mostly older white men relating to me and others in a way that made us uncomfortable.

Beyond these instances which, like many negative, inequitable power dynamics, can occur in many open and 'inclusive' scenarios, I like tapping out of the 'real world' into this work or other performative practices, artificial constructions in which I have real experiences. Our group and visitors give me access to be in the work for my pleasure and interest in this way. It's not the same to practise material in this work alone, as I've done from time to time. The way time feels – and how my attention engages when part of the whole diverse group-visitor situation in *TT* – alters from the way I often have to move and function in the actual world as myself, in/as my identities. I can both get 'out of myself' and be myself.

Becky in Melbourne: I know I was the one who introduced this dumb binary of real and not real worlds, but I want to take it back. I suppose the thing I'm really talking about is the transformation that happens when a process moves from studio to stage. What crumbles or melts away and what rises up? Sometimes I noticed that the longer, deeper relationships linked to longer, deeper practices survived this transition more intact.

Salka in Sweden: This is funny.

Alice in Berlin: You mean the fact that Xavier, Christine [De Smedt], Jan [Ritsema], Salka, Saša [Acentić], Neto [Machado], and Luìs [Miguel Félix] had been practising performing the vocabulary of lions and performing conversations, and embodying plants, machine, and stone (movement behaviour that underpins both *Low Pieces* and *TT, 2015*) for many years, whereas you and I and others only started in 2015? Lion vocabulary in particular ripens with time...

I appreciate these histories and different contextual understandings of the material in one another, but I didn't feel like it located anyone who hadn't been part of *Low Pieces* in some kind of lesser position within the work or with the material. I think the work cares more about transformations between things and how individuals embody and navigate these processes subjectively, than the different forms that we use to do this.

Becky in Melbourne: I had the feeling that I was still just clinging to the edges of the physical/mental/emotional/psychic practices once we began performing and this made it difficult to 'get out of myself' as you put it. The other people you mention were so deeply familiar with the vocabulary, the aesthetics, even the ethics of the situation. They had a long-term community of practice, if you like, so they seemed more able to engage with this idea of equality, of equity, of groupness from a more embodied, experienced place.

Alice in Berlin: I feel like doing the work was constantly learning how to do it and that all our different experiences with the material were as great (equal!) as each other and continued to surprise me, us. The work probably grows from the combination of long-held and fresher interpretations. In the end, I think it was more about our subjectivity than 'expertise' in performing forms. Maybe these things produce each other, changing what being 'experienced' with the work means for each of us and together as a group... The work embraces a lot, open to so many ways of doing it... Like, I love figuring out for myself, each time the choreography in the loop would reach this point, how to become a lion, from a rock...so many conversations were so unique, taking us, the individuals engaged in them, through all kinds of ideas and stories about what it means to transform. I went on these journeys in ways I wouldn't be able to alone, as it was about thinking together. I think being 'good at' this work is to actually not know everything about it (impossible!) or exactly how to do it. It unfolds as we figure it out by asking ourselves how to do things, knowing *what* will happen, but not sure *how* until we are producing it – *how* being *what* – in the moment. Some visitors might have responded to the porousness of the boundaries in the work as an invitation to relate towards some of us, group members older and newer to certain material alike, in ways we didn't like. There's a potential for eroticism in the lion's crawl, the low-level, one-to-one conversations. It's not explicit...and not our responsibility as performers if a visitor taps into this potential. There is no invitation for disrespectful behaviour in the work.

Becky in Melbourne: I think it's fair to say that those visitors understood that their behaviour was antisocial, but assumed a kind of 'well, they're naked in public, so they're asking for it' attitude as a way to rationalise their extreme perviness.

Salka in Sweden: Yeah, I think there was that kind of attitude for sure, but I also think we are edging a certain invitation towards the audience, and it is provocative, we shouldn't be naive to that.

Alice in Berlin: Yes, it was nasty. But maybe it's a bit presumptuous of us to assume that everyone in the public understands and will embody

respectful behavioural codes common to exhibition visiting, art, and performance spectating? The work isn't necessarily trying to explore sexuality or eroticism, nor does it ask for or want codified museum-going viewership, and our hope is that visitors begin to think *with* the work and not just take from it, stimulated by seeing us as objects.

In Sydney, the media might have contributed a lot to particular ways of viewing, attracting visitors with certain expectations. Headlines such as '*Temporary Title* by Xavier Le Roy Will Leave You Panting' and 'Kaldor Public Art Projects Is Back with a Brand New, Entirely Nude, Performance Piece' definitely choreographed visitors' attention before they even entered the room. I think that narrow-minded, conservative cultural attitudes reinforced in Australian society didn't do us performers many favours, nor visitors, who were groomed by the media for a kind of peep show…

Salka in Sweden: Aha, I don't agree. I think the sensual crawling of the lion, the slowness, the laying low, even the one-on-one conversations, all bear something of an eroticism. Again, it's not explicit and perhaps remains a potential but there's certainly a sensuality, a softness, a beauty, an erotic involved.

Salka in Sweden: LOL

Becky in Melbourne: Sometimes I think the single fact that might reveal the most about so-called 'Australia' to so-called 'non-Australians' is the fact that so-called 'Australia' produced Rupert Murdoch!

Alice in Berlin: 🤮 😔

Becky in Melbourne: But Alice, how did the way people looked at you impact your experience of the work? Did it change your relationship to it at all?

Salka in Sweden: Nice question, trajectory. Bringing it to your (Alice) specific experience, concrete.

Alice in Berlin: How visitors saw me – their gazes – produced different sensations in me. Those sensations would change throughout time, people's gazes changed with their experience with the work and how *it* changes. At times, it felt like some people saw me (and others among us) very much in our naked human identity/forms (revealing certain recognisable problems in society in the ways some humans see and treat others), in ways that made me feel like *what* they saw. This was mostly due to their behaviour in the space, not just my sensation of their gaze. Sometimes this relation didn't shift over time, like it refused the potential to change.

Becky in Melbourne: Unacceptable behaviour happened daily, there was that one guy in the safari suit in Sydney who would come all day, every day,

and regularly change position to get a 'better' view of you young women. Kaldor Public Art Projects made an executive decision to ban him, a stance we (the group of artists) didn't support at the time. But I particularly remember this one other time where someone's behaviour disturbed you so much that you broke the aesthetic code of the work and you crawled up to me and whispered that some guy you had spoken to the day before (in the frame of the work) had come back and was calling your name in a creepy sing-song tone whenever you went near him. And you wanted to know what you should do. I said either leave the work immediately and get someone to replace you or go up to him and ask him to stop. I really didn't realise how hard both of those things were for you to do. I didn't understand that I was naming you as the problem and expecting you to be the solution. And I wanted you to do it there and then. I was actually mad with you, disappointed that you couldn't do it. That was so unfair of me.

Salka in Sweden: This is interesting to read.

Alice in Berlin: Me crawling over to you at that time felt like the best, safest thing to do. I don't think I thought too much about it, I just acted. It must have felt like a very direct, correct strategy. I can't remember if I was worried about 'breaking the score', but I don't think my response was out of the work's possibility. I'm sure I felt like 'what the guy is doing shouldn't be happening' – which is true, it shouldn't have – but unfortunately sometimes people are yuck and yeah, it's unacceptable, as you say, and also so hard to stop it happening. I wish I could have told him to fuck off by myself and I probably could have and kind of wish I did, but I guess I just didn't want to. I don't really like doing that to weird strangers. I preferred to not bear the problem alone, so I told you about it, which took the uncomfortable weight off my naked shoulders and weakened the alarming tension I felt was just between him and me. Just to have others aware of the situation, even if you were telling me to do things I didn't want to, did a lot for me. I wanted to deal with the issue together, with my colleagues, my friends. Groups in projects like this feel like family to me, like there's dependence between us. I think I even felt grateful for our little squabble, naked, on all fours, whisper-discussing what to do about the creepy guys, even if you were telling me to do things that I didn't want to do, because finally I wasn't alone with it anymore.

I do look like a naked girl when I have no clothes on, even if what I am trying to do in this work is embody ideas and material that are producing different things of and through me. It's not a total surprise that our nakedness in this work might be arousing for some, even if it does not feel sexy or erotic to me. We're busy performing our score and attuning to what this requires and feeling like a sexy human isn't very present in these activities. But we are naked and people are conditioned to see nudity in

ALICE HEYWARD, REBECCA HILTON & SALKA ARDAL ROSENGREN | Nakedship

certain ways by various forces, many histories we know and recognise. We can't fully understand the experience and intensity of these forces in another's life. Their perception of us as 'kooky nudists' as you said – maybe humans acting like sexy baby four-legged animals or whatever they want to fix on with their gaze when we're performing 'plants', laying on our backs, legs spread – might prevail. I think such attitudes weren't the dominant experiences of visitors, but it could have been like this for some.

Salka in Sweden: Interesting with those moments when we act instinctively. Safe space NOW which here meant 'Becky'.

Salka in Sweden: Funny scene. Amidst the serene lion-plant-mineral world (I enjoy playing it out as I read).

Becky in Melbourne: I began developing some personal strategies to deal with the creeps, using my middle-aged body as a shield. If I saw someone gazing creepily, I would crawl over and sit right in front of them, blocking their view. It was a temporary solution, something I could do within the code of the work. At other times, I would invite the creep into a conversation and tell them that the way they were looking at some of the performers was making all of the performers uncomfortable. But I am so interested in our tacit determination as a group that its aesthetic realm was to remain intact no matter what and our belief that somehow the ethical codes embedded in the work would prevail. We all wanted to believe this even as it was becoming clear that it wasn't working.

Salka in Sweden: I would have liked being able to do that. I remember feeling comfortable especially being close to you, Becky, maybe I tried to use your shield too, hehe. I think I also just sensed you feeling comfortable in your own body (which I have no idea if you actually were) which made it comfortable or safe to stay close to you, or maybe what I sensed was that you were ok to have others chill next to or on you. I did gravitate towards some and not to others in the piece. Some went their own ways, played more solo. And you, Becky, were often warm, haha, that became a thing for me, avoiding someone with cold feet for example.

Alice in Berlin: I think that it would be hard to break the 'aesthetic realm' of the work unless we started doing activities in *extreme* contrast to what (how) is normally composing the work. But we could still think of and share great ways, like your strategies, of dealing with relations with visitors that we, as different individuals and subjects of gazes, and as our group, don't want to accept. I think your view-blocking and surprise scolding tactics are really cool; actions that make a difference within the work, like 'uh-uh, it's not like that for you today!'

I think this work can shift how seeing naked bodies in public can feel like and what this might generate in terms of meaning. That's the

experience we heard about from many people and what I could also sense in the room. Separations and divisions merge and re-emerge between performers, spectators, forms, and ideas. Things move around and change through and over time. Our nakedness in this work offers the possibility to encounter more of a landscape rather than object/s, a possibility for nakedness in public to produce something other, or at least more, than titillation or provocation.

Salka in Sweden: That's what was absent for me, the sharing within the group. Even if the choreography stayed exactly the same I would have liked there to have been more space for, and interest in, discussing and processing incidents like 'the safari guy' and the creepy, disturbing man in Paris. That would have made me feel more supported and less alone in my experience. Once the piece is up and running with all the different shifts happening, it's difficult for us to meet all together and voice and share concerns and experiences. I think that needs to happen more formally next time.

Salka in Sweden: For sure!

Becky in Melbourne: Like what? Like a community? A temporary community?

Salka in Sweden: Maybe similar to the way kids seriously play, where the perception of time produces a setting where other rules apply. I think the slowness and time spent, shared, is crucial in the making of this 'other space/landscape'. Though I do think some people will always be ignorant of, or insensitive to, that proposal and only see naked bodies. I think the shift in architectural space (from a huge auditorium to an intimate theatre), as well as the socio-economic and cultural status of the visitors, plays a major role. I feel this piece was very much made for an everyday museum visitor and perhaps we, as a group, didn't really acknowledge that; we didn't want to look that fact in the eye. How would it be to play it for groups of teenagers, for example? Would it help if it was accompanied by an introduction or would that be too didactic for our taste? Sometimes I think we have too much belief in what the piece can do simply because we don't or won't or can't imagine the world beyond our world – the art in the museum context.

Alice in Berlin: Maybe...other ways different bodies can be together...
We are not really sure how we appear to others, if their gaze changes over the duration of their stay, with our ongoing transformation as the day passes. This is what creates the tensions, the risks, and might contribute to the magic of this performance: that we can't, as individuals, ever be aware of the entire situation at once. The question we still need to ask ourselves when we perform this work is how we respond when visitors' behaviour in this exhibition transgresses what feels ok for ourselves and each other. When we don't all experience the same thing in the same way at the same time.
It is a challenge when someone's relation to you feels objectifying, like you're stuck in it without agency to shift it, it's not changing and your

only choice is to end it. And often how to end it feels complicated and hard to achieve on one's own.

This isn't all about nudity. Human behaviour, gender, and sexuality aren't tied to nudity. Being fully naked can be much less objectifying than other scenarios, dressed and gazed at, in life and performance. It's about the relation of the gaze on you and what behaviour the people in this relation choose to respond with. How they respond to their experience of what they see and if/how we have agency to respond to, accept or reject, our positions in this relation, to keep them dynamic and know they are our choices.

The trickiest part about this oscillation from subject to object through the eyes of another is that you don't get to choose. And that can feel like you're weak or even that it's your fault it's happening. You turn yourself into an object against your will (you are turned), silently and sometimes unconsciously. An experience of being seen through this gaze when it's not necessarily expected or desired in a situation can feel confusing, insidious, and creepy. It's hard to catch, easy to disguise, or just so historic that it unfortunately folds inconspicuously into the fabric of many situations, acting on us and affecting the subjects present differently.

Salka in Sweden: Totally agree. It's not fun to feel you are in the grip of someone's gaze. How to act then? I think taking distance is the most effective tool. Or leaving altogether. My temperamental tendency is to confront an issue, but that failed miserably in Paris where I crawled up to the creep and asked him something like 'How is being a man for you?' I was stranded somewhere between the rules of the work and my need to make him stop behaving in that way. But it really did not work. It felt horrible, made me feel stupid and ashamed. Yuck.

Becky in Melbourne: This makes me think of Lorraine Code.[3] Do you know her? A Canadian philosopher working with feminist epistemologies? Anyway, she asks questions about out of whose subjectivity this ideal (of objectivity) has grown. Whose standpoint and/or values does the thing we call objectivity represent?

Alice in Berlin: I haven't heard of Lorraine. I think that her questions point to the easy habit of detached, patriarchal posturing, claiming objective truths which leave out many experiences and perspectives. *TT, 2015* helped me practise and value speaking from my first-person perspective, rather than from some kind of bodiless (impossible for anyone with a body anyway), omnipotent position. I remember writing something in the Kaldor blog about that in 2015... I can't find it online anymore, but I have been interested in this idea and experience of myself as a process as opposed to an objective fact. Taking on the present as something I am, we are, in the process of becoming. Like, *I am (the) growing, I am (the) falling in and out of love, I am (the) ageing,* etc. I remember reading parts of François Jullien's 'The Silent Transformation' in Sydney, about the *indeterminable* nature of

transformation taking place through time. Maybe it took me a while in my life – could be until this time in 2015 (I was twenty-two or -three) – to feel potential in my transforming position/subjectivity in first-person singular, *I*, because *I* needed to find my agency and action with, against, through, forces that were acting on me, forming me. I needed my own power to catch up with them, to find a dynamic between them.

Our nakedness in this work is alive, in time, in transformation... This isn't photography, it's happening physically and through live thinking processes and that's important in this context and my experience. Performing can be a strategy, through the embodiment of material and encounters with people, to consciously work with, away, against, or through the kinds of forces that can affect my form, to experience and generate agency, not control, over how I can be seen, how I feel, and therefore how I am/what I become. Forces act on me and I act. Performance, for me, is about the interest and pleasure to be transformed and transform myself, *I*, an ongoing process. I don't want to always know or determine specific ways to be seen, but to question, interact with, and change the ways that I could be. How do you experience performance as a way to invite or confront being seen? What I love about dancing and performing is that I don't have a certain image of myself from the outside, in the act. I'm working with other kinds of information, beyond what is visual about me, which I process inside myself while knowing that I'm seen from the outside while performing.

Salka in Sweden: I relate to this. It can feel like freedom.

>**Becky in Melbourne:** I don't experience performing as either 'inviting or confronting being seen' or I guess I'd prefer not to frame it that way. The thing I search for, in both doing and watching performance, is a kind of absorption in the practice. I like to think commitment and concentration are portals to the inside work of the performer. As a performer I become a kind of proxy for experience and as a watcher I am invited into this realm of concentration and commitment.

Alice in Berlin: I hope we get to do this work again, even though it's the most non-COVID-times performance ever...lots of naked people touching and breathing on each other. I would be curious to experience everything we've discussed, in this ever-changing, pandemic period of time – how it is to be a naked body and to be seen now, as individuals and as a group, changing forms in physical, social, and relational connection to each other. What would this generate now? Fear? Revulsion? Nostalgia? Longing? What would happen to the dividing lines between performers and visitors and each other, now?

I enjoy being naked and experiencing the processes of engagement you mention: absorption, concentration, commitment, performing naked.

Being naked in life is usually rare and private. I love performing, being public and experiencing different kinds of relationality. I love transforming encounters with people and being naked opens new physical sensations, the excitement of what is not usual, and it does interesting things to my presence and constitution, even, or maybe more so, when I can move through and beyond feeling the state of being naked and seen as naked, into other processes. I think all of us in the groups who have done this work are into it in personal ways too, as we all found ourselves a part of it, with an interest in performing this work, which is to perform it naked. It's our costume or maybe it's just us without the costumes that we use in daily life.

What was that motto we would sometimes say?

'Everything is possible but you can't do anything'…maybe 'anything' and 'everything' are the other way around? Either way, this was useful for us performing and can also apply to being a visitor hosted in/by a situation you enter. I like it because it implies ethics and responsibility without closing any doors before negotiation begins. We are free, different, and we affect each other, which can be empowering and transformative when we acknowledge and question what might and might not be part of and within our and others' subjectivity and agency, informing and influencing our actions and behaviour, whatever role we perform.

Salka in Sweden: Well put, simply. I mean sometimes that is enough to make a performative space. Maybe we underestimate that simple fact of something being out of the ordinary.

Becky in Melbourne: Spectatorship, performermership, authorship, friendship, relationship, conversationship, transformationship, situationship, nakedship.

-ship: the state or condition of being something; the position, status, or duties of something; the art or skill of something; something showing, exhibiting, or embodying a quality or state; the body of persons participating in a specified activity.

Alice in Berlin: to ship, to shift, to move. Verbs become nouns; nouns become verbs. Ways become whats. To change, to be (the) changing. 'Nakedship' is a state, condition, position, and status, (a) subject/ing to change.

1. The original custodians of this land never ceded it to the colonisers. There is not and never has been a treaty, as such 'Australia' is not recognised by many as the rightful name of the nation.

2. Ovid (43 BC-17/18 AD) was a Roman poet who lived during the reign of Augustus. Enormously popular in his time, today he is best known for the *Metamorphoses* (8 AD), a fifteen-book continuous mythological narrative.

3. Lorraine Code (born 1937) is Professor Emerita of Philosophy at York University in Toronto, Ontario, Canada, and Fellow of the Royal Society of Canada. Her principal area of research is feminist epistemology and the politics of knowledge.

BLOSSOMING
MATURESCENCE

BLOSSOMING
MATURESCENCE

Blossoming Maturescence

> the plants go into rut; the wind
> impregnates them, and their buds swell
> and burst in their time, bringing forth flowers
> and leaves and fruit. I could smell
> the loamy force in the wind.[1]

The tone shifts from the pressure of growth towards
the more tender process of maturing: shimmering,
swarming, shifting formations around the inner
edges of the cells, roaming – no longer racing
or running – right at the rim of nothingness.
Flowing and flocking fields of flowers, winding
waves of wisdom, going upwind, they form
bodies of water entangled with tears, hydro
commons, filled with warmth, sweetness, and
tenderness.
It is maturescence, curling up in intricate texture,
filled by the extravagance of care, revealing light
from undisclosed depths of the reflective skin of
life experience. Cocoon or cradle for the old-born,
these are the luminous years of abundance
and satiety, spiritual vigour and counterbalanced
calm.

A shell formed from sedimentation of what

has gone, scents of what will come, and dead certainty of what won't occur get swept up on the shores of time.

At the threshold where the blooming maturescence takes place one also admits failure and pain to oneself. This intimate process can now also be shown, unleashing the power and significance of standing by failures and pain as polis. The embodiment of imperfections, gaps, mistakes, and accidents won't hurt, neither here nor in other universes.

It is a saturated flourishing state, even if first forebodings of the body's weathering, the wilting of verdure, reveal delicate and needed modifications in terms of effort and engagement. From here it continues at a condensed pace.

^ Dillard Annie Pilgrim at Tinker Creek / Pymble NSW: Harper Collins e-book, 1974 [2007], 114.

PAVLOS KOUNTOURIOTIS

Pain as *Polis*

Spock, (Re)Train, Revolt*

In his homonymous book, philosopher Giorgio Agamben describes *homo sacer* as an entity that is reduced to a bare life where he is not only deprived of being a citizen of the state, but even his very existence, the right to life, is dictated by others.[1] In the state of bareness, the body is only a biological and physiological process without an identity, a meaning, a story. The bare body is something that can be operated, used, tortured, raped, assaulted, opened up, killed, but never sacrificed because it is not pure enough. As such, the bare body has been attributed to refugees, immigrants, trans people, disabled people, people of colour, and other human minorities who have often been subjected to such extreme discrimination that their right to be self-determining of their bodies has been totally removed and handed over to someone else.

There are unfortunately innumerable examples of the *homo sacer* that stretch throughout the history of humanity itself. For example, Dr J. Marion Sims, considered the father of modern gynaecology, carried out excruciating and very controversial experimental operations on pregnant Black women, which he justified by saying that white women could not endure the pain, whereas 'negresses [...] will bear cutting with nearly, if not quite, as much impunity as dogs and rabbits'.[2] Similarly, during Saddam Hussein's reign in Iraq, medical physicians were ordered to hunt down all deserters and refugees and cut off their ears.[3] King Leopold II of Belgium cut the hands and feet of the Congolese Black slaves who

111

resisted him or did not meet the daily quota of production.[4] Very recently in Egypt there were many allegations of the torture of trans people by forced anal examination, rape, and other degrading practices.[5]

Inspecting closely all instances of bare bodies, the common diachronic denominator is pain. As cultural theorist David Morris put it: 'Pain we might say is the universal instrument of force. Force uses pain – or threatens to use it – in order to get its way.'[6] And yet there is also pain that exists and persists daily without the use of any apparent force. In this article, I extend the notion of bareness and *homo sacer* not to a specific body or constellation of bodies, but rather to pain itself. Keeping the focus on pain itself necessitates stripping pain away from other complex situations such as coercion, loss of dignity, torturing, etc., and looking clearly at what is left, the bareness of pain as a universal experience that happens to all living beings throughout the history of time, but also in different situations and spaces (whether in a torture chamber or simply having a headache in the ease of your own living room). By considering the pain of a torture victim next to someone who simply has a headache, by no means am I trying to minimise the horrendous experience of the first. It is undeniable that their pain and suffering is the result of an immeasurable injustice, that of torture and coercion, which needs to be vehemently fought against. In this article, however, I examine the politics of pain itself, not pain as a tool for the exercise of force and power, but pain as *polis*. I examine what role is left in pain if not force, what means are left to deal with pain, whether in torture or elsewhere. By looking at the politics around bare pain, I argue for the dire urgency to (re)train pain perception as a means of political and neuronal revolution.

And what better place to start than by looking into sci-fi?

In the thirtieth episode of the second season of the original *Star Trek* series, when attacked by some malevolent parasitic creatures that take over their hosts' bodies and make them feel pain, First Commanding Officer Spock of the starship Enterprise refuses to take painkillers. For him, pain is essential to his existence: without pain, he would not be the person he is. Painkillers would make him completely forget his identity and he would be subordinate to the parasitic creature that has entered his body.

Pain is a thing of the mind. The mind can be controlled.[7]

Spock explains that the force of the pain exercised over him by the parasite – as a means of coercing him into taking painkillers and consequently forget who he is and enslave himself – can easily be modulated by, or in, the brain. Spock's

solution to the imminent threat that has taken over the spaceship and his human colleagues, who do not know how to deal with their pain, is not to take painkillers but to develop a technique of appropriate mental processing that can allow him to deal with his pain. Contained within the fantastical scenario of this science-fiction television show are serious issues around the use of painkillers and the possibility for the brain to modulate the experience of pain without them.

Despite the series' broad spectatorship, literature around pain in performance (not only in films but also in live and performance art) has focused on the special character of pain on stage, the problematics of staging pain, the difficulty of the spectatorship of pain, and the relation between the audience and the performer.[8] There is a great lack of talk about the ways artists manage to deal with their pain in performance. Indeed, the current literature has identified the socio-political values of performances of self-inflicted pain as a way of bringing serious discourse and attention to the field, has helped to inform the Live Art scene, and supported the establishment of a community of artists whose work carries strong academic, philosophical, and theoretical arguments. But despite the hermeneutic support of academia, there is very little written about being in pain itself (and not about being seen in pain) and ways of coping with pain as a political act. The question that lingers is how Spock manages to deal with his pain, maintain his identity, and save his peers when all had already succumbed to the *lēthē* (forgetfulness) of painkillers, just like Ulysses' peers who eat the lotus fruits and forget who they are and their mission.

Understanding the ways of being in, and coping with, pain without analgesics means seeing pain as *polis*, examining pain's constitutive characteristic: pain influences and affects all beings, their lives and how they manage to lead them. Pain, just like a *polis*, is first and foremost a fortress.[9] Pain is a survival mechanism. We come to it, or rather we are bound to it, in order to survive. It is a defence mechanism designed to help the body defend itself against any permanent damage. Pain is, therefore, not an experience that needs to be alleviated or erased, but rather a bodily privilege that needs to be fortified, trained, and exercised continuously. Without it, our lives are in peril, as in the case of a rather rare, inherited neurological condition called congenital analgesia, where patients feel no pain. They cannot feel the difference between warm and scalding water and therefore get burnt, their tongues and limbs get mutilated when they chew, the tips of their fingers are typically lost through repeated trauma, and so on. In conditions like congenital analgesia, the pain fortress has collapsed or is inexistent. As a result, the lifespan of people experiencing this condition is significantly shortened.[10]

There is no doubt that we need pain to survive. Yet despite pain's benefit to our life, there is little discourse how to fortify and train our pain mechanism. On the contrary, actually, in Western and neoliberal[11] societies, pain has become, by definition, the *homo sacer*: it is reduced to a bare biological process (*zoē*) and needs to be killed and eradicated immediately. Pain does not belong in the realm of politics (*bios*). Pain's meaning and understanding, as well as what to do with it, has been exclusively passed to science and biology. In this state of exception, pain is considered an expression of *phonē* (voice) and not of *logos* (language, reasoning). When pain loses its connection to reasoning and meaning, it becomes the *homo sacer* itself and as such it cannot be sacrificed, only killed. Pain is reduced to *bare life*, simply a biological process that can be explained, interpreted, managed, and administered solely by biology. In the non-Western world, pain has often been considered part of a necessary sacrifice to either come closer to God or find meaning in one's existence, whereas in the Western world, pain needs to be killed. It is killed by painkillers, cleverly invented and designed to make us forget the *archē*[12] and *telos*[13] behind pain's existence. Medicine becomes the great book of interpretation, the gates to inclusivity or exclusivity. And like all gates, it exacts an expensive toll. Pain boosts the pharma economy and, at the same time, robs humans from their own ability to cope with it, to make pain a meaningful experience, an experience of *polis* and *logos*.

Since the reductively biological model for understanding pain prevails, our[14] culture relies heavily on the use of exogenous analgesics. Morris explains that aspirin has in fact so firmly established itself in culture that it is no longer just an over-the-counter analgesic, but rather 'an emblem of our immense faith in chemical assaults on pain'.[15] There is a widespread attitude that a pain-free life is something like a constitutional right.[16] Of course, people in all periods of history have sought relief from pain, but reality has meant that they often found little comfort in the analgesics of their times, had to suffer in silence and become hardened to pain. René Leriche, a surgeon of the early twentieth century, explains:

> Far more than our ancestors, we try to avoid the slightest pain, however fleeting it is, because we know that we have the means of doing so. And, by this very fact, we make ourselves more readily susceptible to pain and we suffer more. Every time we fix our attention on anything we become more conscious of it. So it is in the case of pain.[17]

By so easily relieving pain with exogenous analgesics we have become more sensitive to pain. We have become more dependent on something external to our bodies and, as a result, lost the capacity that our ancestors had to handle pain. So significant is our dependency on these drugs that scientists and cultural theorists speak today of an epidemic of painkiller addictions[18] with great financial costs. These medicines promise that the pain will be eradicated altogether, but the problem is that 'pain, of course did not die. It is so far from dead that it has become a booming business.'[19] The cost of neoliberalism means that big pharmaceutical companies have reaped massive profits by adopting egregious business practices, encouraging prescription overdose. Meanwhile, the number of deaths related to painkillers is skyrocketing. In the USA alone, more than 183,000 people have died from overdoses related to prescription opioids between 1999 and 2015.[20] It is undeniable that the use of exogenous analgesics as a way of dealing with pain has helped soothe some pain and suffering, especially in the case of the terminally ill and those undergoing surgical operations. But the sole use of painkillers over long periods of time has originated new problems in relation to healthcare and pain management and proven itself an overall inadequate method. Another model of understanding pain is therefore necessary.

There is an urgency within our current societies to redefine our relationship with, and perception of, pain because the current Western, neoliberal perception (one that considers pain only through a medical model, as something to be administered to by doctors and killed with analgesics) is inadequate and incapable of dealing with the growing epidemic of chronic pain.[21] 'The pills in a sense just make things worse. Treatment at pain centres and pain clinics often begin with a period of detoxification in which patients gradually withdraw from the host of ineffectual and even harmful medications that they consume, fruitlessly, in hopes of relief.'[22] Something in our understanding of pain needs to change because when the interpretation of pain falls into the medical realm, when cures repeatedly fail, when medical explanations patently fall flat, and when no painkiller can help, we are once again confronted with the ever-present question of how to deal with pain.

In the last few decades, a large and growing body of literature has questioned the purely biological model for understanding pain and explained that the way we express and experience pain varies not only according to genetics and physiology, but, most importantly, as a result of 'learned "hermeneutics": the way we *interpret* our pain',[23] which is influenced by our culture.[24] For example, Viktor Frankl's logotherapy is based on the premise that humans have a will to meaning, which means that seeing meaning in pain can prepare the individual for suffering.

Frankl not only prioritised *logos* instead of *phonē*, he also very importantly identified pain as a prerequisite and interconnected agential module to *logos*: pain demands *logos*, *logos* prepares for dealing with pain.

This dual monadism of pain and *logos* was further concurred in 2007 during Harvard University's Mind/Brain/Behaviour Interfaculty Initiative-organised conference on interdisciplinary research on pain, published in an edited volume of the conference papers called *Pain and Its Transformations: The Interface of Biology and Culture*.[25] The conference and book have been landmarks in the study of pain in that they made the fundamental claim that:

> [B]ecause the mystery of pain cannot be effectively probed merely reductively, it demands a wider interdisciplinary investigation. Ultimately, the solution to the problem requires creative forays into the arenas of philosophy, psychiatry, theological and religious studies, anthropology, literature, musicology, art, and ritual theory if all the dimensions of pain are to be tested and understood.[26]

Enabling a multivocality of *logos* in pain, and allowing for discrepancies in the interpretation of pain, highlights the fact that pain is not only a purely biochemical process in our bodies, but 'rather a complex perception, the nature of which depends [...] on the affective or emotional state of the individual'.[27] This means that when a noxious stimulus is being processed, it is transformed from a simple sensation into the complex mental/emotional events that psychologists and philosophers call perception. 'When we understand pain as perception, we are implicitly challenging the deeply mechanistic tradition in medicine that treats us as divided into separate and uncommunicating blocks called body and mind.'[28] The shift from sensation to perception – parallel to the one from *phonē* to *logos* and *zoē* to *bios* – helps acknowledge that the mind and emotions can powerfully alter the perception of pain and finally, most importantly, highlights the inseparable division between mind and body.

Morris explains that 'all pain – especially all chronic pain – is an interdependent, inseparable, multidimensional union of the two elemental human forces that the Greeks called *psyche* (mind) and *soma* (body)'.[29] In this non-dualist understanding of pain, the processing of pain is essential to the interpretation of the transmitted data and the formation of subsequent data that will be sent from the central nervous system back to the periphery for an appropriate reaction. It is

for this reason that many contemporary scientists have gone as far as to suggest that pain occurs in the brain and not in the periphery of the body. For example, the Penfield Studies are of paramount importance in understanding the role the brain has in pain and pain perception. According to these studies, the subjective experience of pain can be reproduced in the brain without the actual stimulation of the specific peripheral body part. By stimulating the brain electronically, scientists have managed to show that pain, although felt in a specific region of the body, was actually generated in the brain. In these studies, pain is not generated at the site of injury because nothing is happening in that body part. Pain is perceived to be present at the phantom site of injury due to nerve projections.[30] Since pain is generated in the brain, it is both a neurophysiological process and a mental activity. It is mental 'in the sense that it is subjectively experienced "in" what we generally call the mind'.[31] But it is also physical in the sense that nerve cells are activated (and nerve cells and their activity are physical).

Because it is both mental and physical, any work on training pain management needs to deal with the body and the mind simultaneously. Phantom limb syndrome is a useful example that illustrates this point. Following an amputation, the patient reports pain in, and the presence of, the lost limb even though they know the limb is not physically present. This occurs because the limb still exists within the brain's cognitive mapping of the body. The brain sends a signal to the lost limb, but the limb is not there to receive it, so no response comes back in return. Therefore, the brain resends the signal, the process repeats and thus begins a cycle resulting in an overload of electrical signals, creating an alarming perception that the limb is malfunctioning for some reason (experienced as pain). It takes time for the brain to become used to the loss of a limb. Pain management has focused on tricking the brain to perceive that there is still a limb before gradually training it to accept the loss.

The fact that pain is partially culturally constructed, and that our brains are trained to process pain stimuli in specific ways, has several ramifications. It means that since we are trained to perceive pain in specific ways, we can un-train or retrain our perception of, and response to, pain. Moreover, being able to un-train and retrain necessitates understanding the current culture and perception of pain and then finding the appropriate directions for undoing those cultural inscriptions on our bodies that deal with pain perception. Because pain is processed by the brain, an organ which is the product of both culture and biology, any such (re)training needs to attend to both the *soma* and the *psyche*, a point pertinent to the formation of these new techniques of (re)training. These retraining

techniques need to be a combination of bodily, somatic practices and practices that alter brain consciousness. By utilising the actual body as a source of change of consciousness and not the use of exogenous analgesics, the body produces its own endorphins and manages to regulate the perception of pain internally. This shift away from pharmacologically modulated pain perception toward somatic practices that alter brain consciousness does not mean turning back the clock to a time before the discovery of how chemicals like aspirin and ether can alter our perception of pain. It is a step forward into accepting that chemical substances can alter the perception of pain, but rather than using exogenous analgesics, the focus is on building mechanisms for producing endogenous analgesics.

The brain's capacity to (re)train, change, remodel, and reorganise for the purpose of greater adaptability to new situations is referred to in neuroscientific terms as *plasticity*.[32] Contemporary neuroscientific studies indicate that the adult brain can produce new neurons every single day through a process called neurogenesis.[33] These neurons are added to areas of the brain that are crucial to learning and memory and that is how the brain is constantly changing shape. Retraining 'involves the development of entirely new circuits with new and previously unused elements, as well as the modulation of older circuits and connections'.[34] Anatomically speaking, each neuron is connected with other neurons via synapses. Synapses are the points of contact or connection between two neurons. Marc Jeannerod, a neurologist and neurophysiologist who brought neuroscience closer to philosophy of the mind, explained that frequent use of a synapse leads to growth in its volume and efficacy, whereas a synapse used less often loses its capacity to be efficacious.[35] This is what Jeannerod terms 'synaptic plasticity', which explains how the brain anatomically changes its form during the learning process. Furthermore, synaptic plasticity is the actual mechanism of individuation that makes each brain unique despite the commonalities held within all human brains.

> The synaptic plasticity occurring during the learning process, during the development to adulthood, moulds each one's brain. The education, the experiences, the string of circumstances make each brain a unique piece of work.[36]

This transformation of the brain is even visible with the facility of MRI scanners. Today we can trace changes in the brain that occur due to chronic pain or phantom limb syndrome.[37] It is now clear and evident, even through quantitative measures, that the way we experience pain transforms our brain, our perception of our

environment and response to stimuli, and hence our proprioception and sense of identity. Pain is political, since the very definition of politics is that A influences B. Pain transforms our brain. These MRIs are a kind of 'portrait-in-progress' in the sense that our brains are constantly being transformed and the outcome of such transformations is depicted by the MRI images. The MRI scanner can now draw the changes in each individual's identity.

By developing new connections in the brain and dispensing with weaker ones (this process is known as 'synaptic pruning'), the brain transforms and constructs not only itself but also the whole subject and its perceptions, including that of pain. Synaptic plasticity has major ramifications on our understanding of the possibilities surrounding agency of the self, meaning to decide for oneself how to form one's subjective identity and experience. Extended use of exogenous analgesics creates a subject that is dependent on pills, unable to decide for themselves how to deal with pain without recourse to opioids or aspirin. On the other hand, retraining and synaptic plasticity offer the individual self-determination and the ability to form new perceptions of pain according to their will. The core difference between these two approaches is to be found in the distinction that Catherine Malabou, a contemporary French philosopher, makes between flexibility and plasticity.[38] Flexibility focuses on the ability to receive a form, to passively adapt, but not, as in the case of plasticity, to give a form, to 'explode' (if necessary) the given forms and create new ones instead:

> To be flexible is to receive a form or impression, to be able to fold oneself, to take the fold, not to give it. To be docile, to not explode. Indeed, what flexibility lacks is the resource of giving form, the power to create, to invent or even to erase an impression, the power to style. Flexibility is plasticity minus its genius.[39]

For Malabou, modernity currently invests in our brain's plasticity, but attempts to reduce that plasticity to functional flexibility. According to Malabou, we need to exploit more of our brain's capabilities, not just of receiving but *giving* form. Etymologically speaking, plasticity comes from the Greek word πλάσσειν which means 'to mould'. In plasticity, there are three inherent definitions: the ability to *receive form* (in Greek we call clay 'plastic'), the capacity to *give form* (as in the plastic arts), and the possibility to destroy all forms (as in the French word *plastique* which is an explosive substance made of nitro-glycerine and nitrocellulose).

Plasticity is both constitutive and annihilating. As Malabou explains, '[T]o talk about plasticity of the brain means to see in it not only the creator and receiver of form but also an agency of disobedience to every constituted form, a refusal to submit to a model.'[40] In terms of pain perception, retraining and using the brain's inherent capacity to be plastic means undoing the given culture of pain perception and redefining your own perception of pain.

Up until the late 1980s, the scientific paradigm of biological determinism took for granted the idea that DNA constructed the individual, and that their brain (which they did consider mouldable) should be functioning *flexibly*, meaning it exists to merely accommodate needs and abilities as dictated by DNA.[41] This also meant that since we cannot change our perception of pain, we should take pills to temporarily soothe pain and work *flexibly* with it. A radical bio-revolution emerges with the discovery of neuroplasticity, one that confers agency on our bodies: not to the point of being flexible enough to deal with pain through the duration and effectiveness of a drug, but beyond that, to the point when the individual neuron (and subsequently, the whole subject) can mould their identity, forming a new one or demolishing the one imposed on them through external forces.

> A true plasticity of the brain means insisting on knowing what it can do and not simply what it can tolerate. By the verb to do or to make we don't mean just 'doing' math or piano but making its history, becoming the subject of its history, grasping the connection between the role of genetic nondeterminism at work in the constitution of the brain and the possibility of a social and political nondeterminism, a new freedom, which is to say: a new meaning of history.[42]

This neuronal liberation comes with a neuronal ideology. For Malabou, 'retraining' means bringing about a revolution which starts with a relatively small subject such as retraining pain perception, but has ramifications on a whole range of human experience. The revolution in the brain, the revolution in philosophy, the revolution in politics, the revolution in arts: all of these projects can begin with a rejection of the drug-dependent ideology of flexibility that has come to dominate the discourses of modernity and neoliberalism. We need to train ourselves to embody the neuronal, philosophical, and political potentialities of plasticity without any reservations, otherwise we end up falling into rigidity or flexibility.

Malabou's notion of neuroplasticity is very important in understanding the purpose and impact of retraining. Her notion of neuroplasticity functions as a revolutionary explosive aimed at the deflagration of the modern culture of pain and the way the body has been treated and perceived in modernity. In that sense, retraining the experience of pain is not about tolerating pain (which only perpetuates neoliberal economies of drug-related dependencies), it is about liberating the body from the constrictions of such apparatuses as painkillers. Spock was not enduring pain just enough to survive it, he used his experience of being in pain as a weapon to revolt against his oppressors and save himself and his peers.

Choosing neuroplasticity and retraining via the facility of somatic practices that induce altered states of consciousness instead of using exogenous analgesics and purely biological, deterministic definitions of pain means potentiating a nerve that has atrophied and is being stimulated once again. It means that we can all become Spock when dealing with our pain by fortifying pain and its perceptions, enabling the *polis*, rather than alleviating pain or substituting the fortress with aspirin and other pills. This is not a magical new construction, or a *deus ex machina*; the body already holds such sovereign powers that have become dormant through neoliberal culture and its perception of the body and pain. Spock showed us the way, now is the time for the rest of us to (re)train and revolt. (Re)training pain perception means finding the *logos* in and of pain, understanding the political forces at play on our bodies, building upon that discovery to empower the self and the way it copes with pain.

∗ This article often uses some of my discoveries that I made available in my published PhD dissertation (Kountouriotis, 2017) and continues to further explore the political entanglements of pain training in contemporary societies.

1. Giorgio Agamben, *Homo Sacer: Sovereign Power and Bare Life* (Redwood City: Stanford University Press, 1998).

2. Quoted in, M. S. Pernick, *A Calculus of Suffering: Pain, Professionalism, and Anaesthesia in Nineteenth-Century America* (New York: Columbia University Press, 1985), 156.

3. Patrick Cockburn, 'Campaign of Mutilation Terrorises Iraqis', *Independent*, January 13, 1995, independent.co.uk/news/world/campaign-of-mutilation-terrorises-iraqis-1567789.html.

4. Nancy Rose Hunt, *A Nervous State: Violence Remedies and Reverie in Colonial Congo* (Durham: Duke University Press, 2016).

5. Richard Hall, 'Transgender Woman "Tortured" in Egypt Following Arrest for Anti-government Protests', *Independent*, March 12, 2019.

6. David Morris, *The Culture of Pain* (Berkeley: University of California Press, 1991), 184.

7. 'Operation – Annihilate!', *Star Trek*, Season 2, Episode 30 (1967).

8. Jane Blocker, *What the Body Cost: Desire, History, and Performance* (London: University of Minnesota Press, 2004); Rebecca Schneider, *Performing Remains: Art and War in Times of Theatrical Reenactment* (London: Routledge, 2011); Patrick Campbell & Helen Spackman, 'With/Out An-aesthetic: The Terrible Beauty of Franko B', *The Drama Review* 42, no. 4 (Winter 1998): 56–67.

9. The etymological definition of *'polis'* in Ancient Greek is 'fortress'.

10. Clifford J. Woolf, 'Deconstructing Pain: A Deterministic Dissection of the Molecular Basis of Pain', *Pain and Its Transformation: The Interface of Biology and Culture*, eds. Sarah Coakley and Kay

Kaufman Shelemay (Cambridge: Harvard University Press, 2007), 28.

11. Neoliberalism is defined here as an economic theory of the 20th and 21st century which can be most simply characterised in terms of promoting the idea that the economy should be freed from government. Government regulation or other interference in the marketplace (such as state ownership or provision of goods) should be minimised, in order to maximise efficiency. For neoliberalists, success is measured in terms of increases in economic activity (Woods 2010, 4). More than that, it also regulates not only governmental policy but also private lives. As Peter Hall and Michèle Lamont argue, 'neo-liberal ideas promote particular frames used by people to define how they should live their lives, what they are capable of, and for what they can hope' (Hall and Lamont 2013, 18).

12. The *archē* of pain I understand to be the fortification of the body as a survival mechanism that is universal to all beings who can feel pain.

13. By *telos* of pain, I would like to imagine the meaning and purpose each individual could give to their pain, for example, a way to enter into adulthood (as in the case of rituals of passage), reach God (as in the Judeo-Christian story of Job), be considered a man (as in the case of machismo and male rites), inscribe tribal knowledge directly onto the flesh (as in the case of tribal scars and markings) etc. As such, the *telos* of pain is subjective and purely personal.

14. I use the pronouns 'we' and 'our' predominantly to identify what David Morris refers to in his book *Culture of Pain* (1991), and mostly concerned with Western, neoliberal culture, society, and their understanding of pain.

15. Morris, *Culture of Pain*, 61.

16. Ibid., 71.

17. Rene Leriche, *The Surgery of Pain* (London: Balliere, Tindall and Co., 1938), 56.

18. Taite Adams, *Opiate Addiction: The Painkiller Addiction Epidemic, Heroin Addiction and the Way Out* (St. Petersburg: Rapid Response Press, 2016).

19. Morris, *Culture of Pain*, 65.

20. Centers for Disease Control and Prevention, *Prescription Opioid Overdose Data*, 2016, cdc.gov/drugoverdose/deaths/prescription/index.html.

21. Chronic or neuropathic pain occurs when there might no longer be tissue damage and as a result the nerves send the wrong signals and are immune to analgesics. An example of neuropathic pain is 'phantom limb syndrome', where the patient feels pain in the amputated area, although the body part no longer exists, many months after the amputation has taken place and the scars have healed. Where physiological and inflammatory pain both serve a function as survival mechanisms (or in other terms, there is an adaptive reason behind them), in the case of neuropathic pain 'there is no

adaptive function: the pain is the expression of pathology. The pain is the disease' (Woolf 2007, 34). In most of these cases, the painful stimulus has long since disappeared but the pain remains. Being overwhelmed by pain, especially in cases of chronic pain where it can't be effectively treated with drugs, can become a paralysing and totalising experience to the extent where patients can become disabled or pain takes over their personal lives, potentially leading to unemployment and family breakdown.

22. Morris, *Culture of Pain*, 65.

23. Sarah Coakley and Kay Kaufman Shelemay, eds., *Pain and Its Transformations: The Interface of Biology and Culture* (Cambridge: Harvard University Press, 2007).

24. For more information on the matter: Kleinman (1988); Kleinman, Das, and Lock (1997); Morris (1991); DelVecchio (1992).

25. Coakley and Shelemay, *Pain and Its Transformations*, 1.

26. Ibid., 3.

27. Allan I. Basbaum, 'Unlocking the Secrets of Pain: The Science', *Medical and Health Annual* (1988): 86.

28. Morris, *Culture of Pain*, 75–6.

29. Ibid., 158.

30. Howard L. Fields, 'Setting the Stage for Pain', *Pain and Its Transformations: The Interface of Biology and Culture*, eds. Sarah Coakley and Kay Kaufman Shelemay (Cambridge: Harvard University Press, 2007), 42.

31. Ibid., 43.

32. Vida Demarin, Raphael Bene, Sandra Morovic, 'Neuroplasticity', *Periodicum Biologorum* 116, no. 2 (2014): 209–11.

33. For more information regarding the history of the discovery of neurogenesis, see Charles G. Gross, 'Neurogenesis in the Adult Brain: Death of a Dogma', *Nature Reviews Neuroscience* 1 (2000): 67–73.

34. Gross, 'Neurogenesis', 72.

35. Marc Jeannerod, *Le cerveau intime* (Paris: Editions Odile Jacob, 2002).

36. Ibid., 63. The original text is in French and this is my own translation.

37. For more info, see Kountouriotis (2017).

38. Catherine Malabou, *What Should We Do With Our Brain?* (New York: Fordham University Press, 2008).

39. Ibid., 12.

40. Ibid., 6.

41. For more information about a critique against biological determinism as an ideology, see Lewontin (1992).

42. Malabou, *What Should We Do With Our Brain?*, 13.

INTERBEING
ˌɪntəˈbiːɪŋ

Interbeing is a profound philosophical concept that underscores the interdependence of all phenomena in the universe, attending to deep interconnectedness with all of existence. Coined by Thich Nhat Hanh, a renowned Buddhist monk and peace activist, interbeing reflects the idea that nothing exists in isolation; everything is intricately linked in a vast web of relationships. Interbeing challenges reductionist views by emphasising the holistic understanding that all things, living and non-living, coexist and influence one another, foregrounding mutual reliance. It acknowledges the diverse forms of posthuman existence while recognising their underlying shared essence. Awareness of our coexistence with the more-than-human ecology inspires compassionate actions, care, empathy, and responsible behaviour. Practising interbeing means being present, recognising the impact of our choices, and cultivating interconnected wisdom. The concept underscores the importance of addressing systemic inequalities. Ultimately, interbeing challenges the illusion of separation. It calls for a shift in consciousness, calling attention to sustainability, and a more compassionate world that acknowledges the profound truth of 'not two, not one'.

DEATH
dɛθ

Death is the irreversible cessation of life and bodily functions, marking the end of a creature's biological existence. It is a profound aspect of the lived experience, its ultimate biological transition. Death means the permanent halt of vital functions such as respiration, circulation, and brain activity and raises questions about the nature of life, consciousness, and existence beyond death. When nearing death and spiritual transition, navigating these existential challenges with dignity calls for contemplative practices and rituals for staying with the threshold, the transitional zone nesting dreams and visions. Death's enigma (as well as its mystification) fuels human inquiry, motivating us to get to the bottom of life's purpose and impermanence. As an inevitable aspect of existence, it prompts reflection, compassion, and a quest for meaning that transubstantiates biological boundaries. Etymologically, death developed from the verb stem *'die'*, meaning 'to pass away', the ceasing of life in sentient beings, coupled with the Proto-Germanic suffix of *'-thuz'* indicating act, process, condition. The cycle of life becomes a matrix for dignity beyond birth and death, withdrawn from panoptic control.

K.T. ZAKRAVSKY

Passed Out

An Autobiographical Emergency

Selfie with mobile phone, March 2022, © K.T. Zakravsky

1. ACCIDENTAL

Autobiographies.

For a long time, it was a rare privilege to claim an autobiography. Only a few subjects could use the personal pronoun 'I' while telling a story about a human being, a living body – being born and bound to die – they would identify with while telling, or writing, that story.

From the famous canonical autobiography of one Augustinus, written as a 'confession', to Michel de Montaigne's *Essays*, Jean-Jacques Rousseau's confessions, and Jacques Derrida's meta-autobiographical fragments,[1] writing an autobiography has been the privilege of certain educated men who knew how to handle not only the craft of writing, but also the strategies of publication.

If handled well, this appeal to the educated world could result in the inscription of a model biography into a long-term memory, thus making one male individual addressing itself as 'I' a household name, living on long after that body has dissolved into materials having neither a male nor (even) a human identity. There is a certain melancholy, but also a form of poetic justice, to the oft-observed historical law that new individuals and groups – new subjects late to a certain party of power and privilege – cannot simply take over the values, privileges, signs, and tools of status they are about to claim from their previously exclusive owners.

So, one can be as daring as to state that the simple claim of subjects living in female embodiment to write their autobiography just like men did is not so simple. It ranks of the infamous envy Sigmund Freud has taken a certain delight in.[2]

There is one trick to have one's standard autobiographical cake and eat it too: to divorce the narratives, strategies, and immortalities of the autobiography from the sex and gender of its author. The supposed sovereignty of saying the immortal 'I' to that frail body would be an act open to every 'neutral' human being. The fact that predominantly men performed that act for centuries would therefore be nothing but the contingent execution of social power that can be passed on to other subjects in the course of a progressing society.

Well.

It is exactly the claim of a good part of feminism to doubt the neutralised grammar of the first person. So, if embodied women were to enter the telling and writing of 'I' in the course of the creation or invention of an autobiography, this 'I' is not a neutral word ready for the taking. And even if it were – the very use of it as

'neutral', disembodied, abstract, pure, potentially immortal, might bear the very mark of male power and its powerful methods of denying and hiding itself.

Taken to the extreme this could mean that every woman saying 'I' while giving herself a first-person report of her own life would become a 'linguistic transvestite'. She would put on the attire of the other sex, while harbouring the illusion of telling her own story.

The story gets even more complicated if subjects who enter the history of autobiography feel unable to adopt a binary narrative, as a male or female author, of a story in which from birth (as told by others) to death (as not yet experienced and – for all we know – not to be experienced at all) the persisting subject has been assigned one permanent gender he or she fully identifies with.[3]

Indent of those autobiographies of a subject without a stable gender is this one. This autobiography, as episodic, experimental, unstable, precarious as it was and still is, could not understand itself as a case of the great female (performance) artist that became an option to inherit and embody in the twentieth century. It could not become someone like Marina Abramovic or Valie Export. As different as those biographies are from the great genius creator of the male type, this one is still a very different animal. There is no female body, face, image to be cultivated to give a new type of artistic biography a recognisable shape or form.

The female face, body, and image could not be established as the tool at hand to transport a new kind of identity through the cruel thickets of ignorance, scorn, and competition. The apparently most available, most familiar, most intimate assets a woman has to transport herself and write her artistic autobiography – her face, her body, the image of her face and her body – have always been forbidden, tainted, even disgusting fruit to this one.

Does a new subjectivity enter history like an accident?

If those new subjectivities were accidental, it would be a reversal of Aristotelian metaphysics, as the very term 'subject' is the scholastic heir to the permanent 'substance', while the '*accidentia*' are passing properties. Yet as the progressing modern world and its so far unnamed successors are one deconstruction of metaphysical terms, the alliance of subjectivity with the accident and the accidental is as old as the discovery of chance by modern art, from Surrealism to Duchamps, Burroughs, and Cage.[4]

Those men, though, used chance in their art – (an art they often equated to the status of a desired yet objectified [female] partner) – while their own status as the authors of their work and life remained unquestioned.

Female artists, on the other hand, often use their own face and body – and the images of their face and body – as the 'material' of their art. Is it a new effort to link the abstract social power of authorship and ownership back to the accidental, fragile, mortal facts of embodiment? Or is it a new chapter of exploitation, making female artists the smart pimps of their own objectified sexual assets?

The ambivalence remains unresolved, and this one could not enter this track at all. Overweight since the age of seven and suffering from massive gender dysphoria long before there even was a word for it in the Vienna of the 1970s, the familiar strategy of using one's body, sexuality, and sexual relationships to launch a career has never been an option for this one.

Lacking the formal training, institutional support, and social networks necessary for marketing oneself as an 'artist' and getting attention and funding for that extraordinary claim, this artistic autobiography happened, and is still happening, in fragments, in efforts and leaps without consequence, in crazy claims without credit.

One of those episodes was an accident in March 2022, triggered by overactivity on social media and announcements of cancelled trains due to the Corona crisis. The site was a neo-brutalist and utterly ugly and dysfunctional platform of Vienna's new main train station. The local train taking this one to the suburbs where they live was far too short for the gigantic platform. There was an effort to make this heavy body run, ending in a fall on the hard floor, so extreme it felt as though a foot from above had thrust that face to the granite ground, as if that face were to sink through stone to touch the soft earth with which it is supposed to be united in a short while.

Within seconds, a bump, almost as large as a chicken egg, grew from that face.

The selfie is the only document allowing me to claim that accident as an *objet trouvé* in the tradition of Marcel Duchamps – yet in this case the found object is an accident.

I herewith declare my accident a performative work of art, also an event of initiation of which I am not the author but the child. I am, as a working artist, the child of that accident and heir to the treasures it bestows upon me. My autobiography resides in that accident and others (un)like it.[5]

Thus, I have outsourced the (in)stable individuality of that autobiography and am henceforth free to avoid the 'I' and the perpetual 'he' and 'she'.

2. DINOW MARINI

In 2015, there was a round birthday to be celebrated. The artist ZAK RAY, a fluid cloud of trans-identities, 'a transformative unit', lives their performative biography in rituals and irregular events, one of which was a rare gift by the director of the major Viennese dance festival ImPulsTanz, Karl Regensburger. His present was the opportunity of a unique burlesque show in a local theatre, a hybrid event at the threshold of private and public, dilettante and conceptual, in which they got to embody a trans-character of their own creation.[6]

His name is 'Dinow Marini' and his obvious role model is a major member of the Rat Pack, Dean Martin, whose crooning of 'Everybody Loves Somebody Sometime' made the child cry in their garden.

Dinow embodied the seasoned Las Vegas entertainer, teaching all those young aspiring dancers/performers flocking to the city each summer on an educational ticket to not sell their skin for a cent.

Selfie, graphic design © Michael Loizenbauer, summer 2015

And the place no full-bodied genderfluid little monster was ever to enter on an invitation was called 'The Sands Hotel'; grand hotels remain venues of great desire to this one. Intricate allegories are one way to lay burning desires to rest where one so irregular is not welcome to enter. So, Michael Loizenbauer, friend and multi-artist, created those inverted dunes, that queer desert sky, under which Dinow Marini can dream their very own glamorous Rat Pack dreams.

3. FAUN

In the period from 1999–2004, we almost had a proper artistic career. We were touring variations of a solo performance in Vienna, Istria, Berlin, Hamburg, and St. Petersburg. The breeding ground of those pieces was Vazlav Nijinsky's *L'Après-midi d'un faune*, both a canonical dance piece and a score. Using Debussy's music, we created a special choreography using a spotted plaid quoting Nijinsky's costume.

The most amazing version took place on the third floor of a temporary container building right on the Reeperbahn in Hamburg.[7] We went up there, despite our fear of heights, as no other act wanted to perform there. There we made our faun-like, lazy moves on a special spotted bed – the fur spotted with wishes – shouting out to the clients of the sex trade down below that sex is highly overrated.

Video still, camera person unknown, summer 2004

4. ABBANDONATA

So, you have performed a trans-character, a 'drag king' as they say, and the quote of an ancient mythological character, half human, half goat, in total a half god, and genderfluid as an organic consequence of their trans-species – and of course imaginary – identity.

Did you not make use of your face and body, and the images of both, to build an artistic career, just like the Abramovics and Exports you were distancing yourself from before?

What about a fresh new stand-alone asset? What about a spectacular body one has not seen before? We will all be stunned by what the union of medical technology and artistic ambition may soon breed.

They were unable and unwilling to go down that path. Fear and inertia surely played a part, but even more so an understanding of philosophy from an earlier life. The very notion of using one's body like material, like things to be modified according to will and ambition, seems like a major Cartesian fallacy.

They are not sure. Do they respect their body – or all the bodies of all those different periods of their lives – far too much to mould them into a profitable artistic commodity? Or do they want to escape the identification with 'the body', that curse of femininity, altogether?

For sure they do not know any stable 'body' they could permanently identify with. The embodied landscapes, the body pools and body wastelands, the body mountains and body clouds they inhabit never form one solid 'the body' that could be put on a stage or in front of a camera or before critical human eyes.

What you see, and think you may judge, is not me, not them, not us.

That much is certain.

Identity over time, and the memories about ourselves shared by others beyond our lifespan, is produced with the help of media – language and images – that do not do justice to the utterly different ways of an embodied memory.

So, a branch of feminism went into a trap – the search for an embodied (auto)biography and embodied memory got mixed up with an obsession with words about 'the body' and images of 'the body'.

There is no way they could identify their inaccessible, but often utterly joyful, ways of embodying whatever with the norms women apply to themselves by repeating certain words and conforming to certain images.

Yet one thing many women and their kind do have in common – the experience of being exposed.

And that, in a rather phenomenological reading – avoiding all objectivist traps of first forming a distanced concept of 'a body' to then identify oneself with it – is *one* original experience of being embodied.

Or rather: the experience of being exposed – often a traumatic initiation whose memory remains blurred and overwhelming to the point of its eventually redeeming reconstruction – is the very moment when a subject suddenly realises that they have a body others see – and reject.

Only then do humans enter the tedious and unprofitable habit of treating their body, otherwise not a thing in any way separated from 'themselves', as an enemy, a burden, a mass of unruly clay their discipline and ambition has yet to mould into something socially acceptable.

Their traumatic memory of exposure is probably a fictitious scene, a fabricated 'screen memory' overwriting something inaccessible.

A row of naked children, upon entering elementary school at the age of six, are being examined by a cold doctor (male or female) to be classified according to their sex.

To be naked, to be with those anonymous children, to be classified as female, to be identified as one case of the general law of 'female' based on exposed genitalia was the (probably never really happening) start of a biography in revolt.

No, I am not one of that class or group.

Only in retrospect, only from quite some distance, do we pride ourselves on making a conscious choice long after destiny – or trauma – has made it for us.

Being faced with the alternative of hating this unwelcome and soon over-weight body for all my life, thus accepting miserable jobs and equally unattractive partners as my only options, or simply not accepting the female identity at all, I made the choice that wasn't even an option back then, but became one in time.

I became not a woman, or a not-woman.

Today, as an early local case of gender fluidity, preferring to express it in the ways I walk and talk, not making a highly visible spectacle of it, as a younger person might, I feel grateful for the unique time window I got to inhabit. Too old to be one of the new trans-people, also too old to be able to navigate their emerging competition, but young enough to reject a fate as 'woman'. Young enough to rebel against the neo-essentialist cult of the pure biological woman as a homogenous group united by a number of stabile traits arranged around the top-ics of owning a vulva from birth, menstruation, pregnancy, and enjoyment of the receptive part during coitus – and supposedly perpetual victimhood only some odd 'matriarchy' could end – a certain branch of second wave feminism is cur-rently spreading.

Exposure, once again, could be understood as a universal human experience of being individualised. By others, by their unforgiving eyes and cameras.

It always tells the same story, yet staged differently for every body. You look different, you move differently, you walk and talk differently, not like a regular man or woman – you do not belong.

Irregular subjects of all shapes and sizes – many of which born with male genitalia – go through it, are traumatised by it, yet could also become potential new sub-jectivities in a greater history. Being exposed is not the exclusive property of 'women'.

Some may find it both rewarding and noble to fight a feminist struggle while fully identifying with the generic woman being forever shamed and exposed.

Yet to me, to us, to them, it was either death (a social, mental death) or rejecting that female identity altogether – that identification of the female identity with a predestined collective fate of shame and exposure.

We could not and would not live as the perpetual victim.

One way to make sure of that was the study of a philosophy that formed a very abstract discourse on being exposed: the philosophy of Giorgo Agamben's *homo sacer*, the bearer of 'bare life', a generic historical subject in many embodiments who is both excluded and included at the outside by a legal feat.[8]

The philosophical studies that earned me a publication in the context of the 2006 documenta – that would not be hosted by any German-speaking magazine but *Frakcija* (a Croatia-based journal published in English and Croatian) – still also demanded a performance, a concrete embodiment, as the cerebral identity I used to embody did not heal my wounds.

Around this time, I performed several outdoor performances under the heading 'Abbandonata', turning Agamben's abandonment into a tragic aria to be sung on wild fields, such as the one in Odžaci, Serbia,[9] where gigantic mosquitoes made my exposure clearly felt. It was a place next to the Danube, and a former holiday retreat of Tito.

Attached was an acoustic experiment I would wish to pick up again. The voice, and the way it can be heard by an audience, is changing with distance. So, I changed my talk each time the audience came closer, from philosophical lecture to a dialect lament.

The only female role I could embody then was the empress, lonely in her own realm, keeping a safe distance from her subjects.

But her empire was just a wild field – in one case the field opposite the house I live in that once belonged to several people who emigrated during the war. The legal status of that property is so complex, it cannot be sold. It is being managed by an eccentric neighbour who has by now hidden it behind earthworks blocking my view.

Yet to mark the polar tension of my life and habits, I put a TV set on the field, showing a short video I shot in 1999, a puppet theatre with toy soldiers – pirates,

Photographer unknown, 2004

Superwoman, knights, renaissance mercenaries, British guards – while giving a lecture on the paradoxes of 'peacekeeping forces'[10] we first encountered during the 1990s.

That war is still with us, and would come back, is a foreboding the exposed ones could teach the others, if they would listen.

Now we all know.

5. PASSIERT

This series of lecture performances – using improvised spoken text, photos and movements, and sometimes the participation of the audience, ongoing since spring 2022,[11] since the accident – is happening under a ('German') title that cannot be translated.

For that title can mean 'happened' and can also mean 'passed'. It can even, with a hefty Viennese twist, mean 'minced' or 'meshed' (traditional Viennese cooks used to mince meat and mesh tomatoes using heavy iron machinery).

All three meanings are dear to us and important for the project.

The series usually takes place in small, hidden, poorly or unfunded art places run by friends. The performances tend to have the atmosphere of an honourable party clown entertaining rather adult party guests. The neighbourhood of exhibitions featuring mainly photography proved to be favourable.

So, the text being generated on the spot hovers in between memory, confession, sermon, comedy, lament, and critical discourse.

People of a certain age, when talking about themselves and their biographies, tend to refer to their achievements, all the accomplished tasks that form a normative list, some specific to gender, others prescribed for every person who does not want to fall below the threshold of their inherited class.

One mentions all those tasks as successfully completed, as if life were a prefabricated to-do list.

And those many, many people who have either not completed a lot of those tasks or failed at them – not willing or able to lie about it – tend to remain silent in shame.

If their failure lands them in a life as homeless, addicted, sick, or suicidal, only others will speak about them, as a generic problem to be managed.

Being born into minor privilege, as an executive manager's child in a safe and wealthy place – but otherwise not a success, not a woman having had a successful woman's life, no mother and no granny (as many my biological age love to be addressed as) – I should consider myself a failure and keep my mouth shut.

I could refer to being overweight, gender dysphoria, Asperger's syndrome (all of it very true). I could tell stories of massive mobbing, complete ignorance of my talents and needs (starting with my dysfunctional parents) and the typical social democrat ideology of the Viennese school system of the 1970s and 1980s – when submission to some imagined 'class community' (usually dominated by rather violent boys) was all that mattered – and the needs of a daydreaming eccentric just a nuisance to be best ignored or addressed in tedious sermons about said 'community'.

I could do that. It would open up the option of becoming a professional victim performer and forge a career from it.

I wonder – and maybe this would merit some more meta-autobiographical reasoning – why I detest that choice so very much. Is it because the suffering of an oddball from Vienna, Austria, is so ridiculous compared to all the grave suffering in this world? Or is it because the approved 'intersectional' special interest groups of suffering, from 'woman' to non-Caucasian ethnicities or religious groups, do not include the obese, as being obese is still considered a moral flaw, a voluntary choice one reserves scolding for, and not a lifelong disease (which it is in medical terms)?

Do I want to become the advocate of this one victim group so far mistreated and ignored?

No, I don't, even though I reckon that it is high time someone would.

But me, being anyway not much of 'a woman', not identifying what is most real and most alive about myself with 'a body' that can be photographed, not young enough to find satisfaction in social media activism or over-engaged academic or political discourse. Me, not even believing in the function of 'me' and 'I' to keep an autobiographical narrative together – 'I' took another turn, discovering enormous liberty in the fact that 'my' autobiography does not make any sense in the unforgiving eyes of social norms, a certain branch of feminism included.

One could re-define autobiography completely or one could integrate one's times remembered and forgotten into a completely different space-time landscape. One could even do both, as those options are not at all mutually exclusive.

So back to *Passiert* – that series that has so far happened four times in three different districts of Vienna.

One motif defining the work from the start is the use of various photos of my everyday life, my works and biography, one of which is a street scene in the, by now, very touristic city centre of Vienna. I discovered clues in it, as if in my very own version of *Blow Up*.[12] Clues to myself, such as my extended initials. I had to change them from KZ[13] – for obvious reasons my parents had ignored – to KTZ, adding a middle name otherwise not common in Central Europe.

And so, I showed this photography to the audience, saying:

This is my self-portrait as a street.

An act of passing liberation.

Since the third instalment, a new element has emerged: geology.

What might seem random to some (and randomness might in fact be essential to this process) is great solace if not redemption to my autobiographical misery.

Are we not primarily biological entities, and is our life not mainly a biological fact? If so, our main goal would be to prolong the species, to father children or to give birth to them according to our sex – if we happen to be a species of two stabile sexes, which primates tend to be.

When looked at through that lens, my life has not only been a failure, but an ontological scandal. A complete waste of the air I breathed.

Twentieth-century philosophy tends to counter those biological claims with references to human society being somehow 'free' of those biological demands and generous enough to see merit in the lives of childless people who nonetheless are highly functioning when performing certain social tasks.

This does not comfort me. I see humans as profoundly defined by their biological heritage. Everywhere biological claims are making their comeback, as a threat to modern Western democracies, but also as a stern reminder that ideology is not enough to overcome a powerful and defining force such as the imperatives of procreation.

So, let's take yet another strange twist.

Let's acknowledge our existence as natural, biological organisms, but let's also discover our existence as part of a greater universe where interaction between living and 'inorganic' matter plays a major part in shaping things as they have been, still are, and will, for all we know, remain.

Even into the Anthropocene, that new era that has married humanity and geology.[14] From now on, humans are a biological species relevant to geology and geology has entered the short-breathed history of novelty formerly exclusive to human agency.

What would it mean to understand one's life in geological terms? Maybe I do not quite identify with 'the body' or 'my body' as being the essential bearer of my autobiography.

But bones are.

Bones that are, in a way, both too anonymous and too sublime to be in any emphatic sense 'my bones' – I have no special rights to 'my bones' – those bones that I host in such an intimate fashion for all my life, that carry my heavy weight like one patient and reliable set of mules – those bones are, in many complex ways, geological facts. They are made of the stuff the earth, in collaboration with countless organisms and their dead remains, is producing for ages immemorial.

Bones that are heir to all the earth's history, as old as dirt, as old as the earth themselves. They are the perfect hosts of, and witnesses to, this autobiography.

Is this statement a mantra, a prayer, a magic formula?

For certain it is a fact. A fact that awaits to be transformed into a truth.[15] The generous hosts of earth and stone, I adopted as my true parents. My failure in human terms is the open door through which I can enter a zone where geology and autobiography meet.

© Johanna Tatzgern, November 2022

So, on that granite floor the city of Vienna is still using for every new quarter they give to the people, progressing with their obsession of sealing off all their urban projects, one can see me and my bones, one can see us – barely – dance.

Design of photos for this contribution: Jan Lauth

1. Those canonical works of autobiography can all be found online: Augustinus, *The Confessions of Saint Augustine*, Michel de Montaigne, *Essays of Michel de Montaigne – Complete*, Jean-Jacques Rousseau, *The Confessions of Jean Jacques Rousseau*, along with Friedrich Nietzsche's brief parody of a proper auto-biography, *Ecce Homo* (1889). Very dear to my heart starts a 'postmodern' period of autobiographical 'deconstruction' culminating in Jacques Derrida's various works on the subject under that explicit title, see Jacques Derrida, 'Circumfession', *Jacques Derrida*, trans. G. Bennington (Chicago: University of Chicago Press, 1993); J.G. Kronick, 'Philosophy as Autobiography: The Confessions of Jacques Derrida', *MLN* 115, no. 5 (Dec. 2000): 997–1018.

2. Sigmund Freud, *New Introductory Lectures on Psychoanalysis* (London: Penguin, 1933), 158–163.

3. It would be particularly interesting to consider Judith Butler in this context. While already being the defining author of the third wave of feminism, she underwent a biographical transition from (lesbian) woman to identifying as a non-binary personality. It would hold merit to read some of her works with a certain autobiographical edge, such as Judith Butler, *Giving an Account of Oneself* (2005), with regard to the (im)possibility to integrate the queer/genderfluid autobiography into the Western canon of autobiography – or the emerging canon of feminist autobiographical writing (from Simone de Beauvoir onwards), for that matter.

4. Abigail Susik, 'Chance and Automatism: Genealogies of the Dissociative in Dada and Surrealism', *A Companion to Dada and Surrealism*, ed. David Hopkins (West Sussex: Wiley Blackwell, 2016).

5. The understanding of biography being mainly a matter of (accidental) happenings or occurrences and thus subjectivity being the effect of the processing (overwriting and denying) of that accidentality of existence I owe to Martin Heidegger, Giorgio Agamben, and more recently Brian Massumi. See: Massumi's *Semblance and Event: Activist Philosophy and the Occurent Arts* (Massachusetts: MIT Press, 2011).

6. The performance was connected to a concept-performative experiment with fan culture on the occasion of the cult around BBC's *Sherlock*. I posed as a trans-man cosplay double of Andrew Scott's Moriarty (in his disguise as the 'IT guy') at a fan fair in London and managed to get my/our photo taken, consequently editing it and declaring it a conceptual art piece and tool for P.R.: *Zak Ray M.A.D. THE PERSONALITY SHOW*, ImPulsTanz Vienna, 2015. See also the work *MUMOK Troll* at the same festival that summer.

7. See also Irmela Kästner, 'Tanz in Containern', as e-books on gutenberg.org. *Tanzforschung 2010: tanz vermittelt – tanz vermitteln* (Leipzig: Henschel Verlag, 2010). The Faun can be seen at the start of the clip 'Tanz in Containern IV' (vimeo.com/39043467). The video still by Jan Lauth has been taken from 'Tanz in Containern II' (vimeo.com/39043533).

8. Giorgio Agamben, *Homo Sacer: Sovereign Power and Bare Life* (Redwood City: Stanford University Press, 1998).

9. In 2004, Nenad Bogdanovic organised a special performance festival in Odžaci, Vojvodina, Serbia. The small photo, edited by Jan Lauth, has been taken from the website: imaf-festival.weebly.com/imaf-2004.html.

10. Here, that screen image has been replaced with a double body under the full moon, a photograph using long exposure taken by Radek Hewelt for the project *Passenger Diaries*, performed with Mariella Greil (May 2021, edited by Jan Lauth). See also the project website/blog edited by Viktor Fuček: passengerdiaries.uni-ak.ac.at.

11. *Passiert III* left a trace on the internet, as it was part of the Rotlicht Festival at the Viennese art space toZomia, whose theme of sedimentation enforced my turn towards geology. Special thanks to Johanna Tatzgern and Ilse Chlan, performance/photo artists whose work created a favourable neighbourhood. The photo is from this event in November.

12. Michelangelo Antonioni, *Blow Up* (1966).

13. 'KZ', the abbreviation for concentration camp (*Konzentrationslager*), invokes intense negative emotions in a German native speaker. As a scholar of the national socialist camp system (I felt myself obliged to become one around 2005–2008, not only because of my initials), I learned that this abbreviation, which does not really make sense, was used by the inmates while the Nazi administration used, as would be expected, 'KL'. So, even within a reference to the most horrid regime of terror, I was served the more subversive and clandestine version.

14. I owe my existential, artistic, even spiritual affinity to geology to Marcia Bjornerud's amazing book *Timefullness: How Thinking like a Geologist Could Help Save the World* (New Jersey: Princeton University Press, 2018) and the amazing work of Jan Zalaciewicz, who unites profound expertise in geology with the emerging philosophical demands of understanding our epoch as the 'Anthropocene', thus leaving all variations of yet another 'modernity' behind for a break in the timelines in which we try to integrate our biographies.

15. See Elizabeth A. Povinelli, *Between Gaia and Ground: Four Axioms of Existence and the Ancestral Catastrophe of Late Liberalism* (Durham: Duke University Press, 2021).

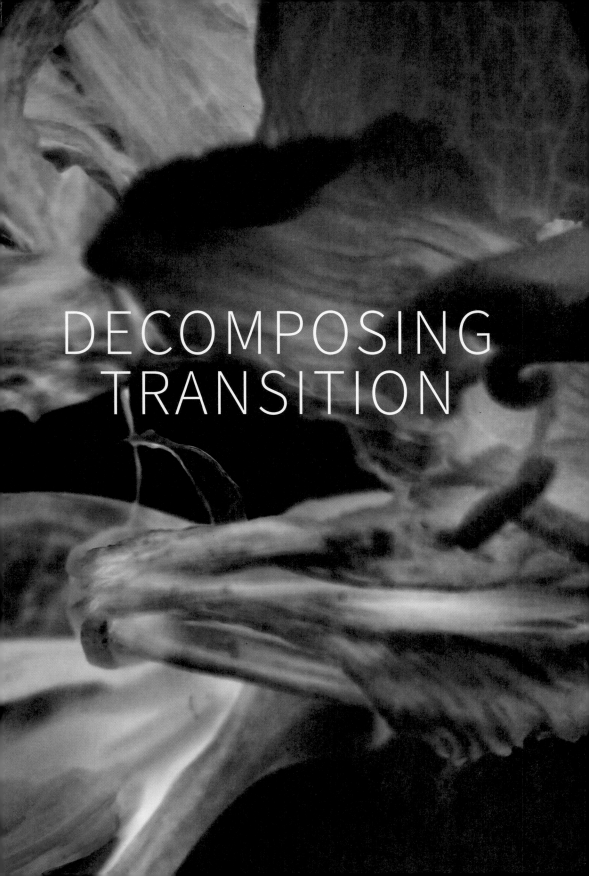

DECOMPOSING
TRANSITION

DECOMPOSING
TRANSITION

Decomposing Transition

This is our life, these are our
lighted seasons, and then
we die.
(You die, you die;
first you go wet, and
then you go dry.)

Uncovering another kind of beauty, swelling
fainter and deeper and then fading out.
The shadows became longer, decomposing more
insistent, it was like emphasising the slowness,
subtlety, and poignancy of dying. Arriving
halfway in the past had made me remember that
tomorrow my body will have been digested by
protostomes. The sunlight makes movement, tenderly
caresses the sluggish dance of geological layering.
I was frozen in the encircling of grief and disgust—
where have you gone?
Faced with choking fear and entangled frostbitten
bodies, inhibited to transition, my senses were in
denial, then welled tears in my eyes. Musty scents
enlighten the autumn, fermenting gut and
rotting skin escort the light in the veins of
transcience. Splinters of the spirit stuck between
the wings of the lungs, breathing out weathering

of burning feelings, tuning in to bulges of love.

The membrane absorbs the vibrations, makes space
for processes of degradation. It is a form of
dismantling nutrients, earthy truths gingerly
tended, manifesting muddy metabolism in
blossoming environments.
An ecology of decomposing transition from
life's exhalation to earth's spell is a
transformative enchantment, revealing
relinquishment and abandonment.

Incantation.

1 Dillard Annie, Pilgrim at Tinker Creek (Pymble NSW:
 Harper Collins e-book, 1974 [2007]), 129.

HEBA ZAPHIRIOU-ZARIFI

Frozen Bodies, Frozen Lives*

*Even though I walk through the valley of the shadow of death,
I will fear no evil,
for You are with me;
Your rod and Your staff, they comfort me.*
– Psalm 23:4

My title for these reflections on a contemporary atrocity, 'Frozen Bodies, Frozen Lives', is not a sick joke because what will follow is not about cryonics, the contemporary pseudoscience of deep-freezing bodies of the deceased in the hope of reviving them in some future. This is also not about the absurdity of that, of spending thousands of dollars to preserve anyone's body in order to enable that person to sleep through the apocalypse until a glad wakeup call invites him or her back to a new era of judgement sometime along the timeline into an optimistically augured new era. The technology of freezing bodies in liquid nitrogen in the hope of their resuscitation past doomsday is not the subject matter of this piece, and its title is not squeezed out of that sad phenomenology. Nor am I even competent to write about sci-fi experiments where death is simply negated, and the conservation of bodies is pursued as a defiance against the usual separation from life.

Nor is this a psychiatric enquiry into the frozen lives of those who, like Frankenstein's monster, crave the warmth of human companionship. And it is not, except tangentially, a study on the complex neurochemical reactions of body-brain connections, though both issues are relevant to the topic of this paper. To 'freeze' is, of course, one of the natural adaptive defences triggered by the onset of a traumatic encounter: like 'playing dead', it is a self-protective instinct to remain motionless when facing a life-threatening danger or overwhelming fear. This text is not so precisely concerned with these lifesaving defences, nor will it attempt to limn the processes of 'melting' the frozenness by sequential discharging of stored-up energies that are released through a painful but conscious reconnection to the normality of embodied sensations.

Rather, 'Frozen Bodies, Frozen Lives' is an investigation into the narrative I would nominate to be called '*Bare Bodies*', the free spaces that open when a body is given centrality and all of its *personae* are stripped away. It is a recounting of untold stories of stolen corpses of murdered or previously imprisoned Palestinians, and an account of their families' lives lived in

143

the shadow of the dead. Those who remain as unburied corpses kept, quite literally, in freezers at the border of occupied zones, are locked in liminality, hovering in spaces between life and death whilst epitomising the memory of the dead as though alive to protest their posthumous fate. The Palestinian poet Mahmoud Darwish, who loved life, in a conversation on death gave an example of living between the two: 'The news bulletin did not say that I am dead. That means I am alive.'[1] 'Frozen Bodies, Frozen Lives' is an attempt to articulate some of the darker practices of the settler-colonial occupying State of Israel that weaponises death and the dead bodies of indigenous Palestinians to serve, directly or indirectly, its ethnoreligious and geopolitical gain. The bodies of the indigenous, no longer belonging to any self or state, are trapped in closed spaces not of their own making. Incarnating both personal and collective identities, the collectively dumped and frozen Palestinian body becomes, in the eyes of the state, the seat of its enacted biopolitics of supremacy, as well as the stage of its outright war of colonial expansionism. Palestinians, having been denied the life of the ordinary, are equally not allowed an ordinary burial. The massacres, the banishment, the calamity, the confiscation of land, the agony of the soul and the yearning of those in exile, are part and parcel of the extraordinary lives of bodies that are coldly lying unburied in a new state without borders, the freezer.

Let us give therefore a more normal context that we can discuss with psychological precision. The human body is the first delineated 'border' to be acknowledged when entering into contact with another bodily inhabited space. The establishment of a healthy boundary sets a limit between the acceptable and the intolerable. The body thus enables a dialectic between entanglement and disentanglement, a dance between the opposites with the body as its still point. It incarnates the political in-betweenness

that sets apart and unites what otherwise violates the body in macro and micro abuses. It is the body, as the person in its entirety, that suffers enforced enclosure, incarceration and torture when boundaries are removed, and the border of a political tug-of-war is enacted over the individual body. The body becomes the political map onto which lines of abuse are etched as borders, walls, gates, fences, checkpoints, ID cards, policed profiling, paranoid panopticons, morbid freezers, as well as the separation line between the living and the dead-alive, at the threshold of life and death. For every aspect of the living there is a demarcation that defines its contour and marks it off as an integral space alongside other spaces. The dead-alive has indistinct, ill-defined contours with one foot in life and the other in death. A timeline is a boundary set between the start of a life and its end, and it appears that even abstract concepts or ideas have boundaries. Wittgenstein could emphatically proclaim that the boundaries of our language are the boundaries of our world.[2] Whether structural to our world or simply the organising activity of our mind, boundaries are 'traces of time inscribed in space':[3] they reveal an identity or erase it.

'Borderising' – Achille Mbembe's word – Palestinian bodies comes as a compensation for Israel's violation of its 1967 internationally recognised borders. It is symptomatic of a state-without-borders establishing its boundaries through a systematic encroachment on Palestinian bodies, impressing its undetermined borders on the borders of determined bodies. Palestinian bodies are subjected to being pawns in the hands of a megalomaniacal endeavour of extrajudicial expansionism that reaches over and beyond the state's recognised borderlines. Israel's appetite for power wolfs down Palestinian bodies in an overwhelming show of all-consuming domination, breaking thresholds of physicality, moral decency and the ethics of politics. Its policy of withholding the bodies of

murdered Palestinians is to remove borders, an abstraction of a reality from within its reality. It aims at exercising a divisive ethnoreligious elitism by dictating who is considered 'in' and who is 'out' of an ever-shifting, undefined Israeli border. Borderising Palestinian bodies enacts Israel's attempt to legalise its illegal intrusion into Palestinian borders. By breaking the limits of its own borders, Israel breaks the integrity of the Palestinian body, 'borderised' in lieu of Israel's absence of borders. The persecution and destruction of the Palestinian body and its removal from geography uncovers Israeli settler-colonialism installed to the detriment of the Palestinian right to exist on their own land, an endeavour repudiated by international law and all human rights organisations, including Israeli organisations such as B'Tselem.

This highlights Israel's illegality as it breaks the legality of its recognised borderland. The illegality of its policies toward the indigenous Palestinians, whose land it has been stealing since the 1948 *Nakba*,[4] is enacted on the bodies of Palestinians stolen and, like the land, so far not returned. Removing borders in geography removes boundaries in the mind. Israel finds itself able to do both. That is its tragic victory, which legitimises further acts of violence. 'Borderised' Palestinian bodies stand at the crossroads between two axes: a horizontal axis geographically and its continuum through the human body, which is violated, removed, and replaced. The intrusive militarised occupation of Palestine is an invasion of the sanctum, the privacy of the body, home, and land. On the vertical axis the violence is structural with repressive, exploitative, and alienating policies exacted on indigeneity, considered lower in the pecking order, dismembering and fragmenting it into disjointed entities with the prospect of dissolving it entirely. After the guns go silent, the roaring noise of pain multiplies in spaces internal and external that extend over the generations. It is not just the lack of equality, but also the lack of equity between occupier and occupied that fuels this violence, which continues with impunity.

Spaces of movement collapse as spaces of liveability are invaded, controlled, and segregated. Spaces of encounter among the indigenous are fragmented, dismembering the collective body into a disjointed mass of uncoordinated elements. A community consists of breathing, moving, creative human beings; under occupation the collective body is restricted, crushed, objectified. Palestinian men, women, and children alike face incredible levels of physical injury, from micro-aggressions to the amputation of body parts. On a daily basis they are exposed to prodding, poking, beating, being spat at, blindfolding, kicking, burning, freezing, torture (psychological if not necessarily physical) – all blatant signs of a power that has lost its power and is yielding to fascism, in the case of Israel into a fascist theocracy as has been warned by Tel Aviv's mayor Ron Huldai. Holocaust historian Daniel Blatman warned in 2017 that Israel was hurtling towards fascism.[5] Now he proclaims that political fate has already arrived under the government of a populist leader. In 'Israel at 75: Fascist, Apartheid and Genocidal Watchdog for U.S. Imperialism', an article by Richard Becker, he clarifies that 'the term "fascist" is not used here in a hyperbolic or exaggerated way. The favourite chant of Israeli fascists is: "Death to the Arabs".'[6]

The level of hatred toward the Palestinian person is expressed in multiple aggressions to mutilate, diminish, humiliate, and ultimately annihilate the Palestinian body with further oppression. Palestinians are resented because they stand in the way of Israel's ambition to exist, on its own, in a land that was always destined to be shared in a multi-confessional, multi-religious mosaic of beliefs. In order to live only among Jewish people, whoever is 'othered' must be treated as a living-dead, meaning a life that ought to be dead. 'Slow death' is what cultural

theorist Lauren Berlant calls the gradual and persistent process of such elimination.[7]

Stealing dead bodies inflicts tremendous psychological suffering on the remaining occupied population, like a slow death on a backburner or a broken heart held in sutures. Piece by piece, blow by blow, the pain decimates life, health, and pride to magnify the shame. Seasons pass, years as well, but the feeling remains the same, of a heavy heart and a torn-out breath. The sky is always clouded even on good days. The sorrow lifts every now and then, but even in small ways it still remains – like a nightmare that never ends or a bad song that can never be sung. It is like a bitter taste at the back of the throat. The memory of the absent haunts the present. In absence-presence those affected families live their lives. In waiting.

The not-knowing splinters the familial and social fabric to bare bodies shredded out of humanity. The geography of the land is missing. How to revive the memory of the deceased without the land? How to embody affective practices if there is no space of safety in heavily militarised, undetermined 'zones' of living? To remember is to put together the members of a broken body, to continue to bond despite the absence and the lack of presence. Palestinian cemeteries are desecrated: bones are unearthed by bulldozers rampaging through Palestinian cemeteries to excavate more land for ambitious Israeli plans. How can the living be at peace if the dead cannot? In the absence of safe-spaces and space-of-temporality to mourn, lament, and grieve, how can a healthy closure occur? The oozing wound needs rituals of grieving to join the flesh and heal. How does bereavement for the personal and communal occur in the absence of a 'third' emotional space for weeping: a tomb, a cemetery, a memorial for the martyrs, a body to cry over? Songs of absence and songs of lament carry the memory of the absent to a resurrected present, in spite of absence. 'I mourn, therefore I am' is Derrida's take on death and mourning.[8] He articulates a new model of mourning as an ongoing conversation with the dead who are within us and beyond us. Palestinians continue to converse with their dead. They place the picture of their deceased in a focal corner of the house where an ongoing conversation continues at the threshold. The living look unto the dead as though to guide and safeguard their living spirit, and the dead look onto the living with an incessant call to 'responsibility and transformation'.[9] It is an incumbent responsibility on the living to demand the perpetrator take responsibility and transform the conditions which made such killings possible. The dead are alive, and so are the absent. Until the bodies of the martyred deceased are recovered, they remain alive through songs and memory and endless waiting. Yet, in their absence, the life of the living is frozen in time.

Israel legalises its detention of Palestinian bodies to contextualise, through jurisdiction, the withholding and/or freezing of murdered-then-abducted bodies. Not to know the whereabouts of the body of the deceased martyr is a psychological torture that gnaws at the lives of those who continuously search without finding. Some bodies have been withheld for as long as thirty years. This reveals the violence brought into the sacredness of life and death and the cruelty of ungodly behaviour. Jewish tradition is very clear that the human body is considered sacred and holy, as sacred in death as it was in life. It even suggests that the human body is the vessel for a holy human life. How to reconcile this tradition with the 'Jewish State' policies toward the body of Palestinians without admitting the racialisation of the human body that Israel so overtly justifies with a caste system of Jew and non-Jew? In the absence of being Jewish, the 'other' is a non-entity, a no-body. The Jewish tradition considers the deceased's soul to be stuck in a state of turmoil unable to find rest until the body's remains are given a proper burial and allowed to be absorbed into the earth. Furthermore, the tradition states that the burial affects

the final peace of the soul and should never be treated lightly. With such beliefs in mind, the 'Jewish State' needs quite a set of rationalisations to behave with such indignity toward Palestinian bodies, leaving them de-sacralised and even de-god-ified. Isn't this a desecration and dehumanisation of the Jewish tradition? The moral bankruptcy of the state is such that Israel needs to re-evaluate the grounds on which it dares to call itself a 'Jewish State'. With not-yet-even skeletons in its border freezers, Israel is perhaps in need of *Tahara*, a cleansing of its system before it can claim the sanctity of bodies. It most certainly needs to learn to respect the guarding of the deceased body until its burial, before it undergoes *Shmira*, the watchful care over the corpse. The use of Palestinian bodies for so-called 'negotiations' or 'political bargaining' is an aberration of the Jewish tradition and the unmasking of Israel's inhuman and degrading treatment of 'non-Jewish' bodies. In another poem, Darwish reminds the Israelis that they have a common enemy with the Palestinians: death. He writes:

(I said) And then what?
What then? (A woman soldier shouts)
You again? Haven't I killed you?
(I said) You killed me, and like you,
I forgot to die![10]

The macabre policy of the state unleashes anxieties, unremitting anguish, sleepless nights, and a degradation in the mental and physical health of bereaved families.

I dream of my son every night, calling my name, calling to release him from the freezer box in which they stored him. I wake up searching for him, calling his name in the hope he will answer. I go back to the street where I last saw him. He was on his way from school.

'I am unable to work, or think; I live in waiting for the return of my child's body. My life is frozen in time, as is my son, frozen in the army's fridges,' cried a young mother. 'This is a form of collective punishment that amounts to war crime,' continued her husband. As I heard him speak, I was reminded of the legal philosopher's words: 'No one who is innocent of wrong may be punished for the wrong done by another.'[11]

The occupying state militarises the natives' natural processes of mourning in the face of ultimate separation by death. The state usurps a central role by monopolising control over the lives of Palestinians and extends its arm beyond the border into death and even beyond the grave, stripping the already bare bodies of Palestinians into inhumanity. In occupied East Jerusalem, burial permits are imposed and travel permissions are adjudicated whilst physical barriers are set up to impede the natives' traditions of grieving and burial rites. The ultimate slash is on this psycho-spiritual aspect, given the encompassing Judaisation and Israelisation of all aspects of life. 'Even our beloved dead cannot escape Israeli violence,' a bereaved father explained.

'We cannot kill the hope of seeing our son again, nor can we kill the anguish the absence of his body causes,' lamented the mother of a recently killed and martyred son. Palestinian rituals of interment are tampered with, if not altogether aborted. The occupying state ensures that Palestinian lives are kept on hold, and spaces of grieving are retained in 'a liminal zone of non-burial and non-closure'.[12] The withholding of bodies was originally set during the British era as 'Defence (Emergency) Regulations, 1945' (Article 133-3), but Israel as the occupying power violates its obligations under international law. 'The families of the deceased have the right to be informed of the fate of their relatives.'[13] Israel has set 'inconsiderate, restrictive, and degrading conditions on families to receive the bodies: paying deposits, restricting the number of participants at a funeral, and the requirement for

the immediate burial of bodies following their release'.[14] But how can a frozen body be buried straight out of a fridge?

Bargaining and delaying, then refusing to give a date, then delaying again is a psychological warfare tactic aimed at affecting the emotions, reason, motives and behaviour of targeted Palestinians. Loading yet more unbearable pain onto their suffering, this invisible torture of the hearts and minds of those who care about a body trapped unburied in a state freezer is employed to destroy the morale of an entire family, if not community. A ploy in the hands of the state, it is yet another tactic to confuse and depress. Many Palestinians refer to this degrading treatment as psychological warfare. Israeli newspaper *Haaretz* revealed that '*Abu Ali Express*' on Twitter and Telegram purportedly concerned with 'Arab affairs' was run by an Israeli 'psychological operations' consultant for the Israeli army, circulating misinformation to manipulate and disinform, degrade and discredit.[15] Refusing to inform parents or partners on the status of their abducted or stolen loved ones is an invisible warfare tactic with visible consequences.

A man in his forties insisted on talking to me when he heard I was enquiring about the suffering of bereaved families. He confided: 'I received a phone call from the army demanding I drop the court case with regard to my son's abduction in exchange for delivering his body.'[16] When prompted to explain, he clarified that the court never rules in favour of Palestinian families. 'All they're trying to do is to avoid a court ruling that would set a precedent against the Israeli policy.'[17] Needless to say, the father immediately dropped the case, and Israel got away with the crime. But the returned body was not his son's. The returned body was 'a mistake'.

It turned out, he explained with constraint in his throat, that the returned body had never been identified. It meant that the family of the 'mistaken' body had no idea that their son had been killed by force and his body had been withheld. They'd been living for years with the hope that he was alive. The grief mixed with confusion and the anger with relief, all erupting as the man and his family realised that, had it not been for the 'mistake', they would never have known the truth about their son's fate. But to know that he'd been dead for so long whilst they had lived in expectation of his reappearance shattered the years of waiting into a black hole. The shock caused ripple effects and their lives were lost to meaninglessness and depression.

Since 1967, Israel has withheld hundreds of Palestinian corpses and, in more recent years, the bodies of Palestinians from Gaza, the West Bank, and East Jerusalem.[18] Human rights groups affirm there has been a significant rise in the abduction of bodies since the 2015 'al-Quds' uprising. 'More than 80 Palestinians were killed and their corpses were held by Israel in freezers. Fifteen of these corpses belonged to women and girls.'[19] Soon afterwards, the occupying army began holding bodies in morgue fridges, clarified a human rights activist.[20] The distraught father of a Palestinian child told me:

> My fourteen-year-old son was neither a militant nor a freedom fighter. He was only a child who loved to ride his bicycle. He was shot and killed. His body was unjustifiably retained for a month. I soon realised that my story was part of a phenomenon of the Israeli army's behaviour. I was shocked. I was shocked to discover my family is part of a phenomenon.[21]

Moreover, the state even sets rules over bereavement ceremonies and funeral processions for the Palestinians of East Jerusalem, imposing restrictions on the place and time of a funeral, often demanding it be held at night. Limitation on the number of attendees is also imposed with hefty penalties if breached. Palestinian graveyards are 'hotspots' of Israeli criminality toward the dead and disrespect toward the spirit of the dead. In

Criminality in Spaces of Death, criminology Professor Nadera Shalhoub-Kevorkian exposes how 'land and its relationship to political identity remain at the heart of the encounter between colonizer and colonized'.[22] The geography where the dead are buried is the primary force shaping this relationship between the Israeli state and the Palestinian dead. The Israeli policies and court decisions that have enabled the state to withhold Palestinian bodies 'have formed a legal corpus that regulates Palestinians after death', conclude legal scholars Noura Erakat and Eghbariah Rabea.[23]

The structural violence of the occupying state expropriates not only the living but also the dead by controlling their burial sites[24] in a 'continuous structural violence predicated by the occupying colonial power'.[25]

Under Israeli military occupation, the Palestinian body is blurred into a non-entity, a discontinued, undefined space to be punctured and pierced. To be alive is to be able to move freely and wilfully exercise one's mobility rights. Freedom of movement is enshrined by the constitutions of numerous states, in international law, and the Universal Declaration of Human Rights.[26] Yet the Palestinian body is caged in, impeded in restricted, fragmented spaces, blocked, obstructed, tracked, chased, hunted. In extrajudicial killings it is captured, abducted, snatched, concealed, frozen, dispensed with. Those multiple militarised strategies put in place to impose the strictly bare minimum on Palestinian human rights and dignity turn the Israeli Basic Law: Human Dignity and Liberty into a joke given its declaring: 'there shall be no deprivation or restriction of the liberty of a person by imprisonment, arrest, extradition or otherwise.'[27] With its unwillingness to uphold its own law, the judicial system might as well be overhauled, and the Supreme Court neutered, as we witness acts done by the far right, the most far-right government in office, in flagrant breach of its own limits. At the end of life,

Palestinian bodies are 'discounted bodies [...] believed to contain no life as such'.[28]

Controlled at gunpoint by the military and their frequent imposed curfews – about 106 permanent, plus some random, checkpoints set even between neighbourhoods – bodies are subjected to perpetual harassment. The tortuous and massive separation wall, meant to split Palestinian bodies from other Palestinian bodies, splits families apart with the father on one side of the wall and the rest of the family on the other. Draconian surveillance systems use social media to track posts and personal data, cyber high-tech and artificial intelligence loom over every house, courtyard, street and quarter, at every corner, school, playground and market, freezing altogether the movement of the native population and thus blurring the lines, even of decency.

With the high-tech Israeli electronic surveillance system, the state no longer needs boots on the ground to coerce the occupied population; it can do it remotely through artificial intelligence, the surveillance system, and mobile phone devices. The surveillance system functions like a predator of human flesh. Insatiable in its appetite to devour, it hunts to kill on the spot, paying no heed to the possible unreliability of electronics. Francesca Albanese, the UN special rapporteur, describes the arbitrary deprivation of liberty from Palestinians as a key instrument of Israel's domination and oppression: 'The reality captured is of an entire occupied population framed as a security threat, often presumed guilty, and punished with incarceration even when trying to exercise fundamental freedoms.'[29] Palestinian occupied territories are subjected to a constantly 'surveyed open-air panopticon'.[30] The state uses technology for a perpetuated carceral continuum. It leads a 'criminal' lightly to the crime scene, then hails the armed perpetrator as hero. With an absolute power to kill, backed by artificial intelligence, the murderer is sovereign in a state founded on theft. This

added layer of Israeli intelligence penetrates the inner world of Palestinians with an added sense of claustrophobia, already encircled as they are and monitored by land, air, and sea in the case of Gaza. Fear of the external world, gripped by a tight fist of constant uninterrupted surveillance, bodies freeze for lack of free, unabated movement. Permanent surveillance has an insidious power; it aims at invading the body. Its porous skin is saturated with multiple eyes that observe the Palestinian body from every direction, bashing its contours with the intensity of a paranoid eye of the state. It fixes and seizes whatever it sees. Installed and activated at every angle, its power is introjected into the body-mind of the observed, instilling a frozenness that trauma from perpetual fear causes. Self-surveillance is a direct consequence of such pursued and tracked bodies. To be seen not through the eyes of a beloved, but scrutinised by the persecutory eye of a sweeping onlooker that captures the viewed in a shot that entraps within the closed room of a propensity to crime. 'L'enfer, c'est les autres' ('hell is other people') is Sartre's punchline in his one-act play Huis-Clos (No Exit),[31] of trapped people behind 'closed doors', or 'in camera' as referred to in jurisprudence. 'We use the knowledge about us which other people have and have given for judging ourselves,' explains Sartre.[32] In whatever I feel or think about myself, others' feelings and thinking always enters. Judgement has no exit; it only condemns. To know oneself through the distorted view of others is hell itself. The Palestinian is judged as dispensable, and hell is the knowledge that as Palestinians they can be dispensed with. The intrusion of surveillance under the auspices of 'security' in the quotidian context is central to maintaining the colonial endeavour of a state that keeps growing at the expense of the Palestinian other living with the bare necessities. To the 'security' leitmotiv of Israeli militarised expansionism, the 'freedom' of Palestinians is sacrificed. It is well known that in many settler-colonial regimes, Israel

included, the acts of seeing by documenting and persecuting by withholding information create unbelievable tension. The aim of possessing this information is to invisibilise individuals by owning their data, and as a consequence to erase the 'subject' in their subjectivity with surveillance rather than an encounter with the real.

What Jacques Lacan identifies as *Tuché* (the Aristotelian idea of *cause*), the traumatic encounter with the real, is in fact a paradoxical form of missed encounter with the real. The reality of the Palestinian body as subject suffers a missed encounter with its reality, a misreading of its reality and content. The naked truth of its authenticity is regarded by the man with the camera and the gun as an object with no content. Antonin Artaud understood the body as a holistic unit identified together with its life force and consequently both demand an ethics of life that preserve the body and refuse to instrumentalise it.[33] A '*corps sans organes*' (body without organs)[34] is a body emptied, with no language to give it reality, a predetermination that eliminates the body's reality. But some of the families of martyrs live with the horror of suspecting that organs have been stolen from the body of their dead, and 'body without organs' takes on a different meaning. There was news that organs were routinely stolen from Palestinian bodies, such as the case at Tel Aviv's Abu Kabir Forensic Institute when, during the 1990s, the unauthorised removal of organs, bone, and tissue took place.[35] Israel has become increasingly involved in the world transplantation industry in the last decade.[36] According to a 2015 European Parliament report, Israeli physicians and patients played a major role in the international organ trade.[37] 'A number of organ trade networks were uncovered in Israel but, until the 2008 legislation, the subject was addressed officially only in circulars issued by directors general of government ministries.'[38] Organ trade since then has increased in neighbouring countries, and Palestinians live with the ghost of not

knowing for certain whether organs had or had not been removed.

Effaced identity etched by the politics of erasure over a frozen human body is a frightening sight to see. It is a disfigurement of the human body into something inhuman: a ravaged body with a tragically deleted identity. 'Ungestalt' (amorphous) is a term used to describe the deformed bodies of the dead in battlefields. Freezing bodies of 'suspected' Palestinians at -40° actively deconstructs, deforms, the human *gestalt* into a monstrosity. Rigidified at sub-zero temperature, the body cannot decompose to become compost for the earth to which it belongs. Marcel Duchamp's sculptures of body parts, which possess curious corporeality, give shape to the formless, alien, if not debased, as an analogy of what looks good but is actually good for nothing. Similarly, the frozen body cannot be interred: it would be alien to its nature, robotised in its inflexibility to thaw within the hours afforded for the burial. It looks good to have returned the body, but it's no good to bury. Harbinger of the absent presence, the frozen, unrecognisable yet disquietingly real body stabs the family with its effaced presence.

Francesca Albanese, the Middle East UN rapporteur, writes after examining the surveillance system imposed on Palestinians as a carceral continuum:

> The incarceration of Palestinians is only one element of a larger carceral landscape, extending beyond prison as a paradigm of governance of the occupied territory. In addition to extensive control, the occupation has advanced Israel's development of powerful surveillance technologies, including facial recognition, drones, and social media monitoring. Examples of these programs include the 'Blue Wolf', an app connected to the Wolf Pack, an Israeli database containing imagery, personal information and

security ratings of Palestinians in the West Bank; and the 'Red Wolf', a system of cameras equipped with facial recognition that identify Palestinians at checkpoints, interact with and feed information into Blue Wolf and Wolf Pack. This has created a 'gamified surveillance' whereby Israeli military units photograph Palestinians without consent, and even engage in disturbing competitions. In Hebron, the so-called 'Smart City Initiative' has led to audio-visual surveillance of Palestinians across town. Similar forms of control are being deployed in east Jerusalem neighbourhoods (e.g. Silwan and Sheikh Jarrah), enhancing restrictions and ultimately widespread carcerality.[39]

Automated surveillance reinforces the already established apartheid and becomes part and parcel of maintaining apartheid. Soldiers at checkpoints with facial recognition apps capture the profiles of Palestinians to allow or deny them passage through checkpoints to the other side of their neighbourhood or another Palestinian village or town. They take pictures of Palestinian children and adults alike during their midnight raids on houses and neighbourhoods. 'Everything is watched. My whole life is watched. I don't have any privacy. I feel they are following me everywhere,' explained a West Bank Palestinian.[40] In one walk through an area of the West Bank, Amnesty reported finding one to two cameras every fifteen feet. Palestinian movements are rendered restricted; fear of being falsely accused, with the likelihood of misread electronic data, could lead to another extrajudicial killing that as per usual will be normalised with impunity. The expressive, externalised interiority that human faces manifest is of a mutating, multidimensional nature. This makes it difficult 'to stabilize a template that allows recognising a unique identity from

a given facial image'.[41] It is virtually impossible to obtain a facial reading accurate enough to analyse or even recognise an individual. These new forms of algorithmic and statistical regimes of power contradict Deleuze and Guattari's notion of *faciality*: the face is 'a very special mechanism' located at the intersection of different regimes of signs.[42] The reflective face is viewed as a sign of individuality. But in close-up, when the camera zooms in, the face becomes the surface of intense relations, traversed by social and historical aspects. How will the Palestinian face 'fit' into all of this? It seems that face recognition technology is rather a 'return to the "dark ages" of phrenology and physiognomy'.[43] Palestinians fear a wave of 'martyrdom by label' due to fake algorithms or a pixel change that might classify faces in categories of criminality as a new type of cover-up. The coordinator for the National Campaign for the Recovery of the Martyrs' Bodies stated that in many cases Israeli authorities withhold bodies of Palestinians to cover up evidence that the Palestinians had been killed at the hands of Israeli soldiers or settler-colonials.[44] Manipulating data-based information can be easily done when the subject, in the eye of the oppressor, is an object.

Because of the need to avoid any risk of being framed, Palestinians prefer to remain confined, and Israel succeeds in imposing another layer of freezing lives by freezing bodies on an already oppressed and besieged population.

'Power is everywhere' and 'comes from everywhere', in Foucault's words.[45] It expresses the experience of Palestinians under intrusive Israeli mass surveillance. Everywhere you look, there are cameras looming over their bodies. The system installed as an open-air panopticon allows the military to incarcerate the indigenous population beyond the Israeli prison system. 'Disciplinary power' instilled over a population is normative; it appears as a reiteration of nineteenth- and early twentieth-century disciplinary methods now re-enacted by the

Israeli high-tech surveillance industry to impose further body-obedience on the Palestinian population. Controlling the population with artillery and boots on the ground is supplanted by micro-control over the individual by using detailed bodily features. Facial recognition with a colour-code system and computer vision of large stores of images uses A.I. to survey the indigenous population of Palestine. These minute coercive technologies provide uninterrupted surveillance. The outcome is to produce docile bodies for repressive regimes. Foucault's *Discipline and Punish: The Birth of the Prison*[46] comes to mind when thinking about the 'automated apartheid', coined by Amnesty International, to describe Israeli 'physical' and 'virtual' apartheid. The Palestinian body is targeted as the object of power. Israel has taken leadership not only in producing but in spreading around the globe surveillance and spying technologies. Spyware Pegasus is just the tip of the iceberg, reports investigative journalist Antony Loewenstein.[47] This cyber-power for spying imposes on the body, to have it ply new systemised norms. Subjugated bodies become the microcosm of control over the wider population through what Foucault described as 'bio-power' (*biopouvoir*): 'an explosion of numerous and diverse techniques for achieving the subjugations of bodies and the control of populations'.[48] Biopower is a technology of power with a distinct tenet as it enables the management and control of entire populations.

In the aftermath of unlawful withholding of slain Palestinian bodies, the absence of tangible presence reduces the bodies of Palestinians to an intangible reality, whilst haunting the living with the unceasing presence of a beloved absent. The body is the site of what Fanon calls the 'zone of non-being'.[49] Every gain to control the 'other' in body and mind is a sum of destructions inflicted with no remorse, guilt or shame on the part of the perpetrator,

in whose eyes neither the dead nor living Palestinians have any inherent humanity. The violence, exacted upon forcibly retained bodies, etches its markings onto the soul of the living, netting them arbitrarily into oblivion, further tightening the grip on the already helpless and besieged community under settler-apartheid military occupation with a frenzied, excessive control over their psyche, body, and mind. In a recent attack on a Palestinian, made refugee in his own homeland, sixteen Israeli policemen blindfolded and assaulted him as he refused to be drawn out of his home.[50] The beating caused serious wounds, with fists thumping 'in all parts of his body',[51] covering every inch of his body in bruises. They concluded their thumping by 'marking' his face with an imprint of the Star of David.[52] The symbol of Israel etched on the cheek of a Palestinian detainee exemplifies in a nutshell the marking of the Palestinian body by Israeli racism at all levels. As usual, Israel's crime will pass with impunity. Israel is currently holding at least 5,000 Palestinian political prisoners, of whom around 1,200 are under 'administrative detention', meaning incarcerated without charges for an indefinite time.[53]

'Palestinians are not exempt from Israeli detention [even] after death.'[54] The necropolitics of the present-day Israeli state means that even the body of a formerly incarcerated political prisoner who died from cancer while in custody will not be released. Since 1967, this policy has been exacted over hundreds of Palestinian corpses, which were 'used as "bargaining chips" in negotiations or potential prisoners swap deals'.[55] Over 370 bodies of dead Palestinians are withheld by the occupying colonial state,[56] and some 256 corpses are buried in the 'Cemetery of Numbers',[57] one example of the Israeli use of collective punishment inflicted on the families of detainees, who relentlessly seek the return of their loved ones' bodies. 'I want to bury my son with full dignity!' cries out a father whose son has been shot dead whilst resisting the Israeli

occupation. Twenty years later the body is still withheld, and the father is still struggling to retrieve it.[58] The state will not even inform him of the whereabouts of his child's body.[59] The parents remain in the dark, and the corpse of their child in a hole darker yet. 'There is no grave to grieve over the loss of our son. Where is he buried? We don't know. Every time we remember him, the wound reopens, a wound that cannot be healed,' the bereaved mother cried.[60]

It is not hard to imagine what grievous harm the retention of bodies causes to those who seek closure to their loss. Every person who awaits the return of their dead wishes to cast a final look at their loved one prior to the burial. To celebrate the life of the dead and honour their death with a dignified burial is a non-negotiable right for every parent who has lost a child. 'To deny Palestinians the right to mourn loved ones is another example of the extent of Israel's dehumanisation, brutalisation, and torment of the millions under its occupation,' writes writer and lawyer Raja Shehadeh.[61] He, like many others, has consistently urged the Israeli authorities to unconditionally release the bodies of murdered Palestinians. Along with many Palestinians advocating for their human rights, he has raised the issue with the United Nations Human Rights Council as well as with the European Parliament and External Action Service, demanding that Israel be made accountable for its brutal policies.

The deletion of the physicality of murdered-then-abducted bodies into the void of sub-zero temperature is the occupying state's arrogant avowal that the horror is directed at the heart of the living to whom the stolen bodies belong. Scarred by the absence of those bodies, their lives hover, in limbo, between life and death. They are frozen in time. The removal of abducted dead bodies from reality tortures the living day and night, day after day, night after night.

Since the inception of the Israeli state on the land of historic Palestine, seventy-five years

of the ongoing *Nakba* have ensured a slow-motion but consistent – family after family, house after house, area after area – ethnic cleansing of the indigenous to make room for settler-colonists. Only specific populations are 'marked out for wearing out'.[62] But what the perpetrators themselves seem to be marked by, consciously or unconsciously, is 'exceptionalism' or what the German philosopher and jurist Carl Schmitt introduced as a 'state of exception' by which a state transcends the rule of law in the name of what it regards as its ward: the 'public good'.[63] Israel has been given carte blanche to ride roughshod over rules and laws for its own good, or so it believes. Even a basic natural law, such as human decency, is out of reach. Practising a prolonged state of exception is utilised, according to Giorgio Agamben, to deprive individuals of their citizenship, thus radically erasing any legal status they may have, let alone their human rights.[64] Palestinians' political, social, and human rights have all been denied, despite the efforts they invest in being treated like any citizen of this world.

A middle-aged mother has been waiting for several years for her daughter's body to be returned from the state's freezers. She explains that years passing with no sign of retrieving the body is like living in 'a frozen time between two worlds'. She adds: 'I feel the blood in my veins has frozen in my body. I roam around the house looking for my daughter. I roam as though I am dead-alive.'[65] Necropolitics is a state-sponsored death. It dictates not only how people should live, but also how they should die. 'Death-worlds' is what Achille Mbembe describes as 'new and unique forms of social existence in which vast populations are subjected to living conditions that confer upon them the status of the living dead'.[66]

In 'Necropolitics', Mbembe outlines how our contemporary world, particularly Western modernity, is plagued with mounting enmity, militarisation and racism, and issues of borders and boundaries.[67] It is festering with fascism and a growing 'desire of apartheid'[68] conflated with the obsessive search for an enemy. By dint of creating enemies, we end up finding them and war becomes not the exception but the norm, the 'sacrament of our era'.[69] Whoever is deemed the enemy of a state is targeted, as a shortcut to establishing sovereignty. The legacy of colonialism and slavery is haunting us with unresolved consequences. The 'nocturnal body' of the so-called 'liberal democracies' that had colonised the world is finally coming to the surface.

'Necropolitics' as a term (but also as a practice) is an extension of Foucault's 'biopolitics' by which social and political power is ramified extensively to control people's lives – in the case of Palestinians it is a total control of their bodies. The question that emerges is the extent to which the Israeli state is going to extend its power, given that death, the process of mourning, and rite of interment are politicised, if not weaponised, to exert biopolitics beyond the grave. Necropolitics is the politics assigned to the walking dead, whereby specific bodies are forced to remain in a suspended state of somewhere between life and death, a contemporary form of what Mbembe calls the 'subjugation of life to the power of death'.[70] The state of exception invests one person or government with the power and voice of authority over others, extended well beyond previously existing law.

Israel today is in flagrant violation of international law on three accounts:

- The four Geneva Conventions regarding the return of the dead to their families.
- Given its failure to abide by the law, Israel must therefore be held liable for inflicting collective punishment prohibited under the Hague Regulations and the Fourth Geneva Convention.
- Last but not least, Israel contravenes the International Covenant on Civil and Political Rights which prohibits torture and inhuman or degrading treatment.

Israel breaks all these laws and behaves as though above them.

Μάρτυς (*martyr*) or Μαρτύριον (*martyrion*) is Greek for 'witness', as it is in Arabic. The شَهِيد (*shaheed*) or شهداء (*shuhada*) literally means 'one who bears testimony' to something, in other words, a 'witness'. Those who bear witness to the Palestinian cause, who sacrifice their lives, are martyrs. They bear witness to the lives lived under oppression. They bear witness to each other's losses and sacrifices (1948 *Nakba* to the present). Journalists like Shireen Abu Akleh, who was shot and killed by an Israeli army sniper whilst bearing witness to the army's invasion of Jenin, is in the eyes of her people a martyr. Innocent children or civilians, who are not necessarily engaged politically or belong to any resistance movement *per se*, are considered martyrs if killed by the occupier. In an act of remembrance, posters with the picture of the deceased, the *shaheed*, will be put up in honour of their sacrificed lives. Equally, political martyrs, those who suffer persecution for advocating their right to live freely or their right to self-determination, those who refuse to renounce their rightful ownership of the land or to let go of their right of return, are martyrs. Palestinians who are shot and killed are also honoured as martyrs, usually not by their choice, but given to them posthumously, by the choice of those who remain. They recognise the injustice of the killing and the courage of those who resist oppression. Martyr's Day is celebrated on January 7 every year. Martyrs are remembered in public demonstrations or private assembly with family and friends. Art exhibitions are put together in remembrance of the dead. The 'One Hundred Martyrs' exhibition in Ramallah in 2001 displayed a single object belonging to each martyr set in a translucid case next to the *shaheed*'s picture. The mission statement of the exhibition was 'to give each *shaheed* [martyr] his or her individuality'.[71] The refusal to comply with the occupier's command

may cost a Palestinian his or her life. They are martyred because they were killed or chose to die for the sole reason of being Palestinian. For what is the value of living in fear or without freedom? Bereaved families acknowledge that one of the main purposes of Israel's policy of retaining bodies of the deceased is to bar the recognition and honouring of the dead as martyrs. But 'the Martyr teaches me: no aesthetics without freedom'.[72]

'A healthy society requires a lively sense of the reality and continuing presence of the dead',[73] thus giving meaning to the reality of the living. Snatching bodies of the deceased deprives the living of their continuous presence that gives essential meaning. Snatching bodies is also to snatch the meaning of death and its integration in the cyclical movement of life. Death without a myth is like a descent into a dark pit. Myths have a vital role: 'they relate us to the transcendence and the infinite'[74] and give 'animate images that symbolically replicate energies within us.'[75] What images are conjured up of murdered-then-abducted bodies, some thrown into the Cemetery of Numbers, others frozen in *mortifer* fridges? What belief in immortality can satisfy an abstraction of death when the body is deformed or missing? In the eyes of the occupier, even in death the occupied is an enemy to be defeated. The policy is so extreme that it might be perceived as an attack on 'resurrection' itself. The fear of Palestinians returning to life as to home goes to that extreme.

The stronger the effort to erase or overwrite an identity, the more, in an uncanny way, the face underneath it is revealed. Certainly, the more Palestinians find that the memory of their existence is being actively erased, the more they assert their identity. There is always a remembered residue, something vital that will never die. Kamal, the father of an abducted sixteen-year-old, stays put beside his son's picture. 'He is gone, but not his smile,' he commented with serenity in his voice and deep grief in his eyes.

In *The Commissar Vanishes*[76] we are shocked to discover that the most compelling images are those that have been censored or falsified. The impossibility of erasure forms the bedrock of depth psychology. If anything, one of the most relevant contributions that depth psychology has made is that nothing is ever erased; out of sight does not equate to out of mind; in fact it is more alive than ever before.

'Life defined only as the opposite of death is not life,' says Mahmoud Darwish.[77] Everyone is entitled to living with dignity. In *Humanity without Dignity*, Andrea Sangiovanni invites us to consider our human vulnerability as a starting point to reflect on the wrongness of treating others as inferior.[78] It is wrong because inferiorising inevitably involves stigmatisation and dehumanisation of the other. Infantilisation and instrumentalisation is another ploy to mistreat the other. Deemed inferior, the other is objectified. All of the above are objectionable because they imply social cruelty that assaults the other's capacity to develop and maintain the integrity of their sense of self. Palestinians are thirsting for dignity, striving for freedom and dying for justice. Their struggle for justice unites many others in the world who are fighting against oppression, colonialism, and neocolonialism.

Thomas Sankara, in his tribute to Che Guevara, reminds us that we might be able to kill a man but not his ideas.[79] Ideas of freedom with justice will never die. Death shows us that, however powerful a government, a state or an army are, one's true reality is death. Martyrs in death continue to uphold that life without dignity is not worth living. Those who remain are then empowered to uphold the values of living, and they are able to do it with dignity. Here I find room for a poem by Fadwa Tuqan, a female Palestinian poet whose words speak for the generations of Palestinians, whether dead, alive or exiled, who will not let themselves become frozen out of existence and in that terrible way eternally erased:

Enough for Me

Enough for me
Enough for me to die on her earth
be buried in her
to melt and vanish into her soil
then sprout forth as a flower
played with by a child from my country.
Enough for me to remain
in my country's embrace
to be in her close as a handful of dust
a sprig of grass
a flower.

This is one way to survive the frost, and it is not too much to ask.

* Statement by the editor: *Only a few days before this book was printed, violence on an unprecedented scale erupted in the Middle East. I thus consider it an absolute necessity to state that Heba Zaphiriou-Zarifi's contribution was written* before *the Hamas attack on Israel on October 7, 2023. I also want to add that we both agreed – beyond the shadow of a doubt – that* Frozen Bodies, Frozen Lives *shall raise ethical questions in relation to bare bodies from a clearly humanitarian and peace activist perspective. It does not, by any means, intend to fuel political polarisation.*

– Mariella Greil
October 12, 2023

1. Mahmoud Darwish, *Memory for Forgetfulness: August, Beirut, 1982* (Berkeley: University of California Press, 1995).

2. Ludwig Wittgenstein, 'Logisch-philosophische Abhandlung', Annalen der Naturphilosophie 14, nos. 3–4, trans. C. K. Ogden, *Tractatus Logico-Philosophicus* (London: Kegal Paul, Trench, Trubner, [1921] 1922), 185–262.

3. Michel Foucher, *L'obsession des frontières* (Paris: Librairie Académique Perrin, 2007), 28.

4. The *Nakba* (Arabic for 'catastrophe') refers to the mass displacement and dispossession of Palestinians during the 1948 Arab-Israeli war. Before the *Nakba*, Palestine was a multi-ethnic and multicultural society.

5. Ayelett Shani, 'Israel's Government Has Neo-Nazi Ministers. It Really Does Recall Germany in 1933', *Haaretz*, February 10, 2023.

6. Richard Becker, 'Israel at 75: Fascist, Apartheid and Genocidal Watchdog for U.S. Imperialism', *Socialism and Liberation* 4, no. 6 (June 1, 2007).

7. Lauren Berlant, 'Slow Death (Sovereignty, Obesity, Lateral Agency)', *Critical Inquiry* 33, no. 4 (Summer 2007): 761.

8. Jacques Derrida, *Learning to Live Finally – The Last Interview. An Interview with Jean Birnbaum*, trans. Pascale-Anne Brault and Michael Naas (New York, NY: Palgrave Macmillan, 2007), 17.

9. Jacques Derrida, *Points...: Interviews* [Points de suspension. Entretiens], *1974–1994*, ed. Elisabeth Weber, trans. Peggy Kamuf and others (Redwood City, CA: Stanford University Press, 1995), 321.

10. Mahmoud Darwish, 'In Jerusalem', *Transference* 3, no. 1, Western Michigan University (Fall 2015).

11. Stephen C. Neff, ed., *Hugo Grotius on the Law of War and Peace*, student edition (Cambridge: Cambridge University Press, 2012).

12. Noura Erakat and Eghbariah Rabea, 'The Jurisprudence of Death: Palestinian Corpses & the Israeli Legal Process', *Jadaliyya*, February 8, 2023.

13. Ibid.

14. Al-Haq, 'Newly Adopted Law to Withhold the Bodies of Palestinians Killed Breaches International Law, Must Be Repealed', March 14, 2018, alhaq.org/about-alhaq/7136.html.

15. Yaniv Kubovich, 'Israeli Army Employs Popular Blogger for Psyops on Social Media', *Haaretz*, August 18, 2021.

16. To preserve anonymity, the identities of private individuals are not disclosed and minor details have been altered. Supervising and supporting the therapists who are doing ground-breaking work locally under extreme conditions has been a humbling and life-changing experience. Whilst working on this material I often felt frozen, unable to 'move' the writing forward, as memories of three generations of broken lives were revisited in the light of the brokenness of the families who wait for their disappeared to return home; sometimes they do, but as a corpse. Their hope and religious faith and attitude have been an enormous source of courage and perseverance, while I, in turn, offered every iota of sustenance I could muster to the lives of those who continue to hope beyond hope *[l'espérance au delà de l'espoir]*. I would like to pay a special tribute to Nadera Shlahoub-Kevorkian, Noura Erakat and Suhad Daher-Nashif for speaking truth to power. I would also like to honour a dear colleague, Adid, who began this work several decades ago and lost his life after an unsuccessful heart surgery. He invited me to meet many of these families harrowed by the absence of closure to their already diminished lives. What they gave me is resilience in the face of such adversity and a surrender to the Self.

17. Ibid.

18. Jack Jeffrey, 'Outcry over Israel Policy of Holding Remains of Palestinians', *Los Angeles Times*, October 8, 2021; 'Israel: Release Body of Slain Palestinian', *Human Rights Watch*, September 14, 2020; Qassam Muaddi, 'Skeletons in the Closet: Israel's Macabre Policy of Keeping Dead Palestinian Bodies from Their Families', *The New Arab*, July 26, 2022; Jessica Buxbaum, 'Where is Bilal?' *Mondoweiss*, February 23, 2023.

19. Suhad Daher-Nashif, 'Suspended Death: On Freezing Corpses and Muting Death of Palestinian Women Martyrs', *Third World Thematics – A Third World Quarterly Journal* 3, no. 2 (August 2018): 179–195.

20. Hossam Shaker, 'Hostages in Israeli Mortuary Refrigerators', *Middle East Monitor*, September 27, 2018.

21. Anonymous, interview with author, n.d.

22. Nadera Shalhoub-Kevorkian, 'Criminality in Spaces of Death: The Palestinian Case Study', *The British Journal of Criminology* 54, no. 1 (January 2014): 38–52.

23. Erakat and Rabea, 'Jurisprudence'.

24. Nadera Shalhoub-Kevorkian, 'Living Death, Recovering Life: Psychosocial Resistance and the Power of the Dead in East Jerusalem', *Intervention* 12, no. 1 (2014): 16–20.

25. Ibid.

26. UN General Assembly, 'Universal Declaration of Human Rights', 217 (XIII) A (Paris, 1948), un.org/en/universal-declaration-human-rights.

27. 'Israel: Basic Law of 1992, Human Dignity and Liberty. National Legislative Bodies/National Authorities', March 25, 1992, refworld.org/docid/3ae6b52618.html.

28. Achille Mbembe, 'Bodies as Borders', *The European South* 4 (2019): 5–18.

29. Francesca Albanese, *Report of the Special Rapporteur on the Situation of Human Rights in the Palestinian Territories Occupied since 1967* (Geneva: United Nations Human Rights Council, June 9, 2023),

ohchr.org/sites/default/files/documents/hrbodies/hrcouncil/sessions-regular/session53/advance-versions/A_HRC_53_59_AdvanceUneditedVersion.pdf.

30. Ibid.

31. Jean-Paul Sartre, *Huis-Clos* [No Exit], theatrical play presented in Paris, May 1944.

32. Ibid.

33. Antonin Artaud, *Œuvres*, ed. Évelyne Grossman (Paris: Gallimard, 2004).

34. Artaud coined the term *'corps-sans-organes'* in a radio play and the term was later adapted by French philosopher Gilles Deleuze.

35. Haim Shadmi, 'Bodies of 21 Palestinians Stored at Abu Kabir', *Haaretz*, June 13, 2002.

36. Noga Klein, 'Israel Became Hub in International Organ Trade Over Past Decade', *Haaretz*, September 20, 2018, haaretz.com/israel-news/2018-09-20/ty-article/.premium/israel-became-hub-in-international-organ-trade-over-past-decade/0000017f-eab1-ddba-a37f-eaff05e70000.

37. Ibid.

38. Ibid.

39. Albanese, *Report of the Special Rapporteur.*

40. Anonymous, interview with author, n.d.

41. Kelly Gates, *Our Biometric Future: Facial Recognition Technology and the Culture of Surveillance* (New York: New York University Press, 2011), 17.

42. Gilles Deleuze and Félix Guattari, *A Thousand Plateaus* (London: Continuum, 2004), 186.

43. Gates, *Biometric Future.*

44. Shatha Hammad, 'Israel's Policy of Withholding Bodies Leaves Palestinian Families in Limbo', *Middle East Eye*, August 8, 2021.

45. Michel Foucault, 'The Birth of Biopolitics', part of a lecture series at the Collège de France and published posthumously, *History of Sexuality Volume I: An Introduction* (New York: Pantheon, [1976] 1978).

46. Michel Foucault, *Discipline and Punish: The Birth of the Prison* (New York: Knopf Doubleday, 1975).

47. Antony Loewenstein, 'How Israel's Technology of Occupation Spreads around the World', *South China Morning Post*, May 29, 2023, scmp.com/comment/opinion/article/3222202/how-israels-technology-occupation-spreads-around-world.

48. Ibid.

49. Frantz Fanon, *Black Skin, White Masks*, trans. Charles L. Markmann (New York: Grove Press, [1952] 1967).

50. Raja Abdulrahim, 'Palestinian Man's Lawyers Say Israeli Police Marked Him with Star of David', *The New York Times*, August 21, 2023.

51. Ibid.

52. Ibid.

53. United Nations Human Rights, 'Special Rapporteur Says Israel's Unlawful Carceral Practices in the Occupied Palestinian Territory Are Tantamount to International Crimes and Have Turned it into an Open-Air Prison', July 10, 2023.

54. Erakat and Rabea, 'Jurisprudence'.

55. Ibid.

56. Ibid.

57. Ibid.

58. Ibid.

59. Ibid.

60. Ibid.

61. Raja Shehadeh, *Occupation Diaries* (London: Profile Books, 2013).

62. Berlant, 'Slow'.

63. Carl Schmitt, *On Dictatorship*, trans. Michael Hielzl and Graham Ward (Cambridge: Polity Press, [1921] 2013).

64. Giorgio Agamben, *State of Exception*, trans. Kevin Attell (Chicago: University of Chicago Press, [2003] 2005).

65. Anonymous, interview with author, n.d.

66. Achille Mbembe, 'Necropolitics', trans. Libby Meintjes, *Public Culture* 15, no. 1 (2003): 11–40.

67. Ibid.

68. Ibid.

69. Ibid.

70. Ibid.

71. Penny Johnson, 'The Eloquence of Objects: The Hundred Martyrs Exhibit', *Jerusalem Quarterly*, no. 12–11 (Winter 2001).

72. Mahmoud Darwish, 'The Politics of Mourning and Catastrophe', *Bethlehem University Journal* 38 (2021): 95–126.

73. Joseph Bottum, 'Death & Politics', *First Things* (June 2007), firstthings.com/article/2007/06/001-death-politics.

74. James Hollis, *Tracking the Gods: The Place of Myth in Modern Life* (Toronto: Inner City Press, 1995), 8–15.

75. Ibid., 54.

76. David King, *The Commissar Vanishes: The Falsification of Photographs and Art in Stalin's Russia* (Edinburgh: Canongate Books, 1997).

77. Darwish, 'Politics'.

78. Andrea Sangiovanni, *Humanity Without Dignity: Moral Equality, Respect, and Human Rights* (Cambridge, MA: Harvard University Press, 2017).

79. Thomas Sankara, *Thomas Sankara Speaks: The Burkina Faso Revolution 1983–1987* (Sydney: Pathfinder Press, 1988).

NUTRITION
njuːˈtrɪʃᵊn

Nutrition is the process of obtaining and utilising essential nutrients for the sustenance and smooth functioning of the living organisms that engage in metabolic activities is vital for growth, energy production, immune function, and survival. The intake, absorption, and metabolism of nutrients is necessary for vital functions of body and soul. Embracing the radical fusion of physical and virtual elements fundamentally involves nutrition and a dynamic and spirited synergy of biological, digital, and metaphysical stimuli. These nourishing grounds pave the way for an inventive understanding of prosperity (stretching beyond post-capitalist realities) in an ever-evolving co-existence that manifests as critical and creative spirit and embodied plural community. Encounters between lifeforms and their emergent ecologies depend on sustained ways of nourishment. The emergence of possibility for change needs sustenance both on the spiritual and bodily plane and diverse forms of intelligences (plant and digital circuits, hydro-commons and human water bodies, interplanetary and geological bodies, human and animal flesh, interspecies and organoids...) will be needed to forge a brighter planetary future.

TANGLEMENTS
'tæŋgᵊlmənts

Tanglements refer to elaborate and complex situations, relations, or structures that are challenging to unravel or understand. Embodied entanglements imply a state of interwoven and diverse world-making. Their complexities suggest a sense of being entwined, at times making it impossible to distinguish individual entities. The dynamic entangling of living and non-living dimensions, which evokes a sense of wonder or bewilderment, makes it challenging to untangle the sophisticated complexity of their microperformativities. Navigating tanglements – intense points of contact – of bare bodies reveals underlying patterns of collective sedimentations of affects that metabolise ecology and unearth transformative potentials and poetic courage through the rhizomatic beauty of growth. Presence is rooted in tanglements across times, eternity and wisdom, in responsibilities across generations (at least seven, and towards the blue horizon).

REBECCA HILTON

Six Dead Bodies

DEAD STRANGER 1990

We are three, we're huddled together walking arm in arm, east to west down the middle of Great Jones Street. An enormous snow has fallen, the city is quieted and softened, fleetingly beautiful. We're bundled up in thick coats, knitted hats, gloves and scarves. We're walking in unison in the crunchy not yet slippery snow. We're talking about a dance performance we've just seen at Judson Church, so it must be Monday. We cross Lafayette, pass the fire station on our left, Bowery is just ahead of us. There is no one else around. It has the feeling of a story we'll tell in the future.

And then we see a body.

It looks like a man. He's on his front, arms slightly out from his sides, palms up, legs a little splayed. He is ghostly white and seems unnaturally thin for his frame. Everything is still except for pale steam rising from his bare body.

Years later, my friend and I agree that he is naked and face down, but she remembers his limbs being bent at unnatural angles and much blood in the snow. She doesn't recall the steam at all and I don't remember the blood. Neither of us remembers who the third friend is to ask how she remembers it.

At almost the exact same moment we see him, a door opens and people come rushing out. They cluster around him, 'no', they don't know him, 'yes', they've called 911. 'Is he dead?' somebody asks. 'Yes,' somebody answers.
We are all really young. Him too.

DEAD GRANDMOTHER 2006

Profoundly deaf for much of her life, she remains sharp as a tack until the end. She has a collection of Australian landscape paintings and whenever she feels like travelling, she takes a painting off her wall and sells it; she takes the Trans-Siberian Express, rides a bus through South America, sails down the Nile and cruises the fjords of Norway. She's handsome and fashion-forward, animal print is a particular favourite. She always has a hand mirror, comb and a lipstick close at hand, in her purse, or stashed down the side of her armchair. Late in life she dyes her hair auburn brown, draws on her eyebrows and wears orangey red lipstick on special occasions.

She loves being the family matriarch.

We are two daughters and three granddaughters standing in a semi-circle around her dead body. She is lying in a bed in a respite care home. She is ninety-six, not in pain, *compos mentis* to the end. My aunt, sister, mother and cousin have made her room pretty, bringing flowers from their gardens, her favourite McKenzie tartan lap rug and several framed family photos. The large window in her room looks out on to a playground, dim sounds of children shouting and laughing float in. She recently moved into this facility and she dies resentful about that, which is consistent with who she was. We stand around telling our usual stories about her, the time she sends us a hairy coconut through the mail from Dunk Island; how much it hurts to hold her hand, her grip more bird than human, more talon than hand; her one-eyed loyalty to three things: the Australian Labour Party, the highlands of Scotland, and the Footscray Football Club, 'They're still our team,' she says after another demoralising loss, even as the losing stretches across decades and generations.

This day her face is bare of makeup, framed by hair so faded it isn't a colour at all, her forehead small but wide, with prominent browbones, her eyes deep set, a marked frown line running between them (something I also have), her nose is medium sized and slightly hooked, her ears are large with fleshy lobes. They're pierced but she has no earrings in them. Her mouth is wide and thin-lipped, turning down at both corners. Her jawline is strong. The skin of her face has a pretty crisscross of lines all over it. I can touch it without touching it, and smell it without smelling it, I know it will feel really soft and smell of Oil of Olay. Lying there dead she looks exactly as she always does: wiry, fierce, curious, formidable. Not at all at peace.

Suddenly she makes a slow, heavy lurch forward toward my mother, coming up halfway to sitting, listing a little to the left. My sister gasps, my cousin shrieks, I squeal-laugh, my mother clutches at my aunt who bursts into tears; if anyone can rise from the dead it would be her. The attendant rushes in 'Oh dear,' she says, 'I've gone and left the inflatable mattress-thingy on. That must have given you quite the fright.' It's a contraption that inflates in different places to help avoid pressure sores. The attendant pulls the plug and she lies gently back down.

DEAD HORSE 2010

In this golden-grey, pale-green corner of the country, ravaged by gold mining and sheep farming, sits our family weekend house. Mum and Dad drive up from town every week and we all gather here for Christmas, New Year's, Easter, school holidays, in groups large and small. Two horses live here, both failed male race horses, Falcon is brown and Raven is black. Not related but inseparable since birth, they're rarely far apart. They enjoy their retirement, no one rides them, they roam the property like magnificent hooved dogs. Sometimes in the early morning, Falcon pushes open the fly wire door of the mud brick house, goes through the kitchen and into the bedroom where he nuzzles my mother until she gets up and feeds him. But mostly they stand around in the shade of a verandah or tree, chewing, stamping, shaking their heads and swishing their tails to disturb the hundreds of tiny black flies sitting on their rumps. The gravel crunches as the car pulls into the driveway, usually the horses trot up from the lower paddock to meet the car but this day they don't. Curious, Mum and me walk down past the old tin windmill and up the gently sloping embankment that surrounds the dam. From there we see Raven standing with Falcon lying motionless at his feet. He's on his side, his body half in half out of the muddy dam water. It's a hot windless day, all is perfectly still for a long time until Raven slowly turns his head to look up at Mum.

It's 1915 and Mum's father is sixteen. He's too young to legally enlist but the army turns a blind eye, especially because the country boys have their own horses. He rides in the Light Horse Brigade at Gallipolli, he and his horse survive. At war's end the army doesn't let the soldiers bring their horses home, they're not allowed to sell them or even give them away to the Turks. Hundreds of battle-weary country boys have to shoot their own horses.

DEAD BROTHER 2013

He is in surgery. They make an L-shaped cut into his body along the right side of his abdomen. They peel back this fleshy flap of him and look in and see that the cancer has spread too far to do anything, the gall bladder is engorged with it, the bile duct devoured by it, there are spots on the liver and the pancreas, and so they close him back up. The doctor, avoiding eye contact, says 'I'm sorry, there was absolutely nothing we could do.' I say, 'Nothing? You couldn' t just take out the bad stuff, the gall bladder, the bile duct? Nothing?'

As we stand and talk I see how hard this part of his job is for him, the communicating part. He talks about my brother's body as if it is a series of parts rather than a whole. To think of my brother as a whole body in relation to other whole bodies, the bodies of the family and friends who love him, is just too hard. Every day there are too many dead and dying bodies and the pain of others is too much to bear.

'You can't just cut something out without having something else or somewhere else to re-attach it,' he says.

'You can't just make a gap.'

And there, near a row of black vinyl seats, my sister-in-law mute with grief beside me, amidst muffled television sounds, distant beeping, dog-eared magazines, discarded Legos, beside a huge dry, crumbling native flower arrangement – I have an epiphany.

I feel my experience of the world shifting in a way that feels permanent. I experience gaps where I once assumed connection. From now on there are more gaps than things.

My brother dies four months later, surrounded by family. I can't be sure but it feels like clandestine assisted dying, something I imagine nurses and doctors do

quite often, just a little bit too much of whatever that pain medication is and his eyes fix, his breathing slows. He dies to the sound of our mother telling us a story about camping along the Great Ocean Road, hers is the first voice and the last voice he ever hears, the symmetry of that soothes me. A rattle, a little rattle and that is it. My aunt is waiting in the corridor and later she tells me I wailed. I don't remember wailing. I sit alone with his bare body covered in a sheet and wait for his wife to arrive. She's been away with friends, a short respite from the constant caring. It is strange and sad and beautiful to sit with him for these hours, it is the last thing our bodies do together.

'You can't just cut something out without having something else or somewhere else to re-attach it,' the doctor said. 'You can't just make a gap.'

Most gaps just make themselves.

DEAD RIVER 2020

She slowly transforms as you drive across her, hundreds of kilometres pass and at some point, you realise that the land has become different, the colours of the dirt have changed from deep brown to dark grey, shrubs have become trees, the flatness has swelled. She's slow. She's subtle. She's bare. She suffers and it shows. We drive on one of the longest straightest freeways in the world, across trickles that were once rivers, through hectares of burnt-out bush silhouetted against the sky, past open cut coal mines and plantation pine forests, through little towns with English names and memorial drives lined with dusty unhappy imported oak trees. Occasionally we drive over flattened remnants of fur and gore, small bodies spread and smeared along the road. In the twilight we zoom past a truly strange sight: a very large, very

dead, very stiff kangaroo face down in a ditch. Only its giant tail and hind legs are visible, it's as if it's been stuffed and then upended there. It's incongruous, incomprehensible, it makes no sense at all. We want to stop but we don't.

A lone, large, grey-brown emu, standing in a clearing, stares as we pass by and a mob of twenty kangaroos bound ahead of us, raising a huge cloud of dust before plunging back into the bush. We arrive at our destination, a state park, every now and then we hear the screech of a far-away trail bike or the bam of a distant gun-shot. We set up camp amongst a stand of dead trees, trees which once grew beside a river which was dammed to make a lake then emptied by decades of drought. Now it's a series of small fetid pools. We wake to the sound of thirty white sulphur-crested cockatoos shrieking and shaking the branches of the dead trees. In Yaraan-doo,[1] the death spirit, Yowi, takes the first deceased person into the sky in a tree, and two white cockatoos follow, squawking angrily as they chase their tree.

Once, so-called 'Australia' teemed with animal and plant life found nowhere else on earth. Since invasion, the introduction of non-native plants and hooved animals, extractive mining practices and unfettered deforestation, have led to irreversible species extinction, soil contamination, salinisation, and erosion. In just 233 years, this place, tended to and cared for by its first peoples for something close to 80,000 years, is slowly filling with barren, dead, and dying bodies of all kinds.

DEAD FRIEND 2023

Dearest RG, *November 13, 2020*

Truth be told, I've been thinking of this for some months now, in those strange unsettled moments before sleep I have found you curled up in the same part of my mind/soul as my my dear brother who died nearly 7 years ago now; the place for tall, kind, brilliant men who die too soon.

I am a terrible correspondent, RG, and I do not have poor health to blame, just a cave person preference for in-real-life encounters or none at all, which at this moment in history is willfully stupid and anachronistic. Obviously I need to change.

But I do talk with you quite a lot in my head. Sometimes something funny happens or someone says or does something curious and you appear – tall, slender, elegant you – your gentle brown eyes slowly light up, your smile becomes a sound, you lean in and down towards the person who said or did the thing and you really want to know where that thought/joke/move/wisp of knowledge might have come from. You want to know as much about the context as the thing. Which has become a secret marker of intelligence for me.

So you are with me always actually.

FUCK OFF DETH is something I saw written on a low wall in grimy Leeds when I was there decades ago. It's stayed with me for all these years. As someone who has too often witnessed death, deth looks more like it feels, somehow its small, tight meanness matches the sudden, chill, hole of loss.

And FUCK OFF DETH is as good a description of life as any other I have come across.

Your magnificent books do that RG, they fucking FUCK OFF DETH. Because there you'll always be, waiting in the past and the present and the future to share something with me.

Much love to you, dear friend.
Becky

Deth did not fuck off and I was with RG when he died at 7:27 am on March 2, 2023.

1. Michael J. Connolly, 'The Southern Cross: Yaraan-Doo – The Place of the White Gum-Tree', *Dreamtime Kullilla-Art online*, kullillaart.com.au/dreamtime-stories/The-Southern-Cross-Yaraan-doo-The-place-of-the-white-gum-tree.

THRESHOLDING
IMMANENCE

THRESHOLDING
IMMANENCE

Thresholding Immanence

When it comes again, the light,
you hold your breath, and
if it stays you forget about it until it
goes again.

Lightning across the bones of time fuses then and
now in one melt accident. The powers of the instant
entanglements tear loose. 'Together as one', they whisper,
'one as many and all in one'.

The undertow of immanence inscribes each and
every one of an endless chain of bare bodies, all
crocheting the fabric of life in its spiritual contiguity.
There are no bodies without incarnate realisation,
the filigree essence of luminous creation smells a
tinge of romance in future perfect.

Dreams the stuff we are made of, get geared up
by whirls of loving affection. The meteorology of
the spirit predicts moist incalescence: the warmth
of the contemplative heart allies with the moderate
breeze cultivated by mindfulness. Does your
intangible integument feel the floating flower
petals? Can you hear the diamonds percolate
the base of consciousness, as finite touches infinite,

as boundaries blur. Whispers of eternity revealed in particles of light.

Through unlocking the profoundness of bare bodies, a threshold has opened up in the tapestry of immanence, dwelling serenely at the source, dancing at the cradle of life.

[1] Dillard Annie, Pilgrim at Tinker Creek (Pymble NSW: Harper Collins e-book, 1974 [2007]), 12.

FIONA BANNON

Inhabited Bodies

Bodies
Nude bodies
Naked bodies
Peeled bodies
Raw bodies
Bodies
Tragic bodies
Nungous bodies
Sculpted bodies
Imagined bodies
In the buff bodies
Unclothed bodies
Exposed bodies
Gymnos bodies
Unclad bodies
Raw bodies
Starved bodies
Stark-naked bodies
Birthday suit bodies
Unwrapped bodies
Buck-naked bodies
Uncovered bodies
Au-natural bodies
Disrobed bodies
Stripped bodies
Pumped bodies
Bare bodies
Bodies

The image, status, identity, and idea of *a* body, of *anybody*, continues to be a cause for fascination. Arguably, we are, and continue to be estranged from, that with which we should be most familiar: *our own discrete existence as body*. Bodies have always been shaped according to specific cultural moments, through varied cultural trends and shifts in identity. In questioning notions of our *lived bodies*, this writing explores ideas of presence, particularly of *bare bodies* leading towards a multiplicity of possibility in relation to the perceived, *peculiar status of the human body*.

- *Your body* is not only possessed by you, it, possesses and constitutes what and who you are, and may become.

- *Your body* is not something you have, it is what you are. By and through your body you come to recognise your existence in the world.

Merleau-Ponty refers to our embodied 'life world' as constituted by our discreet *bodily actions*.[1] Arguably, it is through these physical bodily actions that we learn to orchestrate our experiences. It is here we each learn to distinguish our inner perceptions of the 'outside' world. It is here we each come to recognise how discreet sensations emerge within our bespoke internal world. Much of the information we are taught regarding our physical identities, our muscular, sweating, breathing bodies is derived from contested debates concerning what it is to be alive, alert, social, and adaptable. A breadth of speculation across our cultural norms, politics, and educations influences how we learn to interact, as sensate beings. We are all comprised of a multitude of bodies, all intertwining, all contributing to the ways we each shape the bespoke presentation of 'ourselves'.

WATCHING BODIES

With no single route through which to articulate *felt experiences* when watching bare bodies in performance, the aim here is to intertwine approaches drawn from aesthetics, ethics, performance practices, and politics. Through interweaving these attitudes, it is feasible to forge a route towards bodies as *sensibilities of thought*. What has become apparent in considering these ideas is the accommodations made by practitioners as they tease-out ways to interrogate and ultimately articulate their *felt self* in performance. When considering how we each

recognise our existence *in and through* our bodies, we can explore the *bare body* as an articulating surface, a bespoke route to revealing *our discrete existence* as embodied contexts. For Mabel Ellsworth-Todd, there is value for each of us in capturing a sense of our situated complexity, a place where we gain experience in the ways we might engage with *our* world.[2] It is useful to heed the thought of Ellsworth-Todd reminding us how 'to be alive and to inhabit a body is to be continuously, and radically in relation with the world, with others, and with what, we make of them'.[3]

For Madeleine Gins and Arakawa, it is through the subtlety of our relational body that we each come to establish how to behave as we foster feasible forms of interaction with others.[4] Ultimately, it is amidst such negotiated encounters that we learn to shape the possibilities to move toward discerning, lived experiences. In their work they spoke of *our* vulnerabilities and *our* shared need to forge attentive engagement through our behavioural processes. It is through these *attentions* that we can benefit from our assembled '*located tentativeness*'.[5] At the core of their work was a desire to explore the manner of *an architectural body* seeking to heighten awareness of ways we might each learn to live well, to be 'in rapport with all there is – as a ubiquitous piecing together'.[6] It is through such bespoke, lived experiences that we might explore a host of behavioural changes that shift over time, alter and alert our motivations, and interconnect with our extending associations. In echoing Randy Martin, we might recognise our moving, thinking bodies as 'momentarily legible...materialising before our eyes'.[7] As bespoke, *discrete, articulating surfaces* we continue to experience what are, after all, ever-changing bodily contexts. Our experiences of being bodies have always been shaped according to specific cultural moments, the reinforcing of trends and subtle generational shifts. In questioning the idea of what a sense of a 'natural' body might be, there is a *multiplicity of possibility* in reference to each individual *being-body*. In tracing these ideas, we might shift towards exploring *our felt-sense, our 'bodiliness'*, recognising how, for each of us, it is our *bespoke embodiment that can sense the feel of watching another moving body in space.* For John Dewey, our individual identity remains *emergent*, relying as it does on relations existing betwixt our individual ways of being and learning to live in association with others.[8] We are immersed amidst social processes, each chancing to recognise and learn from our social interconnectedness. It is these multiple associations that provide the possibilities of our individuality. There are many routes to follow in coming to recognise our existence, our associations, and our

learning as *beings in and through space*. In blurring boundaries between facets of what we might each consider to be our lively, fluid bodily states, and turning the lens towards the 'performer', there is a shift towards the resonance of absorbed acts of practice. There are feasible ways through which we can recognise performance by examining, rehearsing ideas, and speculating upon facets of our own practice through which:

the functions of the body may be revealed,
the functions of the body may be concealed,
the use of space by performers is challenged,
the ways performers work to forge associations,
the ways we experiment with expression,
the ways we secure means of reveal embodied sensibilities,
the ways we explore physical forces, forging new meaning and associations.

We are all bodies/persons, each with peculiar status, each distinct. It is through our bodies that we are realised in the world. It is through our bodies that we come to constitute who we are and what we might become. For Victor Ramirez Ladron de Guevara, '[I]t is by and through our bodies, that we come to recognise our existence in the world.'[9] Arguably as 'individuals' we continue to be estranged from that with which we should be most familiar. Bodies have always come to be shaped according to specific cultural moments. Our maturing bodies have never been knowingly 'natural', though the term itself may frequently be promoted amidst societal trends. Socio-cultural notions of image, status, and identity of *the body* continue to fascinate across time and societies. Varied attitudes towards the role of the body and bodily motion have come to prominence through trends concerning the investigation of bespoke identities. We each live through shifting constructions of our bodily identities, often dependent on changing cultural norms, our engagement with bespoke trends in practice, or through discrete bodily modifications.

Our bodies have always been cultural as well as biological. We express ourselves across the outer surface, reveal our personal identities, values, approaches to life, and cultural alignments for living. Understanding what is 'normal' – for which people, in which place, and at what time – is where differences become evident, available, and prized. These sentiments are part of the debate concerning an array of attitudes towards body modification and the recent resurgence in bespoke

body modifications with skin pigmentation, scarring, and implantations. The motivation to engage with what was once considered to be *extreme individualism* continues to gain popularity, reshaping bodies towards bespoke, designed selves.

ACTUALISING PRACTICE

With evident socio-cultural shifts towards inclusive practice and the broadening of identities, changes in attitude towards role-identifiers have emerged. David Schenck's succinct observation that 'it is through our bodily, emplaced self, that we literally are, selves expressed'[10] has value in explorations of the contested arena of human beings where our bodies can achieve peculiar status. Explorations undertaken by Cixious & Calle-Gruber have pertinence when arguing that for each of us, our body/bodies are possessed by us and in turn possess us.[11] It is through our bodies that we each come to recognise our existence in the world, an idea recognised by Maurice Merleau-Ponty when he notes that through our discrete, embodied 'life-world', opportunities arise that ultimately, come to constitute our bodily actions.[12] We can think of our body as **our medium of** *continuing experience*, as **our** *instrument of action*. It is through our emergent perceptions that we determine and shape our actions. Our lived experiences emerge as blended sensations arising within our bodies, through our practised modes of organising dynamic shifts of our physicality. It is through these processes that we come to forge our engagement/s with and perceptions of the world. Gilles Deleuze captures the sentiments when observing: 'As long as you don't know what power a body has to be affected, as long as you learn like that, in chance encounters, you will not have the wise life, you will not have wisdom.'[13]

The images, ideas, status, and identity of *any body, of every body*, continues to fascinate even though arguably we are and continue to be estranged from that with which we might think we are most familiar. Bodies have always been shaped according to specific cultural moments, social controls, and trends. Bodies are seldom 'natural', even though the term may frequently appear in media, across governmental controls and within religious doctrine. Much of the information we share in terms of bodily identity is derived from an array of contested ideas coming into existence across a range of theorising and modelling within and across societies. These cultural twists exist in varied contexts, across disciplinary fields, each seeking to shape debate, targeting, and managing populations. In performance-making we delve into artistry, investigation, unpredictability,

phenomenological integration, each of us framing our experience through an emerging constellation of discrete embodied competences. Immersed amidst the multiplicity of possibilities to be found in our moving, we can explore *generative* ways to express meaning through bespoke forms of representation. It is through facilitating engagement with our ideas and the others with whom we work that our practice of moving fosters new knowledge. Here, we can learn how to facilitate our critical, imaginative, and perceptive faculties. The feasibility of working in such experiential contexts, can teach us ways to *feel our way*, into and through, what are progressive experiences. It is here that opportunities can emerge for discreet explorations of our embodiment. When Meg Stuart speaks of her approach to reasoning her way into engagement with experiments in movement, it is the shaping of the explorative challenge that motivates the trajectory. Stuart recognises her practice as an attempt to 'physicalize the noise, the distractions, the projections that one experiences when meeting another'.[14]

Many of us will recognise how, when working amidst various modes of practice, opportunities can emerge in unexpected ways and in time come to shape the direction of any future explorations. The emergence of ideas in such environments can be opportune in shifting practice and fostering new ways of thinking, of generating and shaping artistic endeavour. It is here that change can emerge with practitioners benefiting from shifts within familiar processes. It is here that bodily practices can be felt as generative, in forging investigative opportunities that lead towards engagement with your own physicality and embodiment. Michel Kliën and Steve Valk speak of a key component of engagement forged through movement-based experimentation when they acknowledge, '[T]he choreographic act is one of cultivation...the shifting and changing and digging over of a situation in the social realm, allows for a new awareness to enter into a specific situation'.[15] Here we can acknowledge ways we each give focus to thinking through bodily interactions, benefiting from our emergent, embodied knowledge. It is a place where we learn in/through our discrete 'bodily being'. This sense of expressive discovery echoes in observations shared by Simone de Beauvoir. When exploring what it means for each of us to be alert and alive she observes that 'to inhabit one's body is cause for celebration'.[16]

Through the *feel of our physicality*, energising our bodily selves, a particular experience, *being audience*, stays with me. *Tragédie* (2012)[17] was choreographed by Oliver Dubois who, when explaining his drive to realise the work, alluded to a

specific thematic desire as his challenge. His aim was to explore what he perceived to be a *gulf between our lived experience, our ways of being human and an embrace of what he sensed to be, our fuller humanity*. The performance work *Tragédie* ran for ninety minutes. The first thirty exhausting minutes played out as a constant, rhythmic march of humans, all different, all distinctly particular, all pounding the ground as they marched downstage, turned and returned upstage before re-entering the space for a repeat, and all naked. From the upstage entrance, the dancers walked in unison with a shared, pounding pace, progressing forward to the apron before turning to travel away – the sustained, marching pace with no change of focus, with a company of people sharing an unending pace, all presenting a bounding sense of naked humanity. Through the time they shared on their journey, revelations were shared with an audience transfixed by the power of human presence: the revelation of difference between discrete bodies, the particularities of chosen body modification, the evident change in bodies through age, through personal history, through family traits, through choices made by each, individual in shaping and colouring their bespoke individuality.

As the performance progressed, the company sustained their shared thudding, paced, striding as they marched down the stage, turning and returning up the stage. The energy of the march was powerful, even hypnotic, with only a fleeting disappearance of each performer as they passed through an upstage drape, quickly re-entering through the tassels a moment later. On their return they recommenced their striding march. The pace was kept to a full stride, heavy and pulsating, accompanied by a sound score that thudded and flooded the auditorium. As *Tragedie* progressed, it generated unexpected fascinations initially found through the myriad of small differences exhibited amongst the dancers as I watched from a darkened auditorium. Memories of the work give a sense of watching a company of individuals, each coping with the repetitive pace, yet maintaining shared time, stride, focus, and determination. As audience, the fine-tuning of these persons/personalities shifted between the mass bombardment of emerging energies as the company marched down the stage, turned, and returned, each following the same path. The fascination drawn from the focus of each performer reinforced the sense of being held by the power of their unified, human energy.

As I scanned the stage looking for chance to capture discrete moments revealed through their repeating score, I moved along the pathways, switched attention, examined the articulation of these human bodies, these human beings in motion, feeling in association with their pulsing momentum.

As a company, they...

march down the stage,
plant each foot heavily into the ground.
The foot fall projected a pounding, repetitive rhythm,
and evident individual nuance of stride,

shift their foot, hip, pelvis alignments,
finding balance in the length of stride,
securing their falling weight each time,
capturing their fall as they moved through space,

reveal differences between bodies,
with evident low and high centres of gravity,
difference in the transference of weight – evident in how a foot lands,
the knees stretch, balance is found in pelvic alignment,
the gait attuned with length of leg, torso and neck –

move with continuous propulsion through space,
each person grounded,
with purpose and association with those they worked alongside,

reveal discrete variations between their physicality's deepness
of breath and carriage of weight,

breathe through continuous challenges,
pounding the floor, maintaining pace,
controlling their discreet beat as they channel a unified task.

As *audience*, our focus intensified, attention shifting towards the details: of repetition, of idiosyncratic shifts of weight, of witnessing repetitive exhaustive effort, of watching naked bodies stride in rhythm and synchrony, of being caught by the disappearance and reappearance of each performer as they momentarily passed through the upstage gauze, of being caught by and following a particular performer as they moved through their paces, of noting their breath and at times our own breath held for a moment, of feeling rhythm in the length of stride, of breath, of swinging arms and of bespoke movements of individuals. These associations

were released by bodies moving, accompanied by the pulsating rhythm of sound that filled the auditorium. The impact of watching powerful, bare-bodies, bare people, move through space with shared determination, momentum, physicality, and endurance was palpable.

> *From my fixed position in the auditorium with the need to peer into a dimly light stage, I was drawn by the array of idiosyncrasies gradually revealed as I chose who and what to scrutinize. The thrill of the driving force of biomechanics was reminiscent of Muybridge's human motion studies. The quality of being in relation with the performers changed as they disappeared into the distance only to return in ever increasing size and detail as they approached the threshold of the stage. For thirty minutes I remained unseen, presented with a fleeting spectacle where my gaze could settle on one performer only for them to disappear, at that very moment a new opportunity burst forward. I had time to understand the form, to predict my choices of who to wait for, only to be thwarted by a shift in location. Performer and audience came to know the game we played. The bombarding physical presence gave way to allegiances forged by individuals who worked in temporary grouping in jerking moments of unison, rhythm and spatial design.*[18]

With little contact between performers in the early stages of the performance, what gradually became evident was the pace and power of bodies, occupying their personal space; at times running chaotically across the stage with arms and legs flailing in the air. The published programme notes promoted the sense of power and rhythm of each body's impulsive movement through space, the revelation of individual, personal bodies unified through shared pace. Drawing on thoughts shared by philosopher and psychotherapist Eugene Gendlin[19] we might recognise these associations as a *bonded mutuality*, a place where what we might feel at any moment is always interactional, living as it does amidst relations, situations and contexts, persons, their language, their past and present. The spatial tensions and play with appearance and disappearance secured what was an exhilarating experience, introducing me to a choreographer who at the time was considered as both transgressive and hybrid. *There was a tangible sense of being captured by the feel of inhabiting other bodies, of being caught by the physicality, moved by the momentum, the effort of bodily inscription and transmission, of sensorial connection.* The sensations align with observations offered by José Gils in work considering

the notion of a *paradoxical body* when arguing that '[d]ance operates as a kind of pure experimentation with the body's capacity to assemble, thus creating a laboratory where all possible assemblages are tested'.[20]

On my part, the memories are of immersion within the bodily sense of experience. It was a performance and audience experience that was consciously felt through my body. There was vibrancy felt through spatial tension, vulnerability too, with respect to their shifting proximities and unexpected coincidences in spatial patterning. It was exhilarating to experience performance through its physical, sensuous dynamism.

For Kira O'Reilly, in her performance work *Untitled Bodies*, **'the action begins where words fail me'**.[21] Using processes of measuring and cutting, the skin is marked/annotated, like a text or a drawing, etching/mapping a history across the surface of the skin. In the work *Sssshh—Succour* (2002) there is a different trajectory to follow in exploring her quest as a palimpsest, scaring tiny marks/cuts of varying sizes across her mapped body. After gradually shaping an array of discreet taped spaces/boxes onto her skin, O'Reilly moves through a slow paced, attentive practice, deliberately creating small-but-visible cuts, each one etched into her skin. Together they create an organizing, visible matrix across the body. When reflecting on the work, O'Reilly records the process, noting the ways a 'palimpsest of tiny scars in varying stages of disappearance is being established on my body from each successive performance. They both document a history of the work and are, indeed, part of the work – collapsing the differences between 'making' and 'performing'.[22]

With the scars etched into place as an act of documentation, capturing an array of features of the experience, together they reveal the journey of the work, the time of healing, with distinct differences evident in each unique scar. The healing body is part of the performed work, shifting and altering as the body seeks to resecure its outer covering, *the skin*. The performance unravels the complicated nature of our bodies as a state of contestation concerning both power and fragility, always aware of the sense of seeking to secure containment and yet always leaky. O'Reilly used features of the work as a route to reveal a sense of progressive collapse between the 'making' and the 'performing'. The intention was to reveal bodily immersion as a dynamic, lived context. A place where 'the scarring can become part of a bodily memoirist process of events, chronicling what has happened within a lifetime, captured in marks we may call scars'.[23] Keith Gallasch notes that it was

these functional and associative processes that drew attention.[24] The deliberate action shared meticulous skill whilst fostering visceral disturbance for those watching. Interestingly, Gallasch recalls a palpable sense of intensity running through the performance, triggering, bodily responses:

> In watching and tracing her map it was...
>
> 1. The performer's essential sense of stillness.
> 2. The attentive taping of the body evoked notions of a skilled butcher's preparation of meat with string.
> 3. The impact of the *bright whiteness* and clinical equipment shared a sense of the attentive care of the surgeon.
> 4. The triggers felt with each deliberate cut of the blade, echoing accidental cuts to one's own flesh are triggered.[25]

Writing in response to the performed works of Kira O'Reilly, Harriet Curtis speaks of being drawn to the work through interest in politicised intervention.[26] Caught by the mapping of the body and of memory, Curtis *re-feels* the visceral transmission between bodies as something palpable. With a strong sense of alert, the inscriptive-though-contemplative process and rigorous cartographic attention to the body left a feel of a *forever, on-going,* and peculiar status of the *human body.* For Moira Gatens, it is through such a Spinozian account of the body that we can sense such a *productive and creative body,* one that changes through time and has unknowable limits, unknowable capacity.[27] Returning to Simone de Beauvoir's observation that 'to inhabit one's body is cause for celebration',[28] we might appreciate that we each think through our bodily interactions and embodied knowledge. We each learn *in and through* our moving and our associations. *I/We/They are never only one,* each of us is accompanied by discrete connections gained through our accumulating experiences. In these ways we are each multiple. We each depend upon dynamic interrelations that exist in/through our associations in space and time. It is here that we can recognise our existence as *receptive beings,* intermingling our individuality and our ways of being-in-relation.

> Movement has the potential to be seismic. It can spread and its energy can be infectious. *I body you, you body me.*
>
> – Doris Uhlich[29]

1. Maurice Merleau-Ponty, *Phenomenology of Perception* (London: Routledge and Kegan Paul, [1945] 1962).

2. Mabel Ellsworth-Todd, *The Thinking Body* (Gouldsboro: Gestalt Journal Press, [1937] 2005).

3. Ibid., 4.

4. Shusaku Arakawa and Madeline Gins, *Architectural Body* (Tuscaloosa: University of Alabama Press, 2002), 65.

5. Ibid., 65.

6. Ibid., 65.

7. Randy Martin, 'Dancing Through the Crisis', *Writings in Dance* 8 (2010): 21.

8. John Dewey, *The Quest for Certainty: A Study of the Relation of Knowledge and Action* (New York: Putman, [1929] 2011), 23.

9. Victor Ramirez Ladron de Guevara, 'Any Body? The Multiple Bodies of the Performer', *Performance Perspectives: A Critical Introduction,* eds. S. Popat and J. Pitches (Basingstoke: Palgrave Macmillan, 2011), 23.

10. David Schenck, 'The Texture of Embodiment: Foundation for Medical Ethics', *Humanities Studies* 9 (1986): 43–54, 46.

11. Hélène Cixious & Mireille Calle-Gruber, Hélène Cixous, *Rootprints: Memory and Life Writing* (London: Routledge, 1997), 30.

12. Merleau-Ponty, *Phenomenology of Perception.*

13. Gilles Deleuze, 'Gilles Deleuze Lecture: Transcripts on Spinoza's Concept of Affect' (1978), webdeleuze.com/php/sommaire.html.

14. Catherine Sullivan and Meg Stuart, 'Catherine Sullivan and Meg Stuart', interview, *BOMB Magazine,* July 1, 2008, bombmagazine.org/articles/catherine-sullivan-and-meg-stuart.

15. Michel Kliën and Steve Valk, 'What Do You Choreograph at The End of the World?', *Zodiak: Unden Taussin Taehen* (Finland: Like, 2007).

16. Simone de Beauvoir, *The Second Sex,* trans. Constance Borde and Shelia Malovany-Chevailler (London: Vintage Books, [1949] 2011).

17. Oliver Dubois, *Tragédie, 2012.*

18. Fiona Bannon, 'Mindful Motion: Engagement with the Messy Vitality of Research', *Contemporising the Past: Envisaging the Future,* Anger, France (July 2014), 141.

19. E. T. Gendlin, 'Experiential Psychotherapy', *Current Psychotherapies,* ed. R.J. Corsini (Irasca, IL: Peascok, 1973).

20. José Gils, 'Paradoxical Body', TDR: *The Drama Review* 50, no. 4 (Winter 2006): 21–35, 30.

21. Harriet Curtis and Michael Hargreaves, eds., *Kira O'Reilly: Untitled (Bodies)* (Bristol: Intellect Ltd., 2018).

22. Kira O'Reilly, 'Kira O'Reilly', *Artists Talking: Exposing Contemporary Visual Arts Practice* (2002), quoted in Jennie Klein, 'Kira O'Reilly', *Rapid Pulse online,* n.d., 2014.rapidpulse.org/kiraoreilly.

23. Keith Gallasch, 'National Review of Live Art: Blood Lines', *realtime,* Dec. 1, 2002, realtime.org.au/national-review-of-live-art-blood-lines.

24. Ibid.

25. Ibid.

26. Harriet Curtis, 'Introduction', *Kira O'Reilly: Untitled (Bodies),* eds. Harriet Curtis and Michael Hargreaves (Bristol: Intellect Ltd., 2018).

27. Moira Gatens, *Imaginary Bodies: Ethics, Power, and Corporeality* (New York: Taylor & Francis, 1998), 68–69.

28. de Beauvoir, *The Second Sex,* 84.

29. Doris Uhlich, 'Statement', dorisuhlich.at/en/biography.

PAIN
peɪn

Pain is a complex sensory experience that serves as a crucial protective mechanism, signalling potential harm or injury. It encompasses physical, emotional, and civic dimensions of how we deal with pain, which varies widely in intensity and nature. Public pain and collective crisis evoke emotional responses, including fear, anxiety, and distress, which affect how we live together as communities. Pain threshold is the point at which pain is first felt. Pain tolerance specifies the level of discomfort an individual can endure. Both depend on genetics, psychological state, cultural influences, and collective handling of suffering and resilience. Pain as a common or shared experience has impacts on *how* compassionate care and the profound impact pain or a wounded existence has on the quality of life will be negotiated intensely in post-anthropocentric societies.

PASSAGE

ˈpæsɪdʒ

Passage indicates a transition, journey, or movement from one state, place, or condition to another. It encapsulates the concept of evolution through time, space, or life stages. Passage involves the movement from one moment to the next, symbolising the flow of time and change, or it implies movement through physical spaces, such as a corridor, pathway, or travel route. Passage can also carry metaphorical significance, representing growth, transformation, or a shift in perspective. Rites of passage are cultural rituals marking significant life transitions, such as birth, adolescence, marriage (relational ties across various lifeforms[1]), and death, activating the journey of the soul, exploration of the unknown, or transitions between life and death, bridging between states or at times facilitating movement between destinations. Navigating passages requires adapting to change, embracing growth and decay, while recognising the significance of transitions. Whether through physical movement, personal evolution, or metaphorical exploration, passages shape posthuman becoming and contribute to the rich tapestry of life's journey.

1. During the project *BIOPHILY* (1993-2002), artist Thomas Feuerstein married a rubber plant. The plant (*Ficus elastica*) is native to the forests of India and a popular houseplant in European living rooms. See thomasfeuerstein.net/50_WORKS/75_LABORATORY/90_Honeymoon.

INGRID DENGG &
SIMONA KOCH

Dream Entanglements

Staying with the Threshold

Dreams have always fascinated mankind. In dreams, we cast off the shackles of everyday consciousness. We become permeable to deeper layers of our being. The Sufis speak here of seven planes of consciousness, beginning with the material world, which we experience through our physical body, through the mental and soul levels to the transcendent world, which we experience through our pure self and light body.

Each of us exists simultaneously on all these levels. But we are rarely aware of this in everyday life. In dreams, however, our experience opens up, just as it does in the retreat process, where we are shut off from everyday life and immerse ourselves in inner experience.

Dreams are therefore also valuable companions in the inner transformation process. They show us where we are internally. They confront us with our weaknesses and inner blockages, but at the same time they also show us how we can overcome these blockages and thus become an important resource. They are a source of creativity and inspiration and inner guidance.

Sufi master Nigel Hamilton, founder of the Centre for Counselling & Psychotherapy Education and the Dream Research Institute in London, has studied the potential of dreaming and developed the so-called 'waking dream process', in

which we relive the dream in our imagination with the help of a trained dream guide, but this time consciously.[1]

The dream guide will ask questions or suggest one or the other intervention. Ultimately, however, it is the inner guidance of the dreamers themselves that guides the dream guides in their work. An important part of the process is also to pay attention to the resonance of the dream events in the body. The guide will, on every relevant occasion, ask where, or how exactly, the dream energy can be felt in the body. This 'felt sense' helps us to make the dream work authentic and grounding.

Simona was already an experienced dreamer when the dreamwork below came about on October 19, 2022. She was doing a two-week spiritual retreat at the time, at the end of which she was confronted with the fact that her grandmother was on the brink of life and death. She immediately went to see her and accompanied her granny, who was very close to her, in her dying process. The following dreamwork is based on a vision Simona had at the time her grandmother died.

Dreamwork on October 19, 2022

Ingrid: Go to the beginning of your vision and describe to me what you hear, see, and feel.

> **Simona:** Already when we talked about it beforehand, an inner image built up. I am in a dark interior, like a cave. It's big, spacious, black, looks like stone.
>
> ...
>
> In front of me is a slit in the structure, like a vertical eye.[2] I can look out – on the outside, I see the sea below and the sky above.
>
> ...
>
> I am very small in this cave, which seems huge right now. I feel the situation.
>
> ...

Ingrid: Can you describe the feeling of being small in more detail? How does it feel?

> **Simona:** It feels as if I am observing the person looking out of the cave myself. [...] So I have changed position – or it is always changing back and forth from observer to subject.
>
> ...
>
> The person sitting there is illuminated by the light coming through the entrance to the cave. It could also be that I am the space.

September 27, 2022. At the time her grandmother died, Simona was sleeping and woke up with the following vision: I am inside looking through a vertikal eye-shaped opening to the outside. Above is the calm sky, unterneath the sea.

Ingrid: Try to feel that you are the space – that you become one with this space.

Simona: The space is spherical.

Ingrid: Where can you feel it in the body?

Simona: The centre is in my heart centre and extends beyond the boundaries of my body. It is unclear whether there is a boundary.

Ingrid: Feel the centre of the circle in your heart, while the dark space around it expands. On the one hand, there is the circular shape, on the other hand, the boundary is open to the outside.

...

Simona: The centre in the heart seems brighter. There is a brightness.

...

Ingrid: Stay with this brightness.

Simona: Now the focus shifts so that my consciousness moves more towards the centre of the circle. Before I perceived it from the periphery, now the consciousness slides inwards.

...

I am now even closer to the centre, but not inside. The centre seems like mist or cotton wool...then comes a soft transition and then there is another sphere or orbit of darkness before the actual centre comes. I am now in the place where the swathes are. After that comes space.

...

Ingrid: What do you feel there?

Simona: The heartbeat is very present right now. It's a strange in-between state. My consciousness has drifted towards the centre and then it has stopped in the transition zone.

Ingrid: If it stopped, there must be a visible or invisible border, right?

Simona: Yes, just these vapours...

Ingrid: Can you try to feel with your hand if you can make contact with these vapours?

...

Simona: Now that you mention it, I notice that I can already move my consciousness towards the centre. I can dive into this diffuse structure, into these yellow swathes.

Ingrid: What do they feel like? Are they positive or unpleasant or indifferent?

Simona: They are inert and it seems to me that towards the centre it becomes rather golden, radiant. Outside, it was still rather white.

Ingrid: And the centre – can you see it or is it more that you sense it?

Simona: I am drifting upside down towards the centre. At my head I am golden, with a gradient down the body to white. There are clouds.

Ingrid: Notice how you feel...it is obviously a movement towards the centre. You feel the pull of the centre. Trust that the force is guiding you at the right pace.

Simona: There is a feeling between the heart centre and the collarbone. Now something like a diffuse sun arises at this point.

Ingrid: Go with your attention to this place and feel how the sun develops there. Let it happen.

Simona: It's as if the clouds have cleared and a sun-like structure has developed there, in the centre of the structure. It's not a glaring light, as in pictures of the sun, but rather a fine light that is not too intense.

Ingrid: Keep your attention on this point between the heart centre and the collarbone.

Simona: The point has now moved inwards. On the outside, Granny has formed like a protective image of stars, embracing and protecting the centre with her arms. Like an orbit around the centre of light.

Ingrid: Take this image into yourself.

...

Simona: My position has changed – I have moved further away and now see the whole thing as if in the cosmos, with the sun in the centre entangled with the spiritual light body of Granny forming the orbit. It's a mixture of her image and the feeling about her personality.

Ingrid: Feel if there is something she wants to tell you and you want to tell her, or if it's okay the way it is now.

Simona: There is a kind of half-shell around the sun in the centre. I have an impulse to form the other half to it.

...

Ingrid: What do you need to make it possible?

Simona: It's already happening. It's like my arms are growing into this structure. Like when an organic tissue develops, like mosses or lichens, structures that grow together.

Ingrid: Granny and you, you form this fabric together, so to speak?

Simona: Yes, exactly.

Ingrid: How does that feel now?

Simona: The perspectives keep changing.

...

The sun has become bigger and now radiates more orange. The entangled texture now connects with the sun. It is as if it melts through the heat and becomes one with the structure of the sun.

Ingrid: You and your granny, have you then also become part of this sun in a way?

Simona: Yes, exactly.

Ingrid: Are you both in the sun or are you still a little outside it?

Simona: I'm not quite sure.

Ingrid: Feel into this sun. Both of you – you and your granny – have contributed to the creation of this sun. It is your common sun. Can you say that?

Simona: I think so.

Ingrid: Try to feel what your impulse is now.

Simona: At the moment it feels like this sun is hanging from my neck like a shining piece of jewellery.

Ingrid: Bring your attention to this sun that hangs around your neck like a jewel. It is a symbol of union with your grandmother.

...

Simona: The sun is small, like a little diamond, and has a very fine radiance. It's something good and carefully made and functioning.[3]

Ingrid: Notice it and take it in.

Simona: It feels like it is inside the chest.

Ingrid: Is that the same place as before?

Simona: Yes. The radiant light of Granny dissolved into the sun and was contained there together with me.

...

Now the slit from before reappears. Now I am in the entrance area, at the transition from inside to outside. I look at the wall, the rock structure at the entrance, which is light on the outside and dark on the inside.

...

Ingrid: In the beginning, you were looking from the inside to the outside – and where exactly are you now?

Simona: No, in the beginning, I, or someone, was sitting in the centre of the cave. Now I am directly on the threshold from the inside to the outside.

Ingrid: And this outside, can you perceive that too?

Simona: I haven't looked around yet, I only see the stone in front of me where the transition from dark to light can be seen. My gaze goes to the left side of the opening.

Ingrid: Then feel within yourself the sense of the threshold you are on... here at the transition between dark and light. Is that possible?

Simona: Hmmm, I don't know.

Ingrid: Maybe you like to touch this rock face?

...

Simona: It's like basalt, with strong, rough, rectangular shapes.

Ingrid: What does it feel like?

Simona: It's angular and cracked, but also smooth, very angular.

Ingrid: Would you like to put one hand on the dark side and one hand on the light side?

Simona: It's like embracing the entrance. The wall is amazingly thin. On the left it's dark, on the right it's light.

Ingrid: How does it feel to embrace this entrance? Are both sides the same?

Simona: With the dark side I notice that it is still unclear where it goes. With both hands, the feeling is that I am in unknown places.

Ingrid: Is it good that you can stop at this threshold because it is something solid?

Simona: Yes. I didn't want to look to the right or to the left yet.

Ingrid: Then try to feel inside yourself where you are more drawn to – the unknown light or the unknown dark?

...

Simona: Hmmm, I have the feeling that the threshold is quite good for me right now.

Ingrid: Okay, then stay on the threshold. The threshold is an important point. In which direction do you want to look from here? You don't have to open your eyes, but where are you drawn to?

Simona: Hmmm, interesting. In the dark, I was actually already there. But it's not that I'm drawn to the other side.

Ingrid: You also said that the dark is unknown.

Simona: Hmmm

...

Ingrid: You don't have to make a decision. At the threshold, you always have the possibility to go into the light or into the dark.

You know that it is also said that the dark is the light that you cannot yet see. It also has a certain protective function. You first have to mature for the light in order to be able to bear it.

But now you have something very important. You have this sun above the heart centre – that is probably the place of the Wheel of Fire.[4] This point was already an issue with you before. And now you have this sun, intense and small. It has landed in your heart centre. You and your grandmother have now become this sun together. I think you also need time until you can fully engage with this inner sun, with this light. That's why the threshold is the right place for you now.

Simona: Yes, exactly, that's how it feels.

Ingrid: Then take in again very intensely the feeling of being at the threshold and at the same time feel the presence of your grandmother and you in the sun, in your heart centre.

...

Simona: Now something else has happened. By holding the rock, I have slipped into the rock – I have become part of the threshold myself.

Ingrid: Good. Take this feeling into yourself and when you are ready, return with your attention to this room.

The threshold Simona experiences in this dreamwork is, on the one hand, a threshold between life and death, which shows itself here as a threshold to transcendence, where duality disappears and something new emerges from Simona's fusion with her grandmother – this shining inner sun in her heart centre. At the same time, this threshold is also closely linked to her spiritual development. The symbol of the cave is the entry into the inner space that is infinite and boundless.

The observer and the observed and the act of observing are one. There is no longer a delimited person, she becomes one with the space.

And she initially experiences this space as dark. The Spanish mystic St. John of the Cross speaks here of the 'dark night of the soul'. Whereas before, in her retreat, Simona had quite colourful and light-filled visions, here she is confronted with a dense and intense blackness. The Sufis speak here of 'black light'. It protects us from the glaring brightness of the light of the spirit, the light of the inner sun, until we are finally able to withstand this light. Light and black light are basically one. What changes is our perception of the inner, subtle light. And also our perception of the self.

Simona remains on this threshold. She becomes a threshold herself, so to speak.

And it might be noteworthy that staying with the threshold is held by some mystics as the true treasure and potential of the spiritual journey. For the well-known tenth-century Sufi master Muhammad al-Niffari, who designated a whole book on 'staying',[5] this is not only a station in between, digesting the former station in order to embrace the station about to be unveiled. During *waqfah* (staying), the wayfarer is put on fire by being cast back in bewilderment and confusion and thus purified from his or her ego as well as from any concepts what we might have 'reached' on our journey. As Niffari puts it: 'The *waqif* [the wayfarer in this state] almost overpasses the condition of humanity and with it temporality is no longer familiar. It transcends the quality of phenomenal existence.'[6]

Translated from German by Mariella Greil

1. Nigel Hamilton, *Awakening through Dreams. The Journey through the Inner Landscape* (London: Karnac Books, 2014).

2. The image of the vertical eye is reminiscent of the representations of the 'third eye' on the forehead of Buddhist or Hindu deities. In Simona's dream, this symbol could mean that her third eye is beginning to open and that she is at a threshold of consciousness that will allow her to have new, transcendent experiences.

3. After the dreamwork, Simona remembered that she inherited a spherical piece of jewellery from her grandmother that corresponds exactly to this inner image.

4. In Vedanta as well as in the Sufi tradition, one speaks of seven chakras or subtle energy centres.

These 'Wheels of Light' serve as gateways to our inner world, but at the same time they are also connected to the functioning of the physical body. In addition, there are a number of smaller energy centres. One of these is the 'Wheel of Fire'. It is located between the collarbone and the heart chakra, and when it opens, according to Nigel Hamilton, it is a sign that the adept is beginning to open up to the transcendent light.

5. *The Mawáqif and Mukhátabát of Muhammad Ibn 'Abdi 'L-Jabbár Al-Niffarí*, ed. and trans. Arthur John Arberry (Cambridge: University Press, reprint 1987).

6. Actually, this quote is compounded by three of Al-Niffari's utterances. See Al-Niffari (1987), 33–34, 37.

THRESHOLD
'θrɛʃˌhəʊld

Threshold signifies a pivotal point of entry or transition between different states, conditions, or experiences. It embodies a boundary that marks a shift from one realm to another, often carrying symbolic or practical significance. This transition point presents a juncture where a change, transformation, or passage occurs. Thresholds can be physical, such as doorways, gates, or portals, as well as metaphorical, symbolising shifts in consciousness, emotion, or understanding. Crossing a threshold often invokes a sense of liminality – an in-between state with potential for growth, revelation, or uncertainty, and can evoke a host of emotions: anticipation, fear, excitement, or relief. The verb 'thresholding', in this context, denotes decisive staying at the point of decision or dwelling at the zone of passage. Initiations, rite-of-passage ceremonies, fertility or funeral rites, but also certain contemporary performances, are staged at the cusp where liminality resides and border crossing takes place. Exploring the profound meaning of cultural, religious, personal, but also ecological, thresholds carries insistence on metamorphoses indicating critical levels of change, impacting biodiversity and ecology. Besides the milestones in an evolutionary process, 'thresholding' – in present continuous – invites continuous

commitment to equally attend to small acts and minor gestures that have the potential to shift or transfigure the way we live together and create this world. Navigating thresholds involves courage, adaptation, and embracing new possibilities. Thresholding responds to a consistent call to reflect on where we have been, where we are headed, and the potential for transformation and change.

WAX
wæks

Wax is a versatile organic substance valued for its properties such as malleability, water resistance, and melting point. Synthesised chemically or derived from plants or animals, wax gets commonly used for candle making. As the wax burns, it undergoes a phase change from solid to liquid, emitting light and heat. Wax has a malleable texture and consistency and brings shine to surfaces of automobiles, furniture, and shoes or is used to coat fruits and vegetables, extending shelf life and maintaining freshness. Wax also aids in creating accurate orthopaedic casts or dental prosthetics. In the amaryllisation project, wax coated the bulb of the plant, laying bare the vigour contained in the sprout. The adaptability of wax continues to make it a valuable substance in a wide array of human or other contemporary lifeforms' endeavours.

Biographies

FIONA BANNON is an experienced academic and department leader, with scholarship and teaching specialism in dance aesthetics, relational ethics, social choreography, and practice-led research. In writing, with *Considering Ethics in Dance, Theatre and Performance* (2018), Fiona positioned body-based learning as a key aspect of our identity and relationality. As an Associate Professor at the School of Performance and Cultural Industries, University of Leeds, UK, Fiona supervises doctoral candidates in the fields of environmental aesthetics and social-engaged dance practice. She is chair to the fledgling World Dance Alliance (WDA) – Europe and, as such, represents Europe as a board member of the global WDA.

ASHON CRAWLEY is Professor of Religious Studies as well as African-American and African Studies at the University of Virginia, USA. He is the author of *Blackpentecostal Breath: The Aesthetics of Possibility*, about aesthetics and performance as forms of social imagination, and *The Lonely Letters*, an epistolary, semi-autobiographical work about love, blackness, mysticism, and quantum theory. *The Lonely Letters* won the 2020 Believer Book Award for non-fiction and the 2021 Lambda Literary Award for LGBTQ non-fiction. Crawley is currently working on two books about the historical role of the Hammond organ in the Black Church and social life.

INGRID DENGG holds a PhD in German Philology and Art History, is a journalist and former trade unionist, and, since 2003, has been on the spiritual path. She is a leader, retreat guide, and dream guide in the Sufi order of the Inayatiyya. In 2019, she translated her Sufi teacher Nigel Hamilton's book, *Awakening Through Dreams*, into German. She is interested in inner-transformation processes and loves to encounter the boundaries of being, for instance during her walks through the wilderness of northern Norway or while she spends seven weeks in complete darkness in a Buddhist monastery.

GURUR ERTEM is a sociologist, dancer, and performance studies scholar. She is currently Research Fellow of the Alexander von Humboldt Foundation, Freie Universität, Berlin, and teaches at the Department of Dance at Mimar Sinan University of Fine Arts as well as the Department of Sociology at Boğaziçi University, both in Turkey. Ertem's trans-disciplinary work combines the arts, and social and political theory in particular dialogue with her Hannah Arendt Scholarship. She is recipient of Akademie Schloss Solitude and Institute for Critical Social Inquiry Fellowships. Ertem has served as a jury member for the German Dance Platform 2020 and curated the iDANS Festival for Contemporary Dance and Performance, Istanbul, 2006-2014. Her recent publications include *Bodies of Evidence: Ethics, Aesthetics, and Politics of Movement* (2018), co-edited with Sandra Noeth.

MARIELLA GREIL works as an artist, dancer, and researcher, focusing on contemporary performance, especially its ramifications in the choreographic and ethical. She holds a PhD and is Senior Artist at Angewandte Performance Laboratory at the University of Applied Arts Vienna, where she currently works on the project *Choreo-ethical Assemblages – Narrations of Bare Bodies*, funded by the Austrian Science Fund (FWF). Her work explores a politicised practice that targets trans-subjective, communicative processes in performative encounters, using the practice of expanded choreography and somatic practices as compositional tools. With Vera Sander, she co-edited *(per)forming feedback* (2016) and, together with Nikolaus Gansterer and Emma Cocker, *Choreo-graphic Figures – Deviations from the Line* (2017). She recently published the monograph *Being in Contact: Encountering a Bare Body* (2021). For more, see mariellagreil.net.

MIA HABIB is a dancer and choreographer working with performance, exhibitions, publications, teaching, mentoring, and curating. She holds a MA in Conflict Resolution and Mediation from Tel Aviv University and a BA in Choreography from the Oslo National Academy of the Arts. With her association, Mia Habib Productions, she has published two books: *Stranger Within* (2021, co-edited with Jassem Hindi) and *How to Die – Inopiné* (2022, co-edited with Ashkan Sepahvand). Her work has been presented globally, in over thirty countries. She worked as a dancer in Carte Blanche, the Norwegian National Company for Contemporary Dance, 2017–2018, for whom she also realised a commissioned work.

ALICE HEYWARD is a dancer, choreographer, and teacher from Australia living in Berlin. Alice's practice develops through diverse collaborations – as author, co-author, and interpreter – constructing different situations for exchange and connection. Through movement/thought, she explores the production of embodied poetics. Her most recent work includes a new project with Adam Linder at the Museum of Contemporary Art Australia and touring works with Luisa Saraiva and Maria Hassabi. In 2022, she created *Tributary* at Klosterruine, Berlin, in collaboration with Maciek Sado and Oisín Monaghan, premiered and/or toured *Tirana* with Luisa Saraiva as research partner and performer, and *Cancelled* and *Here* with Maria Hassabi. In 2020–2021, she collaborated with Fanny Gicquel, making *do you feel the same*, a performance installation in the gallery and public space, *Cry Carpet* with Megan Payne and Jacqui Shelton, and *Here* with Maria Hassabi. She is currently developing a new solo project exploring the figure of the banshee.

REBECCA (BECKY) HILTON is a dance person from so-called 'Australia', currently living in Sweden by way of New York City. As a dancer, choreographer, writer, researcher, and pedagogue, her work explores relationships between embodied knowledges, oral traditions, and choreographic systems, usually via long-term artistic residencies. She generates participatory art practices, experiences, and events situated in private and public spaces including universities, hospitals, shopping malls, national parks, community gardens, friendship circles, and family groups. She is Professor of Choreography for Site Event Encounter at the Stockholm University of the Arts and contributes as an artistic researcher to DoBra, a suite of innovative healthcare research projects based at Stockholm's Karolinska Institute. DoBra is a decade-long, nation-wide research programme exploring understandings of, relationships to, and experiences of ageing, death, and dying in Sweden.

SIMONA KOCH is a German graphic designer with a focus on book design and an artist in the field of artistic research. Her central artistic interest is the investigation of networks of life and organisms. Simona is involved in climate protection and sustainability projects and follows a spiritual practice in the tradition of Sufism and Zen Buddhism. She lives and works in Vienna and Bavaria.

PAVLOS KOUNTOURIOTIS is a performance artist, dramaturge, and performance theorist. He is the Head of the MA Performance Practices at ArtEZ, University of the Arts. His research explores the intersections and politics of pain,

daft bodies in performance and systems that exhaust themselves without the anxiety that prompts human intervention. He holds a PhD from the University of Roehampton in London, a postdoc research at P.A.R.T.S. in Brussels, an advanced Master's in Public International Law from the University of Leiden, and a Master's in Body in Performance from LABAN in London. For more, see kountouriotis.org.

LAUREL V. MCLAUGHLIN is a curator, art historian, writer, and educator whose research and writing explores contemporary research-based new media, performance, and social practice. She is a curator and director of the Collective Futures Fund at Tufts University Art Galleries, Boston, USA, and completing her PhD at Bryn Mawr College, USA, writing a dissertation about performative migratory aesthetics. McLaughlin has published scholarship and critical art writing in *Art Papers*, *ASAP/J*, *Antennae*, *BOMB Magazine*, *The Brooklyn Rail*, *Contact Quarterly*, *Women & Performance*, and *Performance Research*. Her co-edited volume *'Live' Art on Campus and Beyond: Tania El Khoury's Live Art: Collaborative Knowledge Production* is forthcoming with Amherst College Press in 2023.

SALKA ARDAL ROSENGREN works with dance and performance. She graduated P.A.R.T.S. – School for Contemporary Dance, Brussels, in 2010 and has since worked with artists such as Eszter Salamon, Xavier Le Roy, Daniel Linehan, Malin Élgan, Tino Sehgal, Boris Charmatz, Salva Sanchis, Rosalind Goldberg, Gunilla Heilborn, and Sarah Vanhee, among others. She premiered her piece *Lasting Figures* at Weld, Stockholm, in December 2022. As a choreographer, she has collaborated with Mikko Hyvönen (*Trash Talk*), Andrew Hardwidge (*subsubbodysub*), and Nicholas Hoffman (*The Thing with a Hook*), presenting work at MDT, Zodiac, Bâtard Performing Arts Festival, Brussels; Working Title Platform (Beursschouwburg, Brussels), Tanz im August, Berlin; and PACT Zollverein, Essen, Germany. In 2021, she received a MA in Choreography from Uniarts in Stockholm.

BARBIS RUDER is a performance and media artist, musician, and cultural manager. She graduated in Transmedia Art (Brigitte Kowanz) from the University of Applied Arts Vienna in 2015 and earned her PhD in Artistic Research under the guidance of Hans Schabus in 2023. Amongst others, her work has been awarded the 2014 H13 Lower Austria Prize for Performance by Kunstraum Niederoesterreich and the 2015 Art Prize of the Archdiocese of Freiburg. Her performances and sculptural works have been shown at numerous museums

including Künstlerhaus Wien, Landesgalerie Linz (now Francisco Carolinum), Neue Galerie Graz, Galerie Stadt Sindelfingen, ZKM | Center for Art and Media Karlsruhe, and mdm Salzburg. For more, see barbisruder.com.

KATHERINA T. ZAKRAVSKY, K.T. as author and ZAK RAY as artist/performer, is a conceptual and performance artist, philosopher, author, curator, and project manager. She has worked in the fields of urban and sub-urban studies, media, installation, and public art and holds a PhD in Philosophy with a dissertation on Kant's *The Conflict of the Faculties.* She used to teach philosophy at the University of Vienna and between 2021–2023, conducted the artistic-research project *Passenger Diaries* with Mariella Greil, Lucie Strecker, Viktor Fucek, and others. She has been leading the PEEK project *morphoPoly* at the University of Applied Arts Vienna with Jan Lauth, Simone Carneiro, and others. Since 1999, she has realised a number of solo works and cooperations in the field of performance with Oleg Soulimenko and Liquid Loft, amongst others, and is currently engaged in the ongoing series *Passiert* with Johanna Tatzgern and others. For more, see passengerdiaries.uni-ak.ac.at and morphopoly.org.

HEBA ZAPHIRIOU-ZARIFI (GAP, UKCP, IAAP) is a senior Jungian Analytical Psychologist, training analyst, and supervisor, with a private practice in London. A proponent of Justice with Peace, she consults on psychosocial projects in the Middle East, also working with victims of war. Heba is a speaker at international conferences and a published contributor to academic journals. She is leadership trained in BodySoul Rhythms® at the Marion Woodman Foundation, founder of The Central London Authentic Movement Practice, and integrates philosophy, body-psychotherapy, embodied active imagination, and the creative arts into her clinical work. Her alma mater is the Sorbonne, where she gained two master's degrees and wrote her doctoral thesis in philosophy.

Acknowledgements

What is most true is poetic. What is most true is naked life.
– Hélène Cixous[1]

The confluence of diverse concepts of life and poetry has spawned the discourse on bare bodies gathered in this anthology and therewith given rise to a temporary community of artists and researchers living between the covers of this book, even though they are geographically scattered across the globe, each rooted in their respective cultures. What they do have in common, however, is the *courage* to keep facing the ethical challenges of our time in the midst of this complex world. This is an endeavour deeply enriched by each contribution and has been a labour of love. I am immensely grateful to all those who have played a part in its realisation, especially to the artist and graphic designer Simona Koch, who has been an inspiring dialogue partner in the crucial stages of its development. Thanks for your profound generosity, artistic fine touch, and supportive friendship!

This book was made possible with financial support from Division IV – Arts and Culture of the Republic of Austria's Federal Ministry for Arts, Culture, the Civil Service and Sport (BMKÖS), and Bildrecht (SKE Fonds) by the University of Applied Arts Vienna: special thanks to Gerald Bast, Rector, and Barbara Putz-Plecko, Vice-Rector for Research and Diversity; Alexander Damianisch, Head of Zentrum Fokus Forschung and the Department Support Art and Research; Anja Seipenbusch-Hufschmied, Head of the Department of Publications, and Stefanie Schabhüttl, Publication Management, for their encouragement and untiring support. The Amaryllisation project as well as time resources required for the research behind the development of this book were partly supported by an Elise Richter PEEK grant from FWF (Austrian Science Fund).

Thanks to Scott Evans for copyediting and lending his eagle proofreading eye to this project. I am grateful to the editorial team of De Gruyter publishing house,

specifically Katharina Holas. In particular, I would like to thank my colleagues at Angewandte Performance Laboratory, Ricarda Denzer, Nikolaus Gansterer, Asher O'Gorman, Peter Kozek, Daria Lytvynenko, Timothy Nouzak, Jianan Qu, Barbis Ruder, Charlotta Ruth, Jasmin Schaitl, and Lucie Strecker for providing an artistic-critical ecology. I am thankful for colleagues at Home of Performance Practices, ArtEz (H.o.P.P.) who have engaged in meaningful conversations with me on posthuman life forms, daz disley, João da Silva, Pavlos Kountouriotis, Fenia Kotsopoulou, Maeve O'Brien Braun, Nishant Shah, and many students. Furthermore, the exchanges with Rosanna Irvine and Jeroen Fabius in the Research Mentors Team in collaboration with the Core Team Dirk Dumon, Soosan Gilson, Keith Randolph and peers at Co-creation of Movement Masters of Arts, Codarts (COMMA) have been nourishing my research. Conversations on human rights and arts with Walter Suntinger and Marilyn Volkman have been meaningful. Also encountering Dominika Glogowski who deeply engages in socio-ecological dialogue, and meeting Pavel Matela at Farmstudio Residency has been inspiriting. The tender beginning exchanges with Manora Auersperg, Cristiana de Marchi, Efva Lilja, Doris Wilhelmer promise to open new developments. Anne Dillard, I would love to meet you in person, your books have been a great source of inspiration. Thanks to the sound artist Miguel Mesa, for passing by and distracting me at the exact right moment from losing sight of what had motivated the making of the book from the beginning: the practice to respond to what life has in store. Nikolaus Gansterer and Alex Arteaga keep inspiring and challenging me to move on with all contingent agencies. Emma Cocker exudes generous warmth and wisdom, in the field of artistic research and in life, always there to turn towards. Thank you! I would like to thank Iris Julian, for her sustained support of strange practices and collaborations with various life forms, Johanna Tatzgern for living and working in diversity, and Emily Welther, for exchange on practicing joyously the entanglement with plants. I remember gratefully Daniel Aschwanden whose artistic vigour resonates in many corners in Vienna. Extended microtrips with *the Passengers* Kath Zakravsky and Lucie Strecker. Viktor Fuček and guests Radek Hewelt, Werner Moebius, Kira O'Reilly, Jens Hauser, Elke Krasny, Christina Gruber, Andrea Watzinger, Robert Linke, Heinrich Büchel, Thomas Feuerstein, and Daniel M. Büchel have reminded me to look closer and perceive collectively, in its etymological sense. Huge thanks go to those who remind me to keep dancing: Charlotte Ruth, Krõõt Juurak, Anne Juren, Philip Gehmacher, Vera Sander, Stella Geppert, Sabina Holzer, and Claudia Heu among many others! Andrea Rieger and Ute Langthaler are passionate admirers of plants and their

restorative verdure taught me to attend to the details with relish. Also, cordial thanks to my neighbours, who share the love for wild, untamed beauties and cultivated chats in our community garden. Ongoing commitment to the Somatic Extasy Group and friendship dances shared with Sylvia Scheidl, along with her deep appreciation for *gstettn* (Viennese slang for 'forgotten, overgrown, urban zones'), have always been abundantly profound.

Finally, a heartfelt thank you to my family Franz Auzinger, who has been teaching me to respect the earth, to my brother Dominik and his wife Sara, with who I share a love for flowers and bees, and their lovely kids, and, of course, my mother Annemarie, who has moved on from the Wheel of Life.

Last but not least, I thank my husband Werner, your openness and willingness to discuss sensitive and complex topics around the clock all year long is deeply appreciated. Your patience, understanding, and unwavering belief in me have been a source of strength during the challenging moments. And to my son Jaron, I want to thank you for teaching me to stay courageously creative – it is my greatest joy to see you move on in the Cycle of Life!

1. Hélène Cixous and Mireille Calle-Gruber, *Hélène Cixous: Rootprints: Memory and Life Writing* (London: Routledge, 1997), 3.

Mariella Greil (Ed.)
University of Applied Arts Vienna
www.mariellagreil.net

The publication was realised with the financial support of Division IV – Arts and Culture of the Republic of Austria's Federal Ministry for Arts, Culture, the Civil Service and Sport (BMKÖS), and Bildrecht (SKE Fonds). The Amaryllisation project was partly supported by an Elise Richter PEEK grant from FWF (Austrian Science Fund).

With contributions by Fiona Bannon, Ashon Crawley, Ingrid Dengg, Gurur Ertem, Mariella Greil, Mia Habib, Alice Heyward, Rebecca Hilton, Simona Koch, Pavlos Kountouriotis, Laurel V. McLaughlin, Salka Ardal Rosengren, Barbis Ruder, K.T. Zakravsky, and Heba Zaphiriou-Zarifi

Project Management "Edition Angewandte" on behalf of the University of Applied Arts Vienna:
Stefanie Schabhüttl, Vienna, Austria

Content and Production Editor on behalf of the Publisher: Katharina Holas, Vienna, Austria

Concept: Mariella Greil, Vienna, Austria
Cover image and images on pp. 29, 53, 107, 139, and 169: Mariella Greil and Simona Koch, Vienna, Austria
Copyediting and proofreading: Scott Clifford Evans, Vienna, Austria
Graphic design, cover design, and typography: Simona Koch, Vienna, Austria
Chirography: Mariella Greil, Vienna, Austria

Image editing: Pixelstorm Litho & Digital Imaging, Vienna, Austria
Printing: Holzhausen, the book-printing brand of Gerin Druck GmbH, Wolkersdorf, Austria
Paper: Nautilus Classic 120 gsm, Glama Basic 110 gsm
Typeface: Kepler™ by Robert Slimbach/Adobe Originals and Source Sans by Paul D. Hunt/Adobe Originals

Library of Congress Control Number: 2023943510

Bibliographic information published by the German National Library

The German National Library lists this publication in the Deutsche Nationalbibliografie; detailed bibliographic data are available on the Internet at http://dnb.dnb.de.

ISSN 1866-248X
ISBN 978-3-11-134137-8
e-ISBN (PDF) 978-3-11-134144-6

© 2024 Walter de Gruyter GmbH, Berlin/Boston

www.degruyter.com

ORGANISM
ˈɔːɡənɪzᵊm

The term 'organism' refers to a living entity that is capable of performing vital functions necessary for survival and growth in sensitive, systems. It encompasses diverse lifeforms, from single-celled microorganisms to complex multicellular beings that can breathe, reproduce, and respond to stimuli, reasons, catalysts, provocations, encouragements, and momentum through transmogrifying their living structures. They engage in metabolic processes while maintaining homeostasis, adapt to changing environments over generations, enhancing their chances of survival and reproduction. Organisms are mystical bodies that interact with other living and non-living components of their ecosystems and influence ecological dynamics. They have euphonious names such as 'archaea', 'bacteria', and 'eukaryota', which refer to microscopic single-celled organisms with diverse ecological roles, but also to protists, fungi, plants, and animals. Protecting these versatile organisms preserves biodiversity. Organisms symbolise life's complexity and form both inter- and intra-acting agencies unveiling the wonders of the nature-culture continuum. Understanding their interconnectedness nurtures a deeper appreciation for the intricate web of life on Earth.

VIGOUR
ˈvɪɡə

Vigour developed etymologically from the Latin *'vigere'*, meaning 'to be lively, flourish, thrive'. It denotes robustness, vitality, and enthusiastic energy in action, often characterised by physical strength, mental determination, and a zestful approach to tasks, even if they seem vast (such as facing the comprehensive, manifold current crises). In our context, this term envelops an invigorating force that has the potential to propel a plurality of open and porous bodies to pursue socio-aesthetic matters and ethico-political debates with intensity, stamina, and resilience. Perception, receptivity, surrender, and resonance are embraced as lenient, still, eminently vigorous practices of the soul. Vital dedication, passion, and drive in artistic research, endurance in tackling challenges through creative focus and consistency in ethics and aesthetics, call for a determined yet open spirit. Vigour articulates a kind of agential, political work *in practice*, steadily evolving and attuning to aesthetic compositional affinity (*Stimmigkeit*) and contributes to a vibrant and fulfilling existence amidst the shared field of enquiry.